ELEMENTARY GAME PROGRAMMING AND SIMULATORS USING *JAMAGIC*

LIMITED WARRANTY AND DISCLAIMER OF LIABILITY

THE CD-ROM WHICH ACCOMPANIES THE BOOK MAY BE USED ON A SINGLE PC ONLY. THE LICENSE DOES NOT PERMIT THE USE ON A NETWORK (OF ANY KIND). YOU FURTHER AGREE THAT THIS LICENSE GRANTS PERMISSION TO USE THE PRODUCTS CONTAINED HEREIN, BUT DOES NOT GIVE YOU RIGHT OF OWNERSHIP TO ANY OF THE CONTENT OR PRODUCT CONTAINED ON THIS CD-ROM. USE OF THIRD PARTY SOFTWARE CONTAINED ON THIS CD-ROM IS LIMITED TO AND SUBJECT TO LICENSING TERMS FOR THE RESPECTIVE PRODUCTS.

CHARLES RIVER MEDIA, INC. ("CRM") AND/OR ANYONE WHO HAS BEEN INVOLVED IN THE WRITING, CREATION, OR PRODUCTION OF THE ACCOMPANYING CODE ("THE SOFTWARE") OR THE THIRD PARTY PRODUCTS CONTAINED ON THE CD-ROM OR TEXTUAL MATERIAL IN THE BOOK, CANNOT AND DO NOT WARRANT THE PERFORMANCE OR RESULTS THAT MAY BE OBTAINED BY USING THE SOFTWARE OR CONTENTS OF THE BOOK. THE AUTHOR AND PUBLISHER HAVE USED THEIR BEST EFFORTS TO ENSURE THE ACCURACY AND FUNCTIONALITY OF THE TEXTUAL MATERIAL AND PROGRAMS CONTAINED HEREIN. WE HOWEVER, MAKE NO WARRANTY OF ANY KIND, EXPRESS OR IMPLIED, REGARDING THE PERFORMANCE OF THESE PROGRAMS OR CONTENTS. THE SOFTWARE IS SOLD "AS IS " WITHOUT WARRANTY (EXCEPT FOR DEFECTIVE MATERIALS USED IN MANUFACTURING THE DISK OR DUE TO FAULTY WORKMANSHIP).

THE AUTHOR, THE PUBLISHER, DEVELOPERS OF THIRD PARTY SOFTWARE, AND ANYONE INVOLVED IN THE PRODUCTION AND MANUFACTURING OF THIS WORK SHALL NOT BE LIABLE FOR DAMAGES OF ANY KIND ARISING OUT OF THE USE OF (OR THE INABILITY TO USE) THE PROGRAMS, SOURCE CODE, OR TEXTUAL MATERIAL CONTAINED IN THIS PUBLICATION. THIS INCLUDES, BUT IS NOT LIMITED TO, LOSS OF REVENUE OR PROFIT, OR OTHER INCIDENTAL OR CONSEQUENTIAL DAMAGES ARISING OUT OF THE USE OF THE PRODUCT.

THE SOLE REMEDY IN THE EVENT OF A CLAIM OF ANY KIND IS EXPRESSLY LIMITED TO REPLACEMENT OF THE BOOK AND/OR CD-ROM, AND ONLY AT THE DISCRETION OF CRM.

THE USE OF "IMPLIED WARRANTY" AND CERTAIN "EXCLUSIONS" VARY FROM STATE TO STATE, AND MAY NOT APPLY TO THE PURCHASER OF THIS PRODUCT.

ELEMENTARY GAME PROGRAMMING AND SIMULATORS USING *JAMAGIC*

SERGIO PEREZ

CHARLES RIVER MEDIA, INC.
Hingham, Massachusetts

Copyright 2003 by CHARLES RIVER MEDIA, INC.
All rights reserved.

No part of this publication may be reproduced in any way, stored in a retrieval system of any type, or transmitted by any means or media, electronic or mechanical, including, but not limited to, photocopy, recording, or scanning, without prior *permission in writing* from the publisher.

Publisher: David Pallai
Production: DataPage Reproductions, Inc.
Cover Design: The Printed Image

CHARLES RIVER MEDIA, INC.
10 Downer Avenue, Suite 3
Hingham, Massachusetts 02043
781-740-0400
781-740-8816 (FAX)
info@charlesriver.com
www.charlesriver.com

This book is printed on acid-free paper.

Sergio Perez. *Elementary Game Programming and Simulators Using Jamagic.*
ISBN: 1-58450-261-4

All brand names and product names mentioned in this book are trademarks or service marks of their respective companies. Any omission or misuse (of any kind) of service marks or trademarks should not be regarded as intent to infringe on the property of others. The publisher recognizes and respects all marks used by companies, manufacturers, and developers as a means to distinguish their products.

 Library of Congress Cataloging-in-Publication Data
Perez, Sergio E.
 Elementary game programming and simulators using Jamagic / Sergio E. Perez.
 p. cm.
 ISBN 1-58450-261-4
 1. Computer games—Programming. 2. Jamagic (Computer program language) I. Title.
 QA76.76.C672 P475 2002
 794.8'15265—dc21
 2002153036

Printed in the United States of America
02 7 6 5 4 3 2 First Edition

CHARLES RIVER MEDIA titles are available for site license or bulk purchase by institutions, user groups, corporations, etc. For additional information, please contact the Special Sales Department at 781-740-0400.

Requests for replacement of a defective CD-ROM must be accompanied by the original disc, your mailing address, telephone number, date of purchase and purchase price. Please state the nature of the problem, and send the information to CHARLES RIVER MEDIA, INC., 10 Downer Avenue, Suite 3, Hingham, Massachusetts 02043. CRM's sole obligation to the purchaser is to replace the disc, based on defective materials or faulty workmanship, but not on the operation or functionality of the product.

I dedicate this book to Sarah, Martha and Christopher, as well as to the midshipmen of the U.S. Merchant Marine Academy.

Contents

Acknowledgments		xi
Preface		xiii
Chapter 1	**Initial Topics**	**1**
Chapter 2	**3D Game Basics**	**7**
	The 3D Coordinate System	8
	Texturing Basics	10
	Winding Order and Culling	11
	U, V Coordinates	13
Chapter 3	**Your First Program**	**17**
	What Is a Program?	18
	How to Make a New *Jamagic* Program	18
	Getting Back to Your Source Code	22
	Your First Program: Moving Camera and Triangle	23
	Add Colors and Textures, the `Walk` Command, and the *Jamagic* Picture Editor	30
	Using the *Jamagic* Picture Editor	30
	Adding the Texture to Our Triangle	33
	Moving Our Object with the `Walk` Command	36
	Making More Complicated Shapes Using Triangles	40
	Making 3D Shapes with Polygons and the RGB Color Scale	44

Chapter 4 Simple Games 49

- Sphere1 — 50
 - `if` Statements — 51
 - The `Move` Command — 53
 - Sphere1 Code — 55
- Sphere2 — 58
 - Flat, Mesh, and Gouraud Shading — 58
 - Sphere2 Code — 59
- Sphere3 — 61
 - The `SetStatic` Command — 61
 - Collision Detection — 62
 - Functions — 64
 - `Hide` and `Show` Commands — 65
 - Sphere3 Code — 66
- Sphere4 — 68
 - Fog — 68
 - Ending the Game with the Esc Key — 70
 - The `CreatePlane` Command — 70
 - Sphere4 Code — 71
- Sphere5 — 74
 - Adding Background Music and Sounds — 74
 - Displaying Messages on the Screen — 76
 - Calculating Distance between Objects — 77
 - Hierarchy of Operations and Basic Calculations — 78
 - `if-and` Statements — 80
 - Sphere5 Code — 81
- Sphere6 — 84
 - Adjusting Text Color — 84
 - The `SetGravity` Command — 84
 - The `Camera Follow` Command — 85
 - Inertia — 86
 - The Pythagorean Theorem — 87
 - Flags and Counters — 90
 - Determining When the Game Is Lost or Won: Embedded `if` Statements — 91
 - Running the Program — 92
 - Sphere6 Code — 92
- Sphere7 — 96
 - Adding a Child Window — 96
 - Aspect Ratio — 97
 - Controlling Window Refresh Rate — 99
 - Adding Clickable Buttons — 100

Timers	101
Variable Initialization and Functions	103
Variable Types: Integers and Floating Point Numbers	104
Sphere7 Code	105
Sphere8	110
Making Graphics Objects with 3D Modeling Packages	111
Importing the New 3D Graphics	115
Improving the Previous Game	116
Boolean Variables	119
Discriminating Between Good and Bad Collisions	120
Sphere8 Code	122
Adding a Menu to our Game—Menusample Program	129
Adding a Pop-Up Menu	129
The `switch case` Statement	131
Menusample Code	133
Sphere9	140
Importing a Spaceship into Our Game from the CD-ROM	142
Adding More Sounds and Music	144
The `Wait` Command	145
The *Jamagic* Sound Editor	145
Adding a Realistic Water Surface—Tiling and UV Animation	147
Sphere9 Code	149

CHAPTER 5 FLIGHT SIMULATORS 157

Flight Simulator Basics	158
First Flight Simulator Program: `FlightSimulator`	160
Sine and Cosine	160
Sine and Cosine Demonstration Program	166
Sine and Cosine Demo Code: FlightSimulator	168
`FlightSimulator2`	169
Equation for Speed as a Function of Pitch	170
Computer Speed Issues	171
Finding the Jet's Angle	172
Vertical Speed	173
Yaw	175
`SetFocus` Command	176
Airport Image—Compass Heading	178
Criteria for a Successful Landing	181
More on Execution Speed	183
`FlightSimulator2` Code	183

		FlightSimulator3	190
		Sprites and the Analog Instrument Panel	191
		FlightSimulator3 Code	197
CHAPTER 6	**SHIP SIMULATORS**		**205**
	Basics of Ship Controls		206
	Basic Ship Simulator Program: ShipSimulator		209
	Basic Ship Simulator Code: ShipSimulator		218
	Improved Ship Simulator: ShipSim2		224
	Ship Simulator 2 Code		230
CHAPTER 7	**CLOSING REMARKS—DISTRIBUTING YOUR SOFTWARE**		**241**
APPENDIX A	**ABOUT THE CD-ROM**		**243**
APPENDIX B	***JAMAGIC* LANGUAGE REFERENCE**		**247**
INDEX			**293**

Acknowledgments

To the makers of *Jamagic*™ and *MilkShape 3D*™—thank you for making such excellent products.

To Charles River Media—thank you for your support and your confidence in me throughout this effort.

And, to the people without whom I would be nothing—my beautiful wife and my parents—I can never thank you enough.

Preface

If your goal is to make your own three-dimensional (3D) games and simulators, then you are in the right place. Using the *Jamagic* programming language that comes with this book, you will be designing and building your own 3D games and simulators in no time.

Jamagic is a programming language that was specifically designed for making 3D games. It is very similar to C++, and it has many of the same features, but it is considerably simpler to use—it is so easy, in fact, that by the time you reach the end of the book, you will have made working jet and ship simulators.

If you have never programmed before, you'll find that working with *Jamagic* is a great way to learn. If you are a beginner, you'll soon be using loops, conditional statements, functions, and mathematical operators to make 3D games and simulators that can be as good as games you can buy in a store. If you are already an experienced programmer, you will quickly appreciate the power and versatility of *Jamagic*. Using this book, you will learn to make 3D games and simulators by following step-by-step through 15 programs that become progressively more complex. In the first game, you will make a simple sphere that you can move in three-dimensional space using your keyboard. By the sixth project, the sphere will be subject to gravity and while music and sounds will be playing in the background, you will be trying to land it on a surface. By the ninth game, you will be controlling the sphere motion with your mouse and tracking its remaining fuel. In addition, you will know how to make a pop-up menu for your game, how to detect collisions, and how to edit sounds using the *Jamagic* sound editor.

By the time you finish this book, you will have made jet and ship simulators that are very realistic. The jet simulator requires you to land the jet on an airport runway using keyboard controls, and the jet's instrument panel will include a working virtual compass and a rate-of-climb indicator.

The jet will move as if governed by physical laws—you will program the computer to increase the jet's speed when it is diving and decrease it when climbing, the jet will move to the side faster as the angle of roll increases, and critical mistakes (such as landing too hard) will be detected.

If artwork is not your strong point, *Jamagic* comes with many, many 3D objects like aircraft, tanks, ships, trees, bridges, and airports that you can import into your game; this way you can concentrate on programming without having to worry about the considerable problem of making quality 3D artwork.

Here is the bottom line: *Jamagic* is a highly versatile and easy-to-use tool for making 3D games and simulators, and it is quite a bit of fun to use. If your goal is to make games or simulators that can compete in quality with commercially available software, then *Jamagic* is for you.

CHAPTER 1

INITIAL TOPICS

ON THE CD

This book is for anyone who wants to make three-dimensional (3D) games or simulations. Using the *Jamagic* programming language that is included on the CD-ROM accompanying this book, you can access the extremely powerful capabilities of Microsoft's *DirectX®* (the software of choice if you are making 3D games) and be miles further ahead than if you used C++ or another programming language. So far ahead, in fact, that by the end of the book, you will have created your own working jet and ship simulators. Figures 1.1 and 1.2 show screenshots from these simulators.

If you have never done any programming (or are not even sure what programming is), this book will show you how to program, from the ground up, using the very powerful *Jamagic* language. *Jamagic* is very similar to other languages (like C, C++, or Visual Basic) with many of the same features (like loops, conditional statements, functions, and arrays). In fact, learning how to program in *Jamagic* will make learning any other language much easier. The difference is that *Jamagic* has been exclusively designed to access *DirectX* easily and to make 3D games, thus greatly cutting down on the amount of programming that you will have to do.

However, do not believe that making games and simulations is easy. Programming is still a challenging endeavor that requires you to do ocean-sized thinking, much of it mathematical. In fact, quite a bit of this book is

Figure 1.1 Flight simulator screenshot.

Figure 1.2 Ship simulator screenshot.

dedicated to explaining some of the mathematics involved in this type of programming. There is no need to be afraid of this—if you are of average intelligence and are not afraid of thinking, then you should have no major problems.

What can you do with *Jamagic*? Just about anything. You can make first-person shooter (FPS) or role-playing games if you wish, or you can create games very similar to anything you might find on the market today. The author prefers simulators, so this is the vehicle that will be used to teach you *Jamagic*.

Using *Jamagic,* you can easily customize your games. You can make several windows on one screen, each with a different camera showing a different view. You can easily move the camera and objects through your 3D world, and you can do so in linear motion as well as rotation. You can also make clickable buttons or clickable zones, you can move sprites (2D images) across the screen, and you can use animations. In addition, you can easily detect collisions between objects. Clickteam (the creator of *Jamagic*) has done an incredible job with this software.

ON THE CD

In addition, *Jamagic* comes with some really great 3D objects: airplanes, cars, buildings, trees, ships, and spaceships. The importance of this cannot be overestimated since making good 3D artwork is one of the great-

est challenges of making a good game. You can simply import these objects from the full *Jamagic* CD-ROM, or from the CD-ROM that accompanies this book, into your game, and then you only have to worry about the programming. This book will also teach you how to make your own 3D objects using software called *MilkShape 3D*, which is also included on the book's CD-ROM.

Except for the computer, everything you need to make games and simulations is included with this book. However, there are some limitations to the software that is included. First of all, the *Jamagic* software on the CD-ROM is a limited capability version in that you cannot save *stand-alone* games—games that will run on computers that don't have *Jamagic* loaded. In addition, the *MilkShape 3D* software is time-limited, meaning that you can only use it for 30 days after you install it.

If you wish to be able to create stand-alone games, you must purchase *Jamagic* through the Internet at *www.clickteam.com*. To use *MilkShape 3D* beyond the 30-day limit, you may purchase it at *www.swissquake.ch/chumbalum-soft/*. They are both extremely reasonably priced.

This book assumes that you have never programmed before, so if you are already a proficient programmer, you might find the pace a little slow at times. However, if you are anything like the author, who was already familiar with Visual Basic®, FORTRAN®, and C++® languages when introduced to *Jamagic*, you will find that using *Jamagic* is, by comparison, delightful. The author is convinced that anyone who takes the trouble to learn *Jamagic* will have his efforts very well rewarded.

This book is organized into 15 projects of increasing difficulty. You will learn something new with every project. You will start out slowly—your first program will be a simple sphere that you can move around in three dimensions—and you will build gradually to the jet and ship simulators mentioned earlier. These will be far more complicated with clickable controls, working instruments, and realistic motion through a 3D world.

For the first nine projects, you can use a computer with a 166-MHz processor, but you will need at least a 600-MHz processor by the time you get to the jet and ship simulators. Before you start, you should also make sure that you have the capability to read a CD-ROM so that you can load the software that comes with this book.

ON THE CD

To load *Jamagic*, you should insert the CD-ROM into your computer, select Browse, and double-click the file called JamagicDemo.exe. It's very straightforward—you merely have to follow the instructions that will appear on your screen. Bear in mind that *Jamagic* will require about 48 megabytes of your hard drive memory, so you may want to free up some space beforehand if you are running low.

To load *MilkShape 3D,* double-click the file Milksetup.exe on the CD-ROM. The procedure for installing this is also very easy; just follow the instructions that appear on the screen. *MilkShape* will require about 11 megabytes of hard drive memory.

The next chapter introduces 3D game basics. Please read it carefully and make sure that you understand it before you actually begin programming. These efforts will be well rewarded later on because you will understand *why* things are done.

You will begin making your own programs in the fourth chapter of this book. There, the author will explain each line of the programs step-by-step. Though the programs in this chapter will not be difficult to understand, you must make sure that you take the time to absorb the material.

After each program is explained line-by-line, the entire program will be presented; you can type each program directly from this listing. You also have the option of running the programs directly from the CD-ROM without typing them in, but you are strongly encouraged to type them yourself. You will learn much more this way.

If you choose to load the programs from the CD-ROM or if you just want to see what all of the games are like, transfer the programs from the CD-ROM to C:/Programs Files/Jamagic/Projects (you can use Windows® Explorer to do this). You will then be able to run the programs by clicking the red icon in the upper-left corner of your *Jamagic* screen, or by simply pressing the F5 key. Please consult Chapter 3 for more details on how to run programs in *Jamagic.* But remember, it is important that you transfer the programs into the correct directory, or your programs will not run. Also, keep in mind that *Jamagic* must be loaded on your machine before any programs will run.

# CHAPTER 2
3D GAME BASICS

THE 3D COORDINATE SYSTEM

To begin our discussion of 3D basics, we'll first look at a one-dimensional (1D) world, which consists of the line that is shown in Figure 2.1.

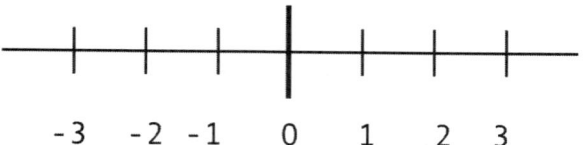

Figure 2.1 The one-dimensional world.

When we say that the world consists of the line, we mean that in this world, it's only possible to move along this line. We'll call the line the x-axis.

If you were told to move to x = 2, you would know exactly where to go: to the spot marked 2 on the line. Likewise, if you were told to move to x = –3, you would also know exactly where to go. You've probably already figured out that anything to the left of the point marked 0 (sometimes known as the *origin*) has a negative value (with a minus (–) sign), while anything to the right has a positive value (with a plus (+) sign, but we usually leave this sign out). You can see that the origin is at x = 0.

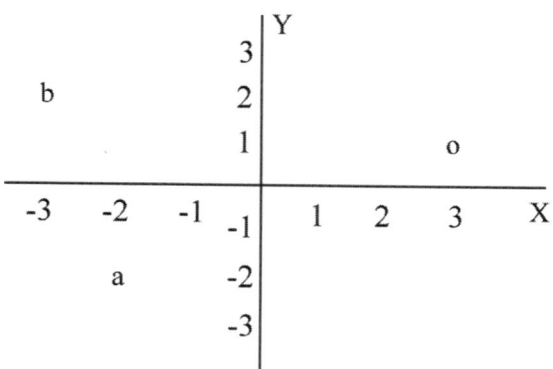

Figure 2.2 A two-dimensional world.

Pretty easy so far, huh? Well, it won't get much harder, but please pay attention to what happens next.

Now let's look at a two-dimensional (or 2D) world, where we add another axis. We will call the new axis the y-axis, as shown in Figure 2.2.

If someone were to tell you to move to the spot x = 3, y = 1 you would know exactly where to go: about where the "o" is marked in Figure 2.2. Typically we would not say an object is at x = 3, y = 1, because this is a little cumbersome. Instead, we simplify this to say that the object is at (3, 1). By convention, the x coordinate is listed first, and the y coordinate is listed second.

Try two more to make sure you understand. The spot marked with the letter "a" in Figure 2.2 is at (–2, –2), while "b" is at (–3, 2).

Unlike early video games, modern games occur in a world like our own—one that consists of three dimensions (3D). In the real world, the spot in Figure 2.2 marked "o" at (3, 1) could be on the paper you are looking at, or it could be two inches directly over the same spot. In other words, in addition to motion on the x and y axes, the third dimension allows motion along an axis that goes in and out of the paper. This third axis is called, reasonably enough, the z-axis, as shown in Figure 2.3.

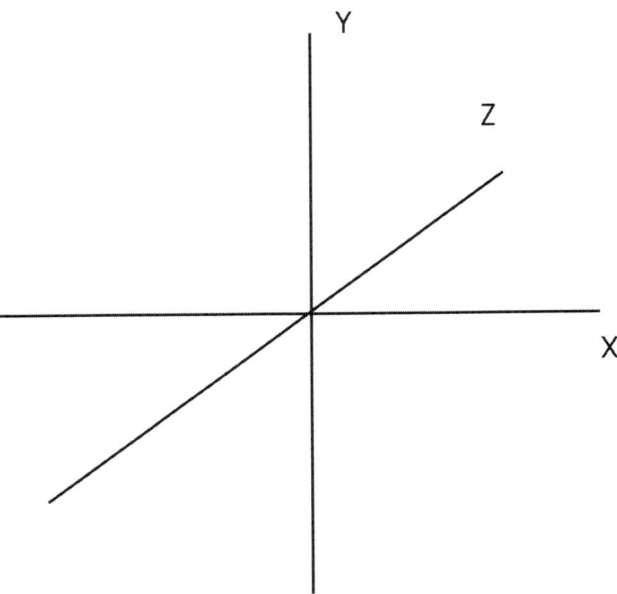

Figure 2.3 A 3D world.

10 Elementary Game Programming and Simulators Using *Jamagic*

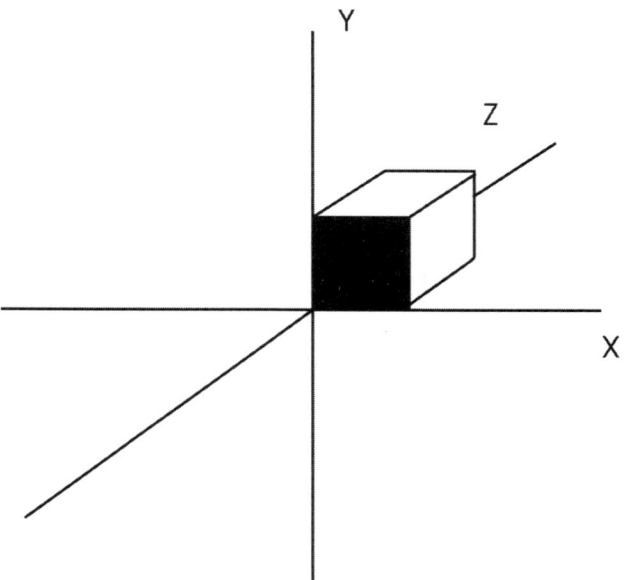

Figure 2.4 An isometric view of a cube in a 3D world.

Typically, 3D worlds are drawn on paper using *isometric views* (meaning that it appears as if you were looking at the 3D figure from an angle). Figure 2.4 shows an isometric view of a cube, with the three axes.

You will notice that the z-axis appears to be going into the paper, if the paper were viewed from the side. Figure 2.5 shows the positive and negative axes in the 3D world.

You can now see that if you have an x, y, z coordinate system set up in your 3D world, you can exactly specify where an object is in your 3D world. For example, latitude and longitude tell you where you are on the surface of the earth (x and z coordinates), but to specify the location of an aircraft, you would also have to give its altitude (y coordinate).

TEXTURING BASICS

Texturing means putting an image on a surface. For example, let's say that you had a game in which a sphere was moving around the screen, attacking other targets. You could assign a blue color to the sphere, but that would be on the boring side. What if you took some pictures of a cockroach colony and scanned them into your computer (or easier still, used a digital

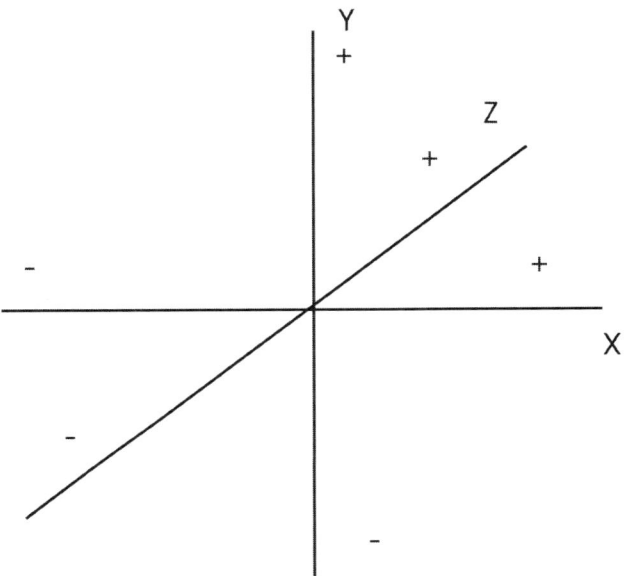

Figure 2.5 Positive and negative axes in the 3D world.

camera)? You could then apply that image to the sphere for a much more interesting effect.

Images can be generated by photography, as just mentioned, or through the use of one of the many available drawing packages, such as Adobe *Photoshop®*, Jasc® *Paint Shop Pro®,* or even Microsoft *Paint®*. *Jamagic* also comes with a drawing/painting tool called the *Jamagic* picture editor. We will be generating an image using the *Jamagic* picture editor very soon.

We will now look at some texturing basics.

Winding Order and Culling

Let's say that you wanted to have a triangle on your screen, with the vertices (plural of vertex, meaning the corners) as shown in Figure 2.6.

You can see that you could specify the location and size of a three-dimensional triangle by listing the x, y, and z coordinates of its vertices.

So, by listing a (−3000, 0, 0), b (3000, 0, 0), and c (0, 1000, 0), we have totally described our triangle in our 3D world… or have we? One thing we have not yet specified is which is the front face of the triangle, and which is

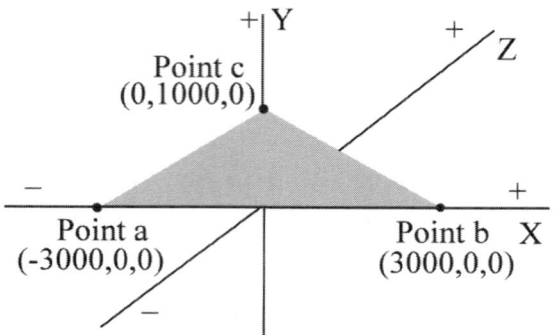

Figure 2.6 Triangle in 3D world.

the rear? In other words, is the front the face we are now looking at, or do we have to look from the other side of the paper to see the front?

We can specify the front face by the *winding order*, or the sequence in which we list the vertices. For example, by listing the vertices of the triangle as a, b, c we indicate that the front face is the side that is visible to us. Listing the vertices as a, c, b (or c, b, a or b, a, c) indicates that the front face is the one visible from the back side of the paper.

There's an easy way to remember this: just think of a screw. If a screw were to turn in the same direction as the winding order of the triangle, then the direction that the screw moves (in or out) is towards the front face.

Hmm....Better think about that one! Let's give an example: if we specify the winding order of the triangle in Figure 2.6 as c, b, a, a screw turning in that direction (clockwise) would screw away from you. That means that the back face of the triangle is facing toward you. If the winding order were specified as a, b, c (counter-clockwise) instead, then a screw turning in the same direction would move toward you, which would mean that the front face is facing you. Think about it a bit before going on!

The next question is: why should we care which is the front and which is the back? There are two reasons: one that's easy to understand, and one that's more difficult:

Easy explanation—When we apply a texture, we have to tell the computer which side of the triangle to put it on, so we need some way to specify which is the front and which is the back.

Figure 2.7 3D cube seen from the front.

Tougher explanation—Remember that computers need to be specifically told everything. They must be told what to draw and how to draw it. As an example, say you are looking at a 3D cube head on so that you would see the image seen in Figure 2.7.

Because the cube is a 3D object, there are faces that are not visible to you; for example, the back face is hidden from your view, blocked by the front face. The computer needs to know that it should not draw the back face here, so by looking at the winding order of the back face and by determining that the back face is facing toward the back of this paper, the computer would then know that there is no need to draw that face. This process of hiding surfaces that are not facing frontward is known as *culling*. Culling can be turned on or off, but the default setting in *Jamagic* is for culling to be activated, that is, back faces will not be drawn unless you tell *Jamagic* to draw them. Therefore, you must specify what the front face is of a 3D surface, since its back face will not be drawn.

U, V Coordinates

When you apply a texture to a surface, you have to tell the computer how to orient the texture. In other words, does the texture go on upside down or right-side up? It is even possible that the texture could be applied at an angle on the surface.

Through the use of u, v coordinates, we can specify which part of the texture goes on which part of the surface. Let's keep clear which is which: the texture is the picture you want to put on the surface.

14 Elementary Game Programming and Simulators Using *Jamagic*

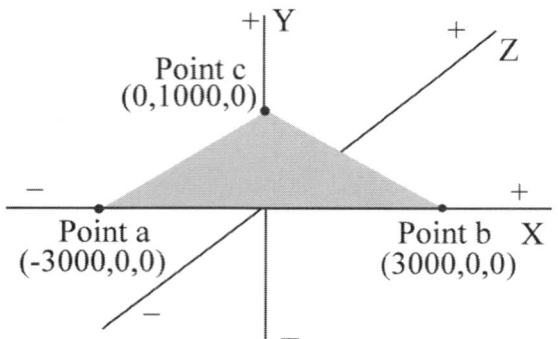

Figure 2.8 Triangle in 3D world.

To demonstrate this, let's say that you were to specify a triangle by specifying the same three points that were specified earlier: a (−3000, 0, 0), b (3000, 0, 0), and c (0, 1000, 0). This triangle is again shown in Figure 2.8.

Now let's look at the texture we want to apply to the triangle. It's a picture drawn with the *Jamagic* picture editor—just a square with some colors—with some numbers called *u, v coordinates* marked on it (see Figure 2.9).

We can give u, v coordinates (the same as x, y, just a different name) to each corner of the texture: the lower corner is (0, 0), the upper-left corner is (0, 1), the upper-right corner is (1, 1), and the lower-right corner is (1, 0).

The following commands in *Jamagic* assign each corner of the triangle to one of the u, v coordinates. Don't worry too much about it now—we will give a full explanation very soon. Just understand the following principle:

```
a(−3000,0,0,0,0)
```

In this statement, The first three numbers are the x, y, and z coordinates of point a, and the last two numbers specify that point a on the triangle goes with point (0, 0) on the picture. Try point b next.

```
b(3000,0,0,0,1)
```

This is very similar to the previous point. The last two numbers specify that point b goes with the u, v point (0, 1) on the picture, while the first three points are the x, y, and z coordinates of the point.

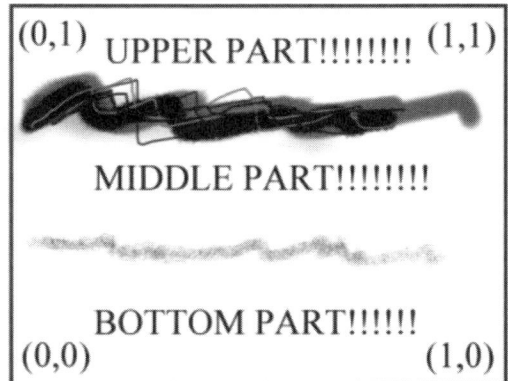

Figure 2.9 The image we wish to apply to triangle, with u, v coordinates marked.

The next one will be easy for you:

`c(0,1000,0,1,0)`

The last two numbers specify that point c goes with the u, v coordinate (1, 0).

Figure 2.10 shows the resulting image mapped onto our triangle as specified by this code.

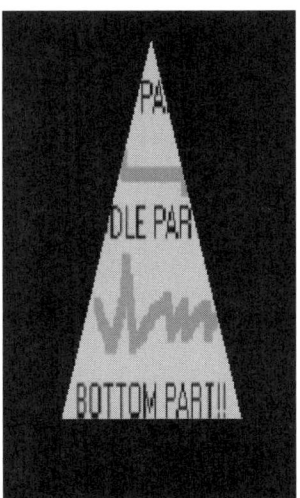

Figure 2.10 Triangle with image mapped using u, v coordinates.

CHAPTER
3

YOUR FIRST PROGRAM

WHAT IS A PROGRAM?

In order to make any game, you are going to have to tell the computer exactly what you want it to do. For example, if your game involves firing a missile when the spacebar is pressed, you must somehow pass this information on to the computer. If you want the missile to destroy different parts of a ship depending on where the missile hits, then you will also have to let the computer know this. And even more basic, if you want a menu to pop up when the program user turns on the game, you must tell the computer to make the menu pop up.

In one sense, computers are very dumb—they cannot figure anything out unless you tell them to. You must give them fully detailed instructions that explain what they must do, how they must do it, and when they must do it. These detailed instructions are given to a computer using a computer program, like the ones you will soon be writing. It is such a program that passes on all the necessary instructions to a computer.

If you want, you can compare a computer program to a cooking recipe. A recipe is a set of specific instructions that a cook must follow: add one egg, beat for one minute, and so on. A computer program is a set of instructions that a computer must follow.

Remember what we said a moment ago about computers being dumb, in a sense? Suppose that we were to tell you something, but we slightly mispronounced one of the words. Chances are, you would still understand what you were told. Unfortunately, computers do not function the same way when it comes to processing programs. If you misspell a crucial word in your program, or if you leave out a semicolon (;) where one is supposed to appear, or if you do anything that's only slightly wrong, then the computer will not recognize it. Everything must be exactly right (although you could program a computer to recognize common errors, but that's a subject beyond this book), so you must be very careful when you type in your code (*code* is another term for your program). Being careful is the best way to avoid bugs (errors) in your program.

Maybe you are a little confused now. If you are, don't worry—once you see some examples, you will know exactly what we are talking about.

HOW TO MAKE A NEW *Jamagic* PROGRAM

Here's the procedure you must follow to make a new program in *Jamagic*:

1. Load the *Jamagic* software.
2. Click the *Jamagic* icon that should have come up on your screen after you finished loading. If there is no icon, you might find *Jamagic* under

Figure 3.1 Initial *Jamagic* screen.

Programs in your Start menu. After you click this icon using either of these methods, some nice spinning graphics come up, after which you will get a screen like the one shown in Figure 3.1.

3. Click File in the upper-left corner, then select New, and then Project. You should now have an image like the one in Figure 3.2.
4. In the Project Name field, change the name from Project to Project1. (It doesn't matter if you use capitals or not: PROJECT1 is the same as Project1. In computer-speak, this means that *Jamagic* is not "case-sensitive.") Please note that you could use just about any name that you want here instead of Project1, but for now, let's stick with this to keep things easier.
5. Leave all the other fields on the New Project form as-is for now. For future reference, however, you should know what these other fields are for:

 The Directory field lets you search your computer and choose where your project will be stored.

 The Project Type drop-down list lets you select what type of application your game will be. One of the selections is a stand-alone application, which means that you'll be able to distribute your game even to

Figure 3.2 *Jamagic* project screen.

users who do not have *Jamagic* on their computers. (This capability will not be enabled in the limited version that comes with the book—you must purchase *Jamagic* from *www.clickteam.com* if you wish to distribute stand-alone games.)

In the Platform drop-down list, you can specify which platform you want your game to work on, which at this time is limited to Windows 32 bit (Win32). This means that it will run on Windows 95 and greater (not Windows 3.1, which is too bad if you are in the stone age of computer use).

In the Project Template field, you can choose a template to follow. It is best to leave this as Default, which is the most general template or setup for the programs that you will use.

6. Now click OK at the bottom of the New Project form. A message will pop up and inform you that the directory you have chosen does not exist and it will offer you the option of creating it. Select Yes. Here you are simply telling the computer to go ahead and start making Project1 and you are asking it to store this project in the directory that you have requested. You will now see the screen shown in Figure 3.3. There are lots of mysterious looking things on this screen, but you'll soon be familiar with most of them.

7. Double-click the Sources folder. Then click the Source subfolder, which should have popped up underneath. Source is short for *source code*, which is computer lingo for your program lines.

Chapter 3 Your First Program **21**

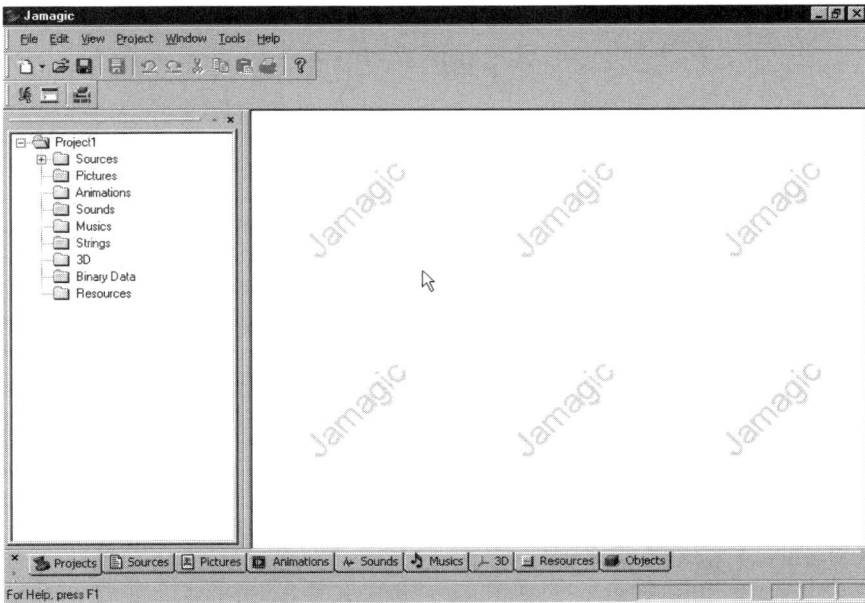

Figure 3.3 *Jamagic* project screen.

8. Click the empty screen that appears. You will see a flashing cursor in the upper-left corner. You are now ready to type in your source code (that is, write your program).

To get started, let's do something really easy, but important—let's add some comment lines. As you will find out the more time you spend programming, it's a very good idea to put lots of comments in your code. When you come across these comments a long time after you write the code, they will help you figure out what you were doing so that you won't have to start all over.

To add the comments, type in the following code:

```
//Project1 by your name here
// This is my first project.
// We will begin very simply, and then add more and more.
```

You can jump to the next line by hitting Enter, but you must remember to put in the slashes (//) at the beginning of each line. These slashes tell *Jamagic* that a comment is coming. In fact, you may have noticed that what you were writing was in red until you put in the second slash. This red font means that *Jamagic* has not yet made any sense out of what you

are writing. By the time you put in the second slash, *Jamagic* knows that a comment is coming, so it changes what you are typing to green to indicate that it is all OK.

You can write anything you want after these slashes. They are for your benefit—the computer does nothing with comments in the sense that they do not affect what your program does. We will use them a lot!

Now let's save what we have. To do so, just click File and then Exit. The computer will ask you if you want to save your project. Answer Yes. You will now find that you have exited *Jamagic* and your usual screen should be visible. Your project, named Project1, has been saved in the C:\Program Files\Jamagic\Projects directory, as was indicated by the default setting in the New Project form.

GETTING BACK TO YOUR SOURCE CODE

To get back into the program you just saved, you need to do the following:

1. Return to *Jamagic* by clicking the *Jamagic* icon on your screen or by clicking *Jamagic* in the Programs portion of the Start menu.
2. Select File from the upper-left corner.
3. Select Open Project. You will see a screen like the one shown in Figure 3.4.
4. Highlight Project1.3dj (your project) by clicking it and then clicking Open, or by simply double-clicking Project1.3dj.

To access your project more easily, you can select it directly from the bottom of the File menu. When you first click File, look at the bottom and you will see a list of the last few programs you've been working on. In your case, assuming this is the first project you have created, there will only be one—Project1—and you may simply double-click it to get right into the program.

5. After selecting your project, you will once again be taken to a blank *Jamagic* screen like the one shown in Figure 3.3. To get at your source code again, simply double-click Sources, and single click the Source subfolder. You should now see your source code again.

Congratulations! You are now ready to begin your first program.

Figure 3.4 Getting back to your program.

YOUR FIRST PROGRAM: MOVING CAMERA AND TRIANGLE

Here is how we will proceed to explain what you need to do to write your first program. Each line of code will be listed below, followed by an explanation of what it means. Please read carefully through the explanations, but don't begin typing in the code yet! You will be asked to do this very soon, but only after you have had a chance to understand what everything means. At the end of this section, after all of the explanations, the entire code will be given so that you can easily type it in. This is the format we will be using for the rest of the book. Here we go!

```
oworld = New World( );
```

This line tells the computer to create a new 3D world in which your game will take place. The world's name is oworld, but you can give it almost any name you feel like (for example, myworld, joesworld, joesgrill, and so on).

The New World part of this line must be typed in exactly as shown in order for *Jamagic* to understand what you are doing. So, the left part of the line above can be almost any name, and the right part must be something *Jamagic* already understands.

Notice that there is nothing inside the parentheses () that follow `New World`. We could put information inside the parentheses that described the 3D world we are creating in more detail, but there is no need to do this at this time. By leaving the parentheses empty, we tell *Jamagic* to use the default values for the `New World` statement.

Also notice that at the end of the line there is a semicolon (;). Almost every line in *Jamagic* ends with a semicolon (this is also true in both the C and C++ languages).

```
ocamera = New Camera(oworld);
```

This line tells *Jamagic* to create a camera in our 3D world (`oworld`) and to call it `ocamera`. Again, the name given to the camera could have been virtually anything: `nicecamera`, `bigcamera`, `candycamera`, and so on. This camera is essential because you will see all of the game action through the camera's lens. As mentioned above, statements to the left of the equal sign can have just about any name, but those to the right must be recognizable to the computer. The `oworld` part of this line in the parentheses following `New Camera` is essential because it tells *Jamagic* in what world to put the camera. Notice that there is also a semicolon at the end of this line.

```
opolygon = New Object(oworld);
```

With this line, we tell *Jamagic* that we will be having a 3D object in our world and that the object will be called `opolygon`. Yes, you guessed it: we could have given almost any other name to our new object, but because we are totally unimaginative people we have chosen a boring name like `opolygon`. For this example, the object we will be using is a triangle. If we wanted to include other objects in the world, we would have to include lines of code like the one above to tell the computer about it.

```
opoint1 = New Point3D(opolygon,-300,-300,0);
```

Wow! That's a nasty looking piece of code, but you'll see that it's really not bad at all.

We are going to mix things up a bit by explaining the last part of this line first. Remember from the previous chapter how objects in a 3D world can be described by giving the x, y, and z coordinates of different points on the object? In this line we are describing the location of one of the points on our object (`opolygon`).

By now, you may have figured out that the name of that point is `opoint1`, and yes, we could have given it any other name like `getthepoint` or `pointless` (we seem to be developing more imagination!).

The part that says `New Point3D` tells *Jamagic* that a 3D point is being made, and `opolygon` in the parentheses tells *Jamagic* that the point will be a part of the `opolygon` object defined in the previous line.

And now we've arrived back at the end of the line! You have probably figured out that –300,–300,0 are the x, y, and z coordinates of the point, and you are probably feeling happy that you took the time to read and understand Chapter 2, right? If you didn't, now may be a good time to go back!

```
opoint2 = New Point3D(opolygon, 300,-300,0);
```

This line tells *Jamagic* to create a second point, `opoint2`, and that it will be part of `opolygon`. It then lists the x, y, and z coordinates of the point.

```
opoint3 = New Point3D(opolygon, 0,1000,0);
```

This line creates another point in the polygon.

```
opolygon.AddPolygon (opoint2,opoint3,opoint1);
```

Here we put all of the points together to form our triangle called `opolygon`. The `AddPolygon` portion of this line tells *Jamagic* to add points `opoint2`, `opoint3`, and `opoint1` to `opolygon`.

Figure 3.5 shows what we now have.

Notice the winding order specifying which is the front face of the triangle and which is the back face. The order is counter-clockwise, so a screw

Figure 3.5 The triangle we are constructing with three points in a 3D world.

turning in the same direction would come towards us. Thus the triangle's front face would then be facing us (please see Chapter 2 if you have forgotten this).

```
opolygon.SetPosition(0,0,0);
```

Here we put the triangle exactly where we want it in the 3D world. The center of the triangle will be at the origin (0,0,0). If we had left this statement out, the triangle would have been drawn at the location indicated by the three points in the AddPolygon statement.

```
ocamera.SetPosition(0,100,-9000);
```

This line sets the position of our camera at (0,100,-9000). You have to be careful where you place the camera or your object may not be visible. By default, the camera faces towards the positive side of the z-axis, as shown in Figure 3.6.

This explains why we gave the camera a z coordinate of -9000. Because the camera is facing towards the positive z-axis, the camera must be placed in the negative z region to ensure that our object at z = 0 will be visible.

If we had placed the camera at (0,100,0), opolygon would not have been visible, resulting in a blank screen when you run the program.

```
ocamera.Walk( );
```

Figure 3.6 *Jamagic* default camera location—toward the positive z-axis.

This line enables us to move the camera around the 3D world. The `Walk` command makes the camera respond to the arrow keys on your keyboard, as described below:

Right and left arrows: The camera moves right or left.

Up and down arrows: The camera moves forward (toward positive z values) closer to your object, or backward (toward negative z values) further away from your object.

The motion right or left with the right and left arrows bears explaining. If you press the right arrow key, the camera will *rotate* to the right, much as if you were to start spinning while sitting on a chair that rotates. Eventually, your object becomes invisible when it spins out of the camera's field of view. If you were to continue holding down the right arrow key, your object would eventually reappear as the camera revolved through 360 degrees, and you ended up back where you started.

Notice the empty parentheses after the `Walk` command. You can adjust the speed at which the camera moves by putting in values here, but by leaving the parentheses empty, we tell *Jamagic* to use the default values. We will cover this more later.

```
While(1)
  {

  }
```

This is a very important part of the program: the game loop. Because programs do exactly what you tell them, if these lines above were not present, the following would happen:

1. A new world would be made.
2. A camera would be added.
3. Three points would be made.
4. The points would be put together to make a triangle.
5. The triangle would be moved to (0,0,0).
6. The camera would be moved to (0,100,−9000).
7. The arrow keys would be given the capability to move the camera.
8. The program would shut down.

Given the speed of today's computers, which can do millions of operations per second (if you have a 1-GHz processor, your computer can do

1,000 million operations per second), this will take a very, very short time. This makes for a pretty bad game since the game is over virtually at the same time that it starts!

We need a way to keep the game going so that the game can wait for the user to have input; in this case, this means that the user uses the arrow keys to move the camera around. The game loop keeps the program going (looping) until the user interrupts the game and tells it to stop.

The statement While(1) tells the computer to keep looping as long as (while) the user does not interrupt the program. In this case, the interruption would be caused by clicking the X icon, which will automatically appear on the upper-right side of the program screen when the program runs. Bottom line—the program runs until the user clicks the X.

Why the two curly brackets with nothing in them? The program will keep looping through the portions between the brackets. In this case, nothing is there, but when we do more complex programs, we will want the looping to include certain commands. You will learn more about this later!

So why not include the entire program in the brackets? That is a good question. The reason is obvious if you think about it. If you looped statements like the ones that set the position of the camera or the polygon, they would be being constantly reset to those positions despite any input from the user. For example, the user would tell the camera to move back by pressing the down arrow key, but the ocamera.Set Position statement would then reset it back to (0,100, –9000), so the user's request would be completed and then immediately overridden. In addition, it may be a waste of time to repeat some statements when having the computer read them once is enough. As you will find, we need to be very concerned with not making the computer work any harder than it must in order to make the program respond as quickly as possible.

Do you notice how the brackets in the last code segment are indented a few spaces? You can start a command anywhere on a line, and many times it's useful to indent lines so that you can more easily follow your program's logic. In this case, indenting really did not help any because this loop is so simple, but you will see that this really does help keep things clear when the programs get more complicated.

The program is done! Now take a look at the entire code. Type it in very carefully, making sure you put in the semicolons at the end of the lines that require them! If you need help getting back into the source editor, please see the previous section's discussion on getting back into your code. Also, make sure you type the portions of the lines that appear to the right of the equal sign very carefully—pay particular attention to making sure that you leave the correct number of spaces after words like New.

For your information, spaces left blank in-between commas are not important. For example 300,200 is the same as 300, 200.

```
//Project1 by your name here
// This is my first project.
// We will begin very simply, and then add more and more.
// 7 June 2002

oworld = New World();
ocamera = New Camera(oworld);
opolygon = New Object(oworld);

// Make the points.
opoint1 = New Point3D(opolygon,-300,-300,0);
opoint2 = New Point3D(opolygon,300,-300,0);
opoint3 = New Point3D(opolygon,0,1000,0);

// Add them to the polygon.
opolygon.AddPolygon(opoint1,opoint2,opoint3);

//Set positions.
opolygon.SetPosition(0,0,0);
ocamera.SetPosition(0,100,-9000);

//Move the camera.
ocamera.Walk();

//Loop until the user interrupts.
While(1)
{
}
```

Before you try to run your program, look it over. Chances are that you have made some form of mistake! Is there a red rectangle to the left of any line? If there is, this means that there is some kind of error in that line. Compare the code you have typed in with the one listed here. Did you forget to put in the semicolons where required?

Bugs, or errors, are a part of programming, and if you were to never have any, you would be the first in the history of programming. Expect errors and look your code over very carefully!

If you try to run your program with any errors in it, the program just won't run, and it will indicate to you where the first error is located in your

code. Don't worry, you cannot hurt the computer by making typing errors in your code, the program just won't run until they are fixed.

Now that you have checked for errors, you are ready to run the program. To do so, look in the upper-left corner of your screen. You will see what looks like a red figure running. To run you program, double-click this Run icon, wait a second, and your game should start.

When the program begins, you should see a blue triangle in front of you (blue is the default color, and it was used because we did not specify which color to use). It's the triangle we built with the three points. Now experiment a bit with the arrow keys. Note how the arrow keys move you in or out, left or right. Try holding down the right arrow key until the object disappears and then reappears on the left side of your screen. Not too bad considering that we only had a few lines of code. If you were programming in C++ and were accessing *DirectX* directly, you would have had many, many more lines of code, and learning how to do a program like this would have taken months of study. This is the beauty of *Jamagic*.

When you were typing in your code, you may have noticed a couple of things. When you first type in a line, a red rectangle appears to the left of the line until the line is correct (in a format understood by *Jamagic*). As mentioned earlier, you can use this visual clue to determine whether you have some bug (error) in your code.

You also may have noticed that the text is black, but that sometimes the black turns blue. This happens when *Jamagic* recognizes commands like `AddAngle`, `New` or `World`. In this way *Jamagic* lets you know that you are typing in commands properly.

ADD COLORS AND TEXTURES, THE WALK COMMAND, AND THE *JAMAGIC* PICTURE EDITOR

Let's make some changes to our project. First, we will make a texture using the *Jamagic* picture editor, and we will then add the texture to our triangle.

Using the *Jamagic* Picture Editor

Get into the *Jamagic* picture editor by right-clicking Picture, which should be directly under Source, and selecting New Picture. A small window that looks like Figure 3.7 will pop up.

You can select the size of the new image you will be making, but for now, stay with the default value of 100 × 100.

The Color Mode section allows you to select the quality of the picture's color. The higher the bits the greater the number of colors possible. You

Figure 3.7 Starting the *Jamagic* picture editor.

may be wondering why you shouldn't just use as high a quality as possible. If you did, you would be burdening the computer's memory, and you want to do this as little as possible. If the computer has to keep track of a large number of differently colored pixels (the dots that make up the screen image), it could slow down your program, making it run too slowly to be any fun to use. The computer has a tremendous number of calculations to perform every second and lots of things to keep track of, so you want to minimize its load. On the other hand, even brilliantly programmed code with great action will be terribly downgraded by bad-looking graphics. The trick is to find the right balance between looks and performance.

Which bits selection to use? Well, it depends on your graphics. Most of the time, 8 bits will *not* be enough, and you will need to go higher. The default setting is 12 bits, and we will stay with this.

When you are finished selecting your size and your color mode, select OK, and you will be taken to the *Jamagic* picture editor, which is shown in Figure 3.8.

The small white square in the middle of the screen is our picture. We will be drawing in it. Look at the sides of the editor screen. You will see the various ways in which you can draw on the image: with spray paint, bucket-fill, text, line draw, and various shapes. At the right of the screen you can see the color selection chart.

Let's make a quick picture using the picture editor. Use the Bucket-Fill tool to paint the entire image a yellow color. To do so, click the yellow color

Figure 3.8 The *Jamagic* picture editor.

from the color selection chart using your mouse and pointer. After you have selected the color, click the Bucket-Fill tool, and then click anywhere inside the image, which should cause it to turn a uniform yellow color.

Next, let's write three messages on the image: one at the top, one in the middle, and one at the bottom. First select green for the top message, then select the Text tool (by clicking the letter A that appears on the vertical menu at the side of the screen), then type in anything that fills in the box. Select another color for the middle and type a message in the center of the image, and repeat the process for the bottom.

Just for fun, let's spray paint a few swaths with the spray paint tool. Like the other tools, first select the color from the color menu on the right part of the screen, and then pick the Spray Paint tool and spray away. Figure 3.9 shows the result.

In another chapter we will go into greater detail about using the picture editor.

Now go to the upper left and click File and then select Save. The image we have just drawn has now been stored in the computer, ready for your use. Now double-click Pictures. You will see our image listed as Picture,

Figure 3.9 The image painted with the *Jamagic* picture editor.

which is the name the picture editor will automatically give any picture we make. Let's change the name to something we'll recognize when we see it. Right click Picture and select Rename, then type the new name in the highlighted area shown as shown in Figure 3.10. Here we have called the new picture `Firstpic`.

Now that we have drawn the picture, we can apply it (texture it) to our triangle. We did not need to draw an image using the *Jamagic* editor. We could have used any of a number of tools like Jasc® *Paint Shop Pro*®, Adobe® *Illustrator*®, or even Microsoft *Paint*® to do this. Generally, software made specifically for drawing will be more powerful and versatile than that included with *Jamagic*. This is not meant to disparage *Jamagic* in any way; the *Jamagic* editor is very good, but *Jamagic*'s main goal is to be a game-programming tool, not a picture editor.

Also, we could have used a digital photograph or images downloaded from the Web. *Jamagic* can accept images in BMP and JPEG formats.

Adding the Texture to Our Triangle

To add this texture, we will need to add some code to our previous program. Double-click Sources, and then single-click Source to get back into our program. We are now in the *Jamagic* source editor again.

As before, we will first list parts of the code and then explain them in detail. Later, the entire code will be listed. Please concentrate on understanding the code for now; type it in later.

Figure 3.10 Renaming the picture.

We need to add u, v coordinates to the three points of the triangle shown in Figure 3.5

We would like point 1 to correspond to the lower-left corner of our image (the u, v coordinates would be 0, 0); point 3 would then correspond to the middle top of the image (with the u, v coordinates of 0.5, 1), and point 2 would correspond to the lower-right portion of our image (with u, v coordinates of 1, 0). We need to add the u, v coordinates that go with each point by modifying the `Point3D` statements in our code. Here we are simply adding the u, v coordinates of each point at the end of each line:

```
opoint1 = New Point3D(opolygon,-300,-300,0,0,0);
opoint2 = New Point3D(opolygon,300,-300,0,1,0);
opoint3 = New Point3D(opolygon,0,1000,0,0.5,1);
```

Now we know with what part of the picture each point of our triangle is associated.

We also need to add the lines described in the following pages to our previous program.

```
otexture = New Texture(oworld,"Firstpic");
```

This line tells the computer that a new texture, named `otexture` (which could have been given any name), will be added to our world, `oworld`. The texture will be the image we just made—`Firstpic`.

```
omaterial = New Material(oworld,otexture);
```

This line instructs *Jamagic* to make a new material that will be stretched over our object; we are calling that material `omaterial`. The fitting of a texture over an object is called *mapping*.

```
omaterial.SetMapped(ON);
```

Here we tell *Jamagic* to prepare `omaterial` to be mapped on to a surface.

```
opolygon.ReplaceMaterial(omaterial);
```

This line finishes the texturing/mapping process by applying the texture in `omaterial` onto `opolygon`, using the u, v mapping coordinates from the `Point3D` statements.

Below we present the entire code. Simply modify your previous program as necessary. Note that the changes include four new lines at the end of the program and a modification of the `Point3D` lines. Comment lines have been added to help you see which lines to change and which lines to add.

```
//Project1 by your name here
// This is my first project.
// We will begin very simply, and then add more and more.
// 7 June 2002

oworld = New World();
ocamera = New Camera(oworld);
opolygon = New Object(oworld);

//Next we've commented out the previous code.
```

```
//opoint1 = New Point3D(opolygon,-300,-300,0);
//opoint2 = New Point3D(opolygon,300,-300,0);
//opoint3 = New Point3D(opolygon,0,1000,0);

//New code
opoint1 = New Point3D(opolygon,-300,-300,0,0,0);
opoint2 = New Point3D(opolygon,300,-300,0,1,0);
opoint3 = New Point3D(opolygon,0,1000,0,0.5,1);
opolygon.AddPolygon(opoint2,opoint3,opoint1);

otexture = New Texture(oworld,"Firstpic");
omaterial = New Material(oworld,otexture);
//omaterial.SetMapped(ON);
opolygon.ReplaceMaterial(omaterial);

//Old stuff
opolygon.SetPosition(0,0,0);
ocamera.SetPosition(0,100,-9000);
ocamera.Walk();
While(1)
{
}
```

When you run the program, you should get an image like the one in Figure 3.11. You can see that the texture we drew has been mapped onto our triangle. Notice that the program did exactly as we told it: the lower-left corner of the image, with the u, v coordinates (0, 0), has been mapped to the lower-left corner of the triangle. The mid-upper portion of the image (0.5, 1) has been mapped to the same part of the triangle, as has the lower part of the image (1, 0). We will experiment further with mapping in the next sections!

Moving Our Object with the Walk Command

Now let's make it so that we can move our triangle around with the Walk command. Comment out the line that says ocamera.Walk() by putting the two forward slashes before it, and type in the following line instead:

```
opolygon.Walk( );
```

Before you run your program, we should point out something that's a little unusual about *Jamagic*. When working with other programming languages like C, C++, Visual Basic, or QBasic, you must save every program after making modifications to it, even if you run the modified

Figure 3.11. Image mapped on triangle.

program. *Jamagic,* on the other hand, automatically saves your program after you run it once. We mention this because many people used to other languages will experiment with a program, try the changes they've made by running the program, and if the results are terrible, decide not to save their work and just stick with the original code. You can't do this with *Jamagic* because you will lose your original code the first time you test your program.

If you wish to improve a program you've spent a lot of time on and are afraid you might make it worse with your "improvements," then the best thing is to make a new program and cut-and-paste your old program into the new source code. You could then work on the new version and still have the old version intact. After you are sure you don't want the old version, you can delete the file using your Windows Explorer. You should not keep programs you do not need; delete them, otherwise your hard drive (where your computer permanently stores information) will quickly fill up.

Another way to experiment without ruining good code is to comment out (with //) the lines you want to change, and type in the new lines underneath them. This way you will always have available what you

started out with, and you can remove the comment slashes to get back your original code.

OK, run the program by clicking the red running figure, and experiment with the arrow keys. You will notice some unusual things! Please spend a few minutes observing what happens before reading on.

You probably noticed that the triangle moves in a different way with the `Walk` command than the camera did. When you use the right or left arrow keys, the triangle rotates about a center vertical axis; the camera moves left or right. When you use the up arrow key, the triangle moves in the direction it's facing and away from the direction it faces when you use the down key.

But you might have been alarmed to have seen the triangle disappear if you kept rotating it, only to have it come back into view as you continued the rotation. Please go back to your program if you did not notice this. What is going on? You might remember from Chapter 2 that every surface has a visible and an invisible surface, as specified by the winding order. When you rotate the triangle, you are eventually reaching its invisible surface, which is, of course, not visible.

Now try typing in the following line after the `Walk` command (you could type this line anywhere in your program after the line that tells the program to make the new world `oworld`):

```
oworld.setbackfaceculling(OFF);
```

Now run the program and see what happens. You can see the back face of your object. With the `setbackfaceculling(OFF)` command, you are telling the computer to show all back views of objects in our 3D world named `oworld`.

You may have also noticed that sometimes *Jamagic* tries to help you along by writing what it thinks you are trying to type in a small window. This makes it easier for you to spell statements that have to be exactly right!

Let's now experiment with the `Walk` command a bit. By leaving the space between the parentheses blank, we are telling *Jamagic* to use default values (or preset values) to move the object. But what if you want to move at a different speed? *Jamagic* gives you tremendous flexibility in choosing speed by allowing you type in numbers in the parentheses. Take a look at the statement below, which shows you how you can modify the `Walk` command:

```
anyname.Walk(player, walk speed, strafe speed, rotation
rate, run speed factor);// should all fit on one line
```

Before we explain this command, it's important to know that all commands in Ja-magic are written on one line. Unfortunately, books are limited in width, so we cannot present the entire Jamagic command without jumping to the next line. Whenever this happens in this book, the author has added a comment (//) to the code that warns you to enter the entire command on one line.

In this command, the `anyname` refers to any 3D object in your 3D world. In our case, it's `opolygon`. `player` applies when there is more than one player using your game. A numeral 1 would refer to the first player, 2 to the second, and so on. We will be using only one player in all of our games, so we'll just leave this blank.

`walk speed` refers to how quickly the object moves in the direction it's facing (up and down arrow keys). The larger the number, the faster the speed. We will use a value of 1000, but you can experiment with this when you are making a game until you get a speed that looks and feels right to you.

`strafe speed` refers to how quickly the object moves from side-to-side while facing in the same direction (in other words, the object moves sideways without rotating about its own axis). `strafe speed` is not activated with the type of 3D object we are using, so it can either be left blank or have any number put in it.

`rotation rate` is the speed at which the object will rotate—pretty obvious! You can experiment with this value until you get the speed you like, or if you like mathematics, you can figure out exactly how fast the rotation will be. The rotation is given in radians per second, so a value of 1 for the rotation rate will result in 1 radian per second, which is about 57.1 degrees per second, or about 1/6 of a full revolution every second. Chapter 4 gives more details on this.

The `run speed factor` refers to running objects. This tells the computer how many times faster running is than walking. For example, a value of 2 means that running is twice as fast as walking. This feature does not apply to our type of object, so it can be left blank, or you can put any number in it.

Now modify your `Walk` command to read as follows:

```
opolygon.Walk(  ,1000,  ,1,  );
```

You can see we left out the factors that did not apply by leaving the space between the commas empty. Try your program now and see what happens. We will wait for you here.

You can see that the triangle now moves faster, both in rotation and in forward/backward motion. If you are feeling really energetic, you might

want to time how long it takes to make one revolution. We specified a rotation speed of 1 radian per second, so it should take about 6 seconds for a full revolution. The final code is presented below:

```
//Project1 by your name here
// This is my first project.
// We will begin very simply, and then add more and more.
// 7 June 2002

oworld = New World();
ocamera = New Camera(oworld);
opolygon = New Object(oworld);
//Next we've commented out the previous code.
//opoint1 = New Point3D(opolygon,-300,-300,0);
//opoint2 = New Point3D(opolygon,300,-300,0);
//opoint3 = New Point3D(opolygon,0,1000,0);
//New code
opoint1 = New Point3D(opolygon,-300,-300,0,0,0);
opoint2 = New Point3D(opolygon,300,-300,0,1,0);
opoint3 = New Point3D(opolygon,0,1000,0,0.5,1);
opolygon.AddPolygon(opoint2,opoint3,opoint1);

otexture = New Texture(oworld,"Firstpic");
omaterial = New Material(oworld,otexture);
//omaterial.SetMapped(ON);
opolygon.ReplaceMaterial(omaterial);

opolygon.SetPosition(0,0,0);
ocamera.SetPosition(0,100,-9000);
opolygon.Walk( ,1000, ,1);
oworld.SetBackFacesCulling(OFF);
While(1)
{
}
```

MAKING MORE COMPLICATED SHAPES USING TRIANGLES

If games consisted of triangles moving across the screen, we could have finished this chapter already. But as you know, life is a lot more interesting than that. In this section, we will learn how to make more complicated shapes using the triangle as our basic building block. Triangles are used in *Jamagic* to construct all 2D and 3D forms. We will first make 2D surfaces, followed by 3D surfaces.

Figure 3.12. Rectangle made of two triangles.

Please examine the rectangle shown in Figure 3.12, placed on a 3D coordinate system. This rectangular shape is composed of two triangles. Triangle 1 consists of points 1, 2, and 3 and Triangle 2 is composed of points 3, 4, and 1 (did you notice we gave the same winding order for both, and that they would both be visible to you from your position since the triangles would screw out toward you?).

We will make a completely new program now to construct our rectangle. Let's call it Project1b. If you have forgotten how to make a new program, please go back and review the early portion of this chapter.

In the following pages, we explain each line of the code; much of it will already be familiar to you! As before, take the time to understand everything we are doing and wait to add the new code until later on, when we list the entire program.

```
oworld = New World( );
ocamera = New Camera( );
oobject = New Object( );
```

These first three lines are pretty similar to those in our first program. However, we are making a new 3D world called `oworld`, a new camera called `ocamera`, and a new object called `oobject`. The only difference is that we are calling our new object `oobject` instead of `opolygon`.

Next, we will specify the four points necessary to define the two triangles that will compose our rectangle. Here is the first point:

```
Point1 = New Point Array(5,-100,-100,0,0,0);
```

This line creates a point called `Point1` (which you could have called almost anything else). The line `New Point Array` tells *Jamagic* that we are creating a point that will be part of a polygon. An array is a list of parameters or numbers. In this case, the parameters are in the parentheses. We also could have made the points exactly as we did in the previous program using the `New Point3D` statement. The advantage of using the array is that

you can re-use it later to draw other points at the same location. The `New Point3D` statement actually makes a point, the point array is a location of a point.

Let's skip over the first parameter inside the parentheses (5) and move to the second, third, and fourth parameters: –100, –100, 0. These three numbers give the x, y, and z coordinates of the point.

The last two parameters are the u, v mapping coordinates. They specify that `Point1` will be associated with the lower-left corner of the texture.

If we were not interested in adding a texture to our object, we would have left the last two parameters out of the parentheses. If this were the case, you might notice that there would only be three parameters inside the parentheses. With the u, v coordinates, there are five parameters inside the parentheses. Hence the first parameter, 5, would have been a 3 if the u, v coordinates were left out.

The next three statements specify the remaining three points and their u, v coordinates:

```
Point2 = New Point Array(5,100,-100,0,1,0);
Point3 = New Point Array(5,100,100,0,1,1);
Point4 = New Point Array(5,-100,100,0,0,1);
```

The two resulting triangles are those that were illustrated in Figure 3.12.

We now need to tell *Jamagic* to put the four points into our object, oobject, as shown here:

```
oobject = AddPolygon(Point1,Point2,Point3);
oobject = AddPolygon(Point3,Point4,Point1);
```

This may seem a little mysterious. Why not put them all in at one time? The answer is that, in order to add shapes to an object, they must be added as individual triangles.

The last lines of code remain unchanged from the first program: they apply the texture, allow the rectangle to move using the `Walk` command, and establish the game loop.

There's just one more detail to take care of before you can run the program. This program does not have the image `Firstpic` in it, so you need to import it in. There is no need to redraw it since we have already done it. However, if you wished to have another texture on this new image, you will have to import another one or draw another one.

To import the image from the first program, right click Pictures and then click Import. In the Projects window select Hard Disc (C:) (you will

need to use the scroll bar to get to it), then select Program Files, then *Jamagic*, then Projects, and then double-click Project1 (which is where our picture lives).

Once in Project1, select Pictures, then double-click our image, `Firstpic`. The image will be added to our program.

Now that we have imported the image to our project, it is time to type in the code. Here it is, complete. You may wish to use cut-and-paste (to cut-and-paste, first highlight the lines you wish to copy by holding the Shift key while pressing the arrow keys, then press Ctrl + C to copy, and then Ctrl + V to paste the copied lines wherever you wish) from your previous program, but at this point, it's probably best for you to get more familiar with the code by doing the keyboard entry yourself!

```
//Program for making a square using triangles

// Create the world.
oworld = New World();
ocamera = New Camera(oworld);

// Create an empty object.
oobject = New Object(oworld);

// Create several points for polygons (with UV).
Point1 = New PointArray(5,-100,-100,0,0,0);
Point2 = New PointArray(5,100,-100,0,1,0);
Point3 = New PointArray(5,100,100,0,1,1);
Point4 = New PointArray(5,-100,100,0,0,1);

// Create three polygons with these points.
oobject.AddPolygon(Point1,Point2,Point3);
oobject.AddPolygon(Point1,Point3,Point4);
otexture = New Texture(oworld,"Firstpic");
omaterial = New Material(oworld,otexture);

// Add the new material to our object.
oobject.ReplaceMaterial(omaterial);

ocamera.SetPosition(0,0,-700);
oobject.Walk();

// Wait for the user to close the window.
While(1)
{
}
```

Figure 3.13 The image mapped onto the rectangle.

Now run it. The image should be perfectly mapped onto the rectangle, and the rectangle should respond to the arrow keys, as before (see Figure 3.13).

If you are experiencing any difficulties, please check your code carefully. Did you type the commands exactly as specified? Did you forget to finish a line with a semicolon? Don't forget that *Jamagic* will show you where your errors are with the small red square to the left of the offending code. If you wish, you may load this program from the CD-ROM that came with the book.

If you think about it, you can now make some more complicated shapes using the `AddPolygon` command.

MAKING 3D SHAPES WITH POLYGONS AND THE RGB COLOR SCALE

In the last section, you saw how we could make more complicated shapes by adding triangles together, but we did not delve into the third dimension. We are now going to add a third triangle at (100, 0, 100) to the two before, as shown by Figure 3.14.

Figure 3.14 Adding a third triangle to our basic rectangle.

Here are the lines responsible for adding the new triangle:

```
// Create several points for polygons (with UV).
Point1 = New PointArray(3,-100,-100,0);
Point2 = New PointArray(3,100,-100,0);
Point3 = New PointArray(3,100,100,0);
Point4 = New PointArray(3,-100,100,0);
Point5 = New PointArray(3,100,0,100);

// Create 3 polygons with these points
oobject.AddPolygon(Point1,Point2,Point3);
oobject.AddPolygon(Point1,Point3,Point4);
oobject.AddPolygon(Point2,Point5,Point3);
```

Note a couple of things about this code: we have added Point5 with a New PointArray call, and we have added one more AddPolygon line, which adds the new triangle to our previous polygon.

We will make a few other changes to our code to illustrate how you can control colors and add them to polygons without having to add a texture. The colors we will add will be *flat* colors—that is, totally uniform. Textures that you create with nonuniform colorings are much more realistic, but you should also be familiar with flat colors and the RGB scale.

Let's say that you had three buckets of paint—one red, one green, and one blue—and you wanted to mix them to create different colors. By controlling the amount of each color paint you add, you could come up with a very wide range of colors. The RGB (you guessed it; it stands for red, green, blue) scale for color control works in the same way, specifying the amounts of red, green, or blue that are added together. In this scale, 255 is the most

that you can have of a color, and 0 is the least. The color RGB (0, 0, 255) specifies blue, while RGB (0, 255, 0) gives green and RGB (30, 100, 200) gives some mixture of all three colors. Below is a list of some common colors and their RGB equivalents:

Black	255, 255, 255
Blue	0, 0, 255
Cyan	0, 255, 255
Green	0, 255, 0
Yellow	255, 255, 0
White	0, 0, 0
Red	255, 0, 0
Magenta	255, 0, 255

We add the following statements to our code:

```
omaterial = New Material(oworld,GetRGB(50,150,200),
            "lightblue");// all on one line
```

This line tells *Jamagic* to make a new material called `omaterial` and that it is to be applied in `oworld`. In addition, the RGB code for the material is given, and the name you are giving the color is light blue. The name of the color is for your own benefit—the program does nothing with this at this time. You could have called it almost anything you wanted.

```
omaterial.setflat(ON);
```

This statement tells *Jamagic* to use the flat coloring mode, as opposed to *Gouraud* (the default setting) or *Lambert* shading, which are much more realistic shading techniques than those that can be had with flat colors. Gouraud shading, which we will use soon, gives a 3D effect to a surface by altering the shading of the *vertices* of the polygons used to make up a figure. Lambert shading is similar to Gouraud shading, but it is more burdensome to the computer's memory. As far as the author can tell, the differences between Gouraud and Lambert shading are so small as to make them indistinguishable.

And finally we add the following:

```
oobject.ReplaceMaterial(omaterial);
```

This statement, which you've seen before, applies the material to our strange-shaped oobject.

You may now type in the entire code presented below:

```
//Program for making a complicated shape using triangles

// Create the world.
oworld = New World();
ocamera = New Camera(oworld);

// Create an empty object.
oobject = New Object(oworld);

// Create several points for polygons (with UV).
Point1 = New PointArray(3,-100,-100,0);
Point2 = New PointArray(3,100,-100,0);
Point3 = New PointArray(3,100,100,0);
Point4 = New PointArray(3,-100,100,0);
Point5 = New PointArray(3,100,0,100);

// Create three polygons with these points.
oobject.AddPolygon(Point1,Point2,Point3);
oobject.AddPolygon(Point1,Point3,Point4);
oobject.AddPolygon(Point2,Point5,Point3);

omaterial = New
Material(oworld,GetRGB(50,150,200),"lightblue");
omaterial.SetFlat(ON);

// Add the new material to our object.
oobject.ReplaceMaterial(omaterial);

// Add the movement of the camera.
ocamera.SetPosition(0,0,-700);
oobject.Walk();

// Wait for the user to close the window.
While(1)
{
}
```

CHAPTER 4

SIMPLE GAMES

Now that we have some of the more basic concepts under our belts, we are ready to make some games. In this chapter, we will build some programs that will teach you the basics: Sphere1–Sphere9. These programs will evolve to eventually produce a game in which you will land a spacecraft on an island's landing pad.

In this final game, there are several other things that you need to take into account. You will be flying over water, and you must use your thrusters to position yourself so that you can land properly. In addition, you cannot waste fuel because doing so will cause the spacecraft to miss the target island and get very wet, thus ending the game. The game will also eventually include background music, sound effects, and a game menu.

The goal of these programs is to prepare you for the full-blown aircraft flight simulator that we will explore in the next chapter. These programs have been designed to get you ready in small steps; in fact, our first program will be fairly simple—it will just involve moving a sphere-shaped spacecraft around the screen. After this, the programs will get progressively more complicated. Needless to say, along the way you are going to learn quite a bit about programming.

ON THE CD

The code for each of these programs can be found on the CD-ROM that comes with this book, so you do not need to type in the code if you do not feel like it. However, please bear in mind that you will get much more out of the book if you do enter the code!

SPHERE1

In this program, you will learn how to use the following:

- The keyboard to move objects around the screen
- `if` statements
- `Move` commands to move right, left, up, and down
- `AddAngle` commands to rotate an object about its x, y, and z axes
- The `CreateSphere` command

In the previous programs in Chapter 3, we moved objects around the screen using the `Walk` command, which was very useful. However, we were restricted to rotating the object and moving it forward/backward. What if we want to make the object move in other directions, like up, down, or sideways? And what if we want to use other keys instead of the arrow keys to cause such actions to occur? In this project, we will move a sphere

Figure 4.1 Screenshot of the Sphere1 project.

around the screen using some more versatile commands. Figure 4.1 shows what the end result should look like.

`if` Statements

Consider the following *Jamagic* statements:

```
if(Keyboard.IsKeyDown(Keyboard.UP))
{
   mysphere.Move(-200,2);
}
```

This looks pretty mysterious, but let's think about it. The statement is saying: if the up arrow key is pressed, then move the object `mysphere` −200 units back (note the negative sign in front of the 200; this indicates backwards motion—motion towards the camera); this motion is to take 2 seconds to occur.

Now try to understand what the following statements do:

```
if(Keyboard.IsKeyDown(Keyboard.DOWN))
{
   mysphere.Move(100,2);
}
```

Obviously these are very similar to the previous statements, but now if the down arrow key is pressed, the object `mysphere` is moved ahead 100 units in 2 seconds. The fact that there is no negative (–) sign in front of the number 100 indicates that the number is positive.

The codes for other keys are listed in the Help section of the *Jamagic* software, but here are a few more that will be used in our game, followed by comment lines that tell you what they are:

```
if(Keyboard.IsKeyDown(Keyboard.RIGHT)) // right arrow key
if(Keyboard.IsKeyDown(Keyboard.LEFT)) // left arrow key
if(Keyboard.IsKeyDown(Keyboard.SHIFT)) //shift key—moves up
if(Keyboard.IsKeyDown(Keyboard.CAPSLOCK)) //Caps Lock key
                                         //to move down
```

The `if` statement is an extremely powerful and useful programming tool, and it exists in just about every programming language.

Here is another example of an `if` statement (please note that we will not use this example in our program—it's presented only for illustration purposes):

```
if (speed = = 3)
{
mysphere.move(10)
}
```

These lines mean that if `speed` is equal to `3` then `mysphere` will be moved `10` units forward. You get the basic idea: everything inside the brackets is done when the condition specified in the `if` statement is met.

From this, you might have been able to figure out that the `if` statement has three parts:

1. The `if` statement itself, which tells which condition to test for, with the condition to be tested in parentheses (`if (speed = = 3)`)
2. The brackets, which indicate the end and beginning of the action to be taken
3. The action to be taken (in our example, the action is to move `mysphere`)

Now that you know the components of the `if` statement, let's look at the one we have been discussing a little more closely. For instance, you may be wondering why there are two equal signs in succession in the statement `if (speed = = 3)`. The reason is that the single equal sign (=) is used to set a value. For example, the statement `speed = 3` can be used in your

code to set `speed` to a value of 3. If you tell *Jamagic* "if (speed = 3) you are setting speed equal to 3," then the `if` statement is automatically satisfied! By using two equal signs, you are telling *Jamagic* that you are just seeing whether the value of `speed` is the same as 3.

The Move Command

The `Move` command needs to be explained in more detail also. The entire syntax for the command is as follows:

```
myobject.Move(distance, time, animation, animation speed);
```

`myobject` refers to the 3D object you want moved. `Move` moves it in the direction that the object is facing, and `distance` is the number of units you want the object moved. `time` refers to the number of seconds you want the move to take—if you want the object to cover the specified distance quickly, use a lower number of seconds. Incidentally, if you use any number lower than 1, such as 0.5, make sure that you do not omit the zero. If you do, you will get an error message. This is true in all cases. If you leave out the `time` parameter, then the object will cover the specified distance immediately.

An important note about leaving out the `time` parameter (for example, `myobject.move(100);`): this can be very useful if you want the object to keep moving as you hold down the key. Normally, if you specify the time and duration, the object moves the distance specified in the time specified, but you must press the key again if you want the object to continue moving beyond the specified distance. By leaving out the `time` parameter, the object will keep moving as long as you hold down the key. The downside of this is that the speed at which the object will move depends on the computer. This means that your game might seem much too slow on some machines or much too fast on others.

The `animation` parameter is the animation to be played, if any, while the object moves, and `animation speed` is the speed at which the animation is to be played. We will not use these features in this text. You are encouraged to explore the Help section of the *Jamagic* software, or wait for the advanced version of this book.

Here are some other `Move` commands:

```
mysphere.MoveRight( );

mysphere.MoveLeft( );
```

```
mysphere.MoveDown( );

mysphere.MoveUp( );
```

These are pretty much self-explanatory. For example, `mysphere.MoveRight()` moves the object `mysphere` to the right, based on the direction the object is facing. The same parameters can be used inside these parentheses as were previously discussed for the `Move` command.

There is one last statement we will learn in this section:

```
mysphere = oworld.CreateSphere(100,100,100,10,10);
```

This statement creates a 3D sphere for us in our world. The sphere's name is `mysphere` and our world's name is `oworld`. The first three numbers inside the parentheses indicate the size of our sphere, which, in this case, is 100 units in the x direction, by 100 in the y and z directions.

If these numbers were not equal to each other, say (100, 50, 60), then the "sphere" would not be a sphere, instead, it would be elliptically shaped in the 3D world—like some form of egg.

The last two parameters in the parentheses indicate the number of triangles you want the sphere to be made of in the x and y directions. Remember how every 3D object is made of triangles? The more triangles you specify, the smoother looking your sphere will be.

You may be wondering why you shouldn't just use a huge number of triangles for better appearance. The answer is that there is a limit, based on your computer's speed and memory, of the number of triangles or polygons that can be tracked by your computer without slowing down your game. That is the reason why commercially available games do not show anywhere near the detail of a "real-world" scene: computers do not (yet) have the capacity to keep track of so many polygons. You will do well to remember this when making your games—if you end up with a very slow game you will know what to check!

OK, you should now be ready to type in the complete code. To do so, make a new program called Sphere1 in your Projects subdirectory and then type in the following code. Please note that the `if` statements go inside the game loop. This makes sense, since the computer should be constantly checking for user input. Recall that items in the game loop keep repeating, while the initial code that lies outside of the game loop is looked at only once at the beginning.

Sphere1 Code

```
//
// Sphere1: First Spherelander game. Will create sphere and
// move it around
// with the arrow keys plus cap and shift keys.
// Covers: if statements, using keyboard to move objects,
//         move commands, createsphere command

// Create a new world with a new camera.
oworld = New World();
ocamera = New Camera(oworld);

// Create a sphere.
mysphere = oworld.CreateSphere(100,100,100,10,10);
mysphere.SetPosition(0,0,0);

// Camera
ocamera.SetPosition(0,0,-500);

//Game loop

While(1)
// The first bracket indicates start of game loop.

{
if(Keyboard.IsKeyDown(Keyboard.UP))
 {
   mysphere.Move(-200,2);
}

if(Keyboard.IsKeyDown(Keyboard.DOWN))
 {
   mysphere.Move(200,2);
}
if(Keyboard.IsKeyDown(Keyboard.RIGHT))
 {
   mysphere.MoveRight(-200,2);
}
if(Keyboard.IsKeyDown(Keyboard.LEFT))
 {
mysphere.MoveLeft(-200,2);
}
```

```
if(Keyboard.IsKeyDown(Keyboard.SHIFT))
 {
mysphere.MoveDown(200,2);
}
if(Keyboard.IsKeyDown(Keyboard.CAPSLOCK))
 {
    mysphere.MoveUp(200,2);
}
// The last bracket shows the end of the game loop.
}
```

You may be wondering why we put in negative numbers in the `MoveRight` and `MoveLeft` statements. The problem is that the `CreateSphere` command makes a sphere that is facing you, which means that the front of the sphere has right and left directions reversed relative to you (this is like what happens if a person is standing in front of you and pointing to his right; he is pointing to your left). Because we want the sphere to move to our right in the `MoveRight` command, we have to tell the sphere to move to its left, or negative right. Of course, it may have been a lot simpler to use the statement `MoveLeft(10)` when the right arrow key is pressed!

After you have finished typing in the code, please run it. You should get a big blue sphere that is controllable via the keyboard, as shown by Figure 4.1. The up and down keys should make it go forward/backward, the right/left keys should move the sphere to the sides, and the Caps Lock and Shift keys should move the sphere up and down. Already this supplies much more flexibility than the `Walk` command used in Chapter 3.

Want even more control of the sphere? Try adding the following statement so that you can rotate the sphere: (of course, you would have to replace `myobject` with `mysphere` below):

```
myobject.addangle(x,y,z,duration);
```

This command rotates an object called `myobject`. The parameters in the parentheses specify how much to rotate it: the first parameter denotes how far to rotate it in radians about the x axis, the second about the y axis, and the third about the z axis. Please consult Figure 4.2, which shows this rotation about the axes.

You may recall that radians are similar to degrees: there are about 57 degrees in one radian and 2 pi radians per revolution. Hence, the statement

```
myobject.addangle(pi,pi/2,pi/4,5);
```

Figure 4.2 Rotation about the three axes.

describes a rotation of pi radians about the x axis (180 degrees), pi/2 radians about the y axis (90 degrees), and pi/4 radians about the z axis (45 degrees). The number 5 at the end specifies that the rotations are to take 5 seconds to execute. Of course, specifying less time will cause the rotation to occur more quickly.

Try adding the following code to your Sphere1 program, below the other `if` statements, but inside the game loop. The code will cause 180 degrees of rotation about the x, y, and z axes when the F1, F2, and F3 keys are pressed. The rotation will take four seconds to finish:

```
if(Keyboard.IsKeyDown(Keyboard.F1))
{
  mysphere.AddAngle(Pi/2,0,0,4);
}

if(Keyboard.IsKeyDown(Keyboard.F2))
{
  mysphere.AddAngle(0,Pi/2,0,4);
}

if(Keyboard.IsKeyDown(Keyboard.F3))
{
  mysphere.AddAngle(0,0, Pi/2,4);
}
```

When you run this code, you will see the sphere rotating about the different axes. Please do this before going on to the next project.

SPHERE2

We will now make a new program called Sphere2, so you'll have to start a new source code. In this program, we will investigate the different types of shading we can use in our projects: flat, mesh, and Gouraud. Please see Figure 4.3 for a screenshot

Flat, Mesh, and Gouraud Shading

In this project, we make three spheres and apply different shading techniques to each. Here is the first new statement in this code:

```
mysphere.SetGouraud(ON);
```

This statement applies Gouraud shading to the object `mysphere`. The result will be a nicely shaded object with a realistic look.

```
mymaterial.SetFlat(ON);
```

Figure 4.3 Screenshot of Sphere2 program for experimenting with shading techniques.

This statement causes a material we create (`mymaterial`) to be applied in a flat mode that has no shading effects.

If you should wish to return to a mesh-type surface (the default until you apply a texture) you can use the following command:

```
object.SetWireFrame(ON);
```

Please type in the following code after you start a new project called Sphere2; this code will create three spheres with different shading. As you will see, you have already learned quite a bit! Some of the things that you have already learned that are in this code include the use of RGB colors, the use of the keyboard to move the spheres, the `CreateSphere` command, `if` statements, and much more.

Sphere2 Code

```
//
// Sphere2: Second Spherelander game. Will add second
    // sphere
// and 3rd sphere,
// gouraud shading, flat color

// Create a new world with a new camera.
oworld = New World();
ocamera = New Camera(oworld);

// Create a sphere with Gouraud shading.
mysphere = oworld.CreateSphere(100,100,100,10,10);
mysphere.SetPosition(0,0,0);
omaterial = New Material(oworld
    ,GetRGB(50,150,200),"lightblue");//one line
mysphere.SetGouraud(ON);
mysphere.ReplaceMaterial(omaterial);

//Create a 2nd sphere with flat solid color.
sphere2 = oworld.CreateSphere(100,100,100,10,10);
sphere2.SetPosition(-300,-100,1000);
mat2 = New Material(oworld,GetRGB(0,200,0),"green");
mat2.SetFlat(ON);
sphere2.ReplaceMaterial(mat2);
```

```
//Create a 3rd sphere with flat mesh.
ball3 = oworld.CreateSphere(100,50,50,10,5);
ball3.SetPosition(500,500,1000);
mat3 = New Material
    (oworld,GetRGB(50,150,200),"lightblue");//one line
ball3.ReplaceMaterial(mat3);

// Camera
ocamera.SetPosition(0,0,-3000);

//Game loop
While(1)
{
if(Keyboard.IsKeyDown(Keyboard.UP))
 {
   mysphere.Move(-200,2);
 }

if(Keyboard.IsKeyDown(Keyboard.DOWN))
 {
   mysphere.Move(200,2);
 }
if(Keyboard.IsKeyDown(Keyboard.RIGHT))
 {
   mysphere.MoveRight(-200,2);
 }
if(Keyboard.IsKeyDown(Keyboard.LEFT))
 {
   mysphere.MoveLeft(-200,2);
 }
if(Keyboard.IsKeyDown(Keyboard.SHIFT))
 {
   mysphere.MoveDown(200,2);
 }
if(Keyboard.IsKeyDown(Keyboard.CAPSLOCK))
 {
   mysphere.MoveUp(200,2);
 }

// The end of the game loop follows.

}
```

It's very important that you notice several things about this program when you run it. First, note the difference between the blue mesh sphere and the blue mesh ellipse at the upper-right corner of the screen. They both have the same color, but the ellipse's color is totally uniform. The blue sphere, on the other hand, has a very realistic lighting effect on it due to the Gouraud shading.

You should also notice that the green sphere is totally filled in with a flat color—not very interesting at all (sorry green sphere!).

Now for some fun! Something kind of fascinating happens when you "collide" the blue sphere (by using the arrows and keys) with the solid green sphere. The two blend together to form one at the spot of contact, as shown in Figure 4.3.

And here is something else that is also very interesting: if you maneuver the blue sphere behind the green sphere, you will see that the blue sphere becomes invisible where the green one covers it up. This is something like what happens when someone with a big head blocks your view of the screen at a movie. This makes our 3D world much more believable doesn't it? Try it now!

SPHERE3

In this program, we will study the following:

- `SetStatic` and `Optimize` commands
- Collision detection
- Functions
- `Hide` and `Show` commands

These items will allow us to instruct the computer to check for collisions between objects, and they will make one of the 3D objects invisible should a collision occur. In addition, we will be able to make objects reappear if a button is clicked. Figure 4.4 shows an example of this occurring.

The `SetStatic` Command

A static object is one that you designate as static in your program; that is, that the object does not move. For example, the statement

```
sphere2.SetStatic( );
```

would tell the computer that `sphere2` will not move. We do this in order to simplify the process for the computer when the program runs. If an object

Figure 4.4 Sphere3 screenshot. Collision detection activated. The use of functions introduced.

is specified as static, then the computer can ignore it when it is making certain calculations, which allows the program run faster. If any objects are specified as static, you must insert the following statement anywhere after the SetStatic commands:

```
myworld.Optimize(mycamera);
```

This statement tells the computer to optimize the calculations in myworld, putting the earlier SetStatic command into effect. Without optimizing the camera, using the SetStatic command has no benefit.

Collision Detection

Collision detection refers to the process of determining if two objects are touching each other. You will agree that collision detection is crucial for game creation. For example, without collision detection, you would have no way of knowing if a missile hits a target.

Collision detection can be expensive from a computational point of view in that if done unwisely, it could slow down your program. Fortunately *Jamagic* makes this task simple for you.

Why is collision detection time-consuming? Consider how you would determine visually if two objects are touching, for example, a baseball and a bat frozen in time and pretty close to each other. If you were viewing the scene from the pitcher's viewpoint, it would not be easy for you to be sure if the two are touching—you would have to see it from several different angles to be sure. It sounds complicated when you break it down, and it is, but it's even harder for the computer.

Visually, it's easy for you to check only the important parts of the bat and ball for contact. For example, why bother checking the back of the bat or the back of the ball if only the surfaces facing each other will come in contact? The computer, unless it has some algorithm (or method) for determining which triangles of the bat are close to which triangles on the ball, needs to check them all for collision. If there is some algorithm for determining which triangles to check, it still has to check a large number of triangles for collision since the program realistically cannot know exactly which two triangles to check; in addition, the algorithm itself is probably time-consuming.

Now that you know how complicated this is for two objects, consider checking for collision between three or more objects: say the pitcher, the bat, and the ball. The program would then have to check, at very close intervals in time, when all three are relatively close to each other and when the triangles on each object might collide. Perhaps you now have a feeling for how time-consuming these calculations can become, especially with objects that have lots of polygons in them for better appearance.

Jamagic does some of the work for you by only checking for collisions between objects that are in the same predetermined three-dimensional zones. You can further reduce the computational burden on your computer by writing your code so that the program checks for collisions only for non-static objects (objects that you have not declared as static) that matter. For example: if it's not important to the outcome of a game if a person collides with other objects in the game, then do not enable collision detection for that person.

Here are some of the commands you will need to know. They deal with detecting collisions between an object called `mysphere` (or any name) and any static object (that is, an object you specified as static):

```
mysphere.SetCollision(TRUE,Object.COLLISION_TYPE_SLIDE);
```

This command tells *Jamagic* that collision detection is activated (`TRUE`) for the object `mysphere`, and that if `mysphere` collides with any static object,

it should slide along the boundary of the object it collides against. Alternately we could say

```
mysphere.SetCollision(TRUE,Object.COLLISION_TYPE_STOP);
```

In this case, `mysphere` colliding with a static object will result in `mysphere` stopping its motion. You would then only be able to move it in a different direction than the one that caused the collision.

If you want to consider collisions between `mysphere` and any other non-static object, then you need another `SetCollision` statement, like the following, for the other object:

```
mysphere2.SetCollision(TRUE,Object.COLLISION_TYPE_SLIDE);
```

Functions

In this program and those that follow, we will use *functions* extensively, which we will now explain. Functions are sets of instructions that tell the program what to do, and they are super-important because they are so useful. In fact, functions are used in just about every programming language there is.

Consider the following statement:

```
oworld.OnCollide = docollision;
```

This command tells the computer that if any collision occurs in our world, then it should do whatever the `docollision` function tells it to do. The `docollision` is a part of your program that you will add to the game loop.

Let's say that you were building a model car with four wheels, and that constructing the wheels was a pretty long process. Instead of listing the instructions for building the wheels four times, it would make sense to list them just once. Each time you get to a part where you need to build a wheel, you could then simply refer the reader to the wheel-building instructions.

A function is very similar. It is a set of instructions that, in order to save space and conserve effort, you do not feel like repeating over and over. It makes sense to use a function to specify what action will be taken when objects collide, especially if more than two objects are being checked for collision or if collisions can occur many times.

How and where do you write the instructions in your function? In *Jamagic,* typically you will put them outside of the game loop, at the very end of your program. Here's the code that contains the `docollision` function :

```
Function docollision
{
    mysphere.Hide;
    mysphere.ReplaceMaterial(mat2);
}
```

Recall that this function is called when there is any collision. The brackets designate where the function begins and where it ends.

Incidentally, did you notice how the function code is indented? This is not necessary, but it makes it easier to determine which parts are inside the loop. When the projects become more complicated, indenting will be a big help in deciphering your own code.

Hide and Show Commands

When the function is called it will do two things: make `mysphere` invisible using the `Hide` command, and change the material applied to the surface of `mysphere` to `mat2`.

The `Hide` command does not destroy the sphere; it merely makes it invisible. It's possible to make the object reappear using the `myobject.Show` statement, as illustrated below:

```
if(Keyboard.IsKeyDown(Keyboard.F4))
  {
  mysphere.Show;
  }
```

Before you type in the program, you should know that sometimes you may want to send some information to the function you are calling—say the speed or position of an object. In this case, you might include that information (or arguments) in parentheses after the code for the `docollision` function. However, there is no need to do this if the variables you want to send to or from the function are values that have been *initialized* (or given a value to) earlier in the program. More on this later.

In the following code, please note that we have modified the `Move` *commands to make the objects move more quickly.*

Please type in the code below carefully. You may find that you are better off just modifying the previous program:

Sphere3 Code

```
//
// Sphere3: Third Spherelander game. Will add collision
// detection
// Hide Command, Functions
// Upon collision of two spheres, 1st sphere will disappear,
// and will
// change color.
// Set static command.
// Optimize camera command.

// Create a new world with a new camera.
oworld = New World();
ocamera = New Camera(oworld);

// Create a sphere with Gouraud shading.
mysphere = oworld.CreateSphere(100,100,100,10,10);
mysphere.SetPosition(0,0,0);
omaterial = New Material(oworld,GetRGB(50,150,200),
"lightblue");// should go with previous line!
mysphere.SetGouraud(ON);
mysphere.ReplaceMaterial(omaterial);

//Create a 2nd sphere with flat solid color.
sphere2 = oworld.CreateSphere(100,100,100,10,10);
sphere2.SetPosition(-300,-100,1000);
mat2 = New Material(oworld,GetRGB(0,200,0),"green");
mat2.SetFlat(ON);
sphere2.ReplaceMaterial(mat2);
sphere2.SetStatic;
oworld.Optimize(ocamera);

//Create a 3rd sphere with flat mesh.
ball3 = oworld.CreateSphere(100,50,50,10,5);
ball3.SetPosition(500,500,1000);
mat3 = New Material
    (oworld,GetRGB(50,150,200),"lightblue");//one line
ball3.ReplaceMaterial(mat3);

// Camera
ocamera.SetPosition(0,0,-3000);
```

Chapter 4 Simple Games

```
//Set collision detection on.

oworld.OnCollide = docollision;

mysphere.SetCollision(TRUE,Object.COLLISION_TYPE_STOP);

//Game loop
While(1)
{
if(Keyboard.IsKeyDown(Keyboard.UP))
 {
   mysphere.Move(-100,0.5);
 }

if(Keyboard.IsKeyDown(Keyboard.DOWN))
 {
   mysphere.Move(100,0.5);
 }
if(Keyboard.IsKeyDown(Keyboard.RIGHT))
 {
   mysphere.MoveRight(-100,0.5);
 }
if(Keyboard.IsKeyDown(Keyboard.LEFT))
 {
   mysphere.MoveLeft(-100,0.5);
 }
if(Keyboard.IsKeyDown(Keyboard.SHIFT))
 {
   mysphere.MoveDown(100,0.5);
 }
if(Keyboard.IsKeyDown(Keyboard.CAPSLOCK))
 {
   mysphere.MoveUp(100,0.5);
 }

if(Keyboard.IsKeyDown(Keyboard.F4))
 {
   mysphere.Show;
 }

}
Function docollision
{
```

```
        mysphere.Hide;
        mysphere.ReplaceMaterial(mat2);
}
```

Please run the program and experiment with it. You will see that the program has done exactly what we've told it to do. When a collision is detected between the moving sphere and a static object, the moving sphere becomes invisible. When you press the F4 key, mysphere becomes visible again, but the collision has altered its color. You might want to note the difference between the moving sphere's color and that of the stationary sphere after the collision. They both use the same material, but the moving sphere still has Gouraud shading activated.

SPHERE4

In this project we will learn about:

- Fog
- Quitting the program using any key
- Adding and rotating a plane

Using fog, you can develop some interesting depth effects. For instance, as you move the sphere away into the fog, you will notice that it becomes more and more difficult to see, until it's entirely invisible. On the other hand, objects that come toward you out of fog give you a very realistic perception of decreasing distance that increasing the size alone cannot give.

We will also add a plane surface to our object. Planes are two-dimensional, and are great for establishing apparent surfaces. Pay attention to this discussion because we will be landing on a surface like this one in a soon-to-come project!

Figure 4.5 shows how fog and planes can be used.

Fog

The fog will be added with the statements discussed here. Once again, the statement will be given first and an explanation will follow.

```
ocamera.EnableFog(ON);
```

This statement tells the computer to put a fog effect on our camera ocamera.

Figure 4.5 Sphere4 project using fog and planes.

```
ocamera.SetFogColor(GetRGB(30,0,0));
```

You can figure this one out yourselves—we are setting the color of the fog using the RGB scale.

```
ocamera.SetFogMaxZPosition(5000);
```

This command tells the computer that nothing will be visible that is more than 5000 units from the camera.

```
ocamera.SetFogMinZPosition(3000);
```

This command establishes when the fog will first become visible. In this case, no fog effects are visible unless an object is beyond the specified distance of 3000 units. Of course, numbers other than 5000 or 3000 must be used, but just remember that the MaxZ value must always be greater!

For objects that are between MaxZ and MinZ, *Jamagic* makes them hazier the further they are from the camera. In other words, objects close to MinZ will be more clearly visible, while those close to MaxZ will be almost invisible.

Ending the Game with the Esc Key

We also want to add a feature that will allow us to terminate the game using the Esc (Escape) key. This is easily done with the following self-explanatory statements:

```
if(Keyboard.IsKeyDown(Keyboard.Escape))
{
   End;
}
```

The `CreatePlane` Command

We will be adding a two-dimensional plane with the following commands:

```
myplane = oworld.CreatePlane(500,500);
```

With this command we create a plane, `myplane`, and we place it in our world, `oworld`. The dimensions of the plane are (500, 500).

```
myplane.SetPosition(0,-200,0);
```

With this command, we locate the plane's center at (0, –200, 0).

```
matp =New Material(oworld,GetRGB(0,100,50));
```

Here we create a new material surface that we will apply to our plane.

```
matp.SetFlat(ON);
myplane.ReplaceMaterial(matp);
```

In these code lines, we apply the material in a flat mode and instruct *Jamagic* to put the material onto `myplane`.

Now we need to change the orientation of the plane. By default, the plane gets made as if it were lying on the x and y axes. In other words, the plane will be like a picture hanging in front of you, as you look from the negative z axis.

We want to make the plane seem like a floor surface, so we need to rotate the plane through pi/2 radians (90 degrees) in the negative direction, rotating it about the x axis. We change the plane's angle with the following command:

```
myplane.SetAngle(-Pi/2,0,0);
```

After rotating the plane, if we also wanted to change the angle of the plane about the y or z axes, we could do so using the last two parameters in the parentheses.

Finally we make the plane a static object with the following command:

```
myplane.SetStatic();
```

Please type in the program carefully and run it. Observe what happens when the sphere gets far enough away—it should become more and more difficult to see, until it is totally invisible. In Figure 4.5, the spheroid far off on the right seems hazy from the start of the program , as does the static sphere. This is because they are both between the MinZ and MaxZ values.

Sphere4 Code

```
   //
// Sphere4: 4th Spherelander game. Will add fog commands
// to previous program. Beware to add fog in program before
//adding objects
// to program, or the fog will not be applied to objects
// until moved.
// Distances in fog commands are relative to the camera.
//
//Will add a plane and rotate it down - pi/2 radians
   // about
//the x axis.

// Create a new world with a new camera.
oworld = New World();
ocamera = New Camera(oworld);

// Fog commands
ocamera.EnableFog(ON);
ocamera.SetFogColor(GetRGB(30,0,0));
ocamera.SetFogMaxZPosition(5000);
ocamera.SetFogMinZPosition(3000);

// Create a sphere with Gouraud shading.
mysphere = oWorld.CreateSphere(100,100,100,10,10);
mysphere.SetPosition(0,0,0);
omaterial = New Material
    (oworld,GetRGB(50,150,200),"lightblue");//one line
mysphere.SetGouraud(ON);
mysphere.ReplaceMaterial(omaterial);
```

```
//Create a 2nd sphere with flat solid color.
sphere2 = oworld.CreateSphere(100,100,100,10,10);
sphere2.SetPosition(-300,-100,1000);
mat2 = New Material(oworld,GetRGB(0,200,0),"green");
mat2.SetFlat(ON);
sphere2.ReplaceMaterial(mat2);
sphere2.SetStatic();

//Create a 3rd sphere with flat mesh.
ball3 = oworld.CreateSphere(100,50,50,10,5);
ball3.SetPosition(500,500,1000);
mat3 = New Material
    (oworld,GetRGB(50,150,200),"lightblue");//one line
ball3.ReplaceMaterial(mat3);
ball3.SetStatic();

// Create a plane and rotate it so it's flat.
myplane = oworld.CreatePlane(500,500);
myplane.SetPosition(0,-200,0);
matp =New Material(oworld,GetRGB(0,100,50));
matp.SetFlat(ON);
myplane.ReplaceMaterial(matp);
myplane.SetAngle(-Pi/2,0,0);
myplane.SetStatic();

// Camera
ocamera.SetPosition(0,0,-3000);
oworld.Optimize(ocamera);

//Set collision detection on.

oworld.OnCollide= docollision;
mysphere.SetCollision(TRUE,Object.COLLISION_TYPE_STOP);

//Game loop
While(1)
{
if(Keyboard.IsKeyDown(Keyboard.UP))
 {
   mysphere.Move(-100,0.5);
 }
```

```
if(Keyboard.IsKeyDown(Keyboard.DOWN))
 {
   mysphere.Move(100,0.5);
 }
if(Keyboard.IsKeyDown(Keyboard.RIGHT))
 {
   mysphere.MoveRight(-100,0.5);
 }
if(Keyboard.IsKeyDown(Keyboard.LEFT))
 {
   mysphere.MoveLeft(-100,0.5);
 }
if(Keyboard.IsKeyDown(Keyboard.SHIFT))
 {
   mysphere.MoveDown(100,0.5);
 }
if(Keyboard.IsKeyDown(Keyboard.CAPSLOCK))
 {
   mysphere.MoveUp(100,0.5);
 }

if(Keyboard.IsKeyDown(Keyboard.F4))
 {
   mysphere.Show;
 }

if(Keyboard.IsKeyDown(Keyboard.ESCAPE))
 {
   End;
 }

// Game loop end follows.
}

Function docollision
{

    mysphere.Hide;
    mysphere.ReplaceMaterial(mat2);
}
```

Sphere5

Now things are becoming interesting. We are inching our way to our first full-blown game, but first we have to crawl a little more. In this program we will do a lot:

- Add background music.
- Add a sound when a collision occurs.
- Display a text message on the screen.
- Display *x* distance between two objects.
- Add the and operator to our `if` statement.
- Perform basic mathematical operations.

Please see Figure 4.6 for a screenshot of the program.

Adding Background Music and Sounds

Adding background music is a simple, yet very important task. To better understand what we are saying, try turning the sound down during a game—you will probably find that the experience will not seem anywhere near as rich.

Figure 4.6 Sphere5 screenshot. Sounds and music have been added, and distances are computed and displayed.

You can start by making a new project, or you can just make changes to your previous project. Once you have a project started, you can import the music file from one of the games in the *Jamagic* electronic manual.

To import the music, you must first right-click Musics a few lines below Sources on the *Jamagic* screen, and select Import Music Files. A window will appear with a place for you to enter information. Use the arrow near the top to scroll your way to Program Files/Jamagic/Examples/Advanced. Once there, double click the demo game Fish, and then click Musics. Now double-click `melody`, which will be the tune played during our game.

Alternatively, you could have loaded one of the many terrific MIDI music files from the Jamagic *CD-ROM (applies only to the full-capability version of* Jamagic*), which we will explore in a later project.*

Here are the commands involved in playing music in the background; as in the past, the explanations follow the commands:

```
omusic = New Music("melody");
```

This line tells *Jamagic* that a new piece of music will be added to the program, and that is name is `melody`. Please note that the music must be imported into the program before you run it, as just described.

```
omusic.SetLoop(ON,3);
```

The `melody` tune (which the program now recognizes as `omusic` from the previous statement) lasts only a few minutes, so if we want music to play for longer periods, we must loop the music. The command just mentioned tells *Jamagic* to loop `omusic` three times. If you want to make sure that music plays for the entire game, just use a huge number instead of the number three.

```
omusic.Play();
```

This statement starts the music playing. It will not start until it sees this command.

```
omusic.pause();
```

This statement pauses the music, and it can be restarted again with the following:

```
omusic.resume();
```

Sounds are very similar to music, but they are generally much shorter in duration. However, we can make sounds come on and turn off using the same commands as those we used with music.

In this case, the name of the sound is `catch` and you will have to import it into the project, just as you did with the music:

```
osound = New Sound("catch");
osound.SetLoop(ON,1);
osound.Play();
```

Like the music file imported earlier, the sound will be imported to our project from one of the Advanced Example Games in the *Jamagic* electronic manual. To import a sound, right click Sounds (a few lines beneath Sources) and follow the same procedure used to import the music into the game. The sound we want is in the advanced game called Rolling Ball 3D. When you get into the Rolling Ball 3D directory, click Sounds instead of Musics, and then double-click `catch`.

You may edit sounds using the Jamagic *sound editor, which will be covered in a later section.*

Displaying Messages on the Screen

Displaying messages on the screen is very useful, especially when simulating vehicles because the user might need to know information like the amount of fuel remaining, the speed of travel, the heading being followed, and so on. We will now spend some time discussing the commands we will be using to display such messages. As always, the command will be given first, followed by an explanation.

```
mytext = New StaticText(CurWindow," ",100,10,150,20);
```

This line tells *Jamagic* to make a new text called `mytext` and to place it in the current window (`CurWindow` is a statement that *Jamagic* recognizes). The set of quotes can hold a message like "Get me out of here!"; if it did, that message would be printed on the screen. However, because we will need to display a message that is constantly changing, we put the quotes in and leaving them blank; by doing so, we are telling the computer that something will be written later.

The numbers 100 and 10 indicate the x, y location of the text. It's easy to get confused here because a different coordinate system is being used for locating text on the screen than was used to move the objects in the 3D

Figure 4.7 Screen coordinate system.

world as discussed earlier. The screen coordinate system is a little strange: in this scenario, the upper-left corner of the screen is the origin (0,0). if you move to the right from this corner, you are increasing the positive values of x, and when you move down from the origin, you are increasing the positive values of y (see Figure 4.7). Your screen size is automatically set at 640 pixels wide by 480 pixels in height by *Jamagic*. We will learn how to adjust this later.

The numbers 150 and 20 specify the width and height of the message. You must specify a height and width exactly the same size or larger than the size of the actual message or the message will be cut off.

One of the messages we want to display is the x distance from the static sphere to the moving sphere. By the *x distance,* we mean the difference between the two spheres' x coordinates. This computation will be useful in the next game when we'll want to know how far away our sphere is from the landing spot, which will help us determine when we need to apply our thrusters to slow down.

Calculating Distance between Objects

We will place the static sphere at (–500,0,0) and the moving sphere (`mysphere`) at (0,0,0) (this means that their centers are at those locations). Each sphere is 100 units in diameter.

We can easily find the distance between the centers of the spheres by saying

x distance = (x coordinate of static sphere) – (x coordinate of `mysphere`).

Notice that under some situations (like when the static sphere is to the left of the moving sphere) the value of the distance would be negative. We would prefer for distance to always be positive. To make it positive, we can use the absolute value function (which most programming languages in-

cluding *Jamagic* have) to make any negative numbers positive. This can be done by using the following equation:

distance = abs((x coordinate of static sphere) − (x coordinate of `mysphere`)).

As you have probably figured out, using abs() takes the absolute value of whatever is inside the parentheses.

If you think about it, you will agree that in order to determine how close the spheres are to each other, we prefer to know the distance from the outer edge of one sphere to the outer edge of the other, not the distance from center to center. We will cover this momentarily.

Consider the following *Jamagic* command:

`mysphere.GetX;`

This gives us the x coordinate of the object we call `mysphere`. We know that the static sphere is always at x = −500, so we can calculate the distance (which we will give the name `dist`) from center to center by using the following:

dist = abs(−500 − (`mysphere.GetX`)),

However, recall that we want the closest distance from outer edge to outer edge. Since each edge is 50 units from the center (recall that each sphere is 100 units in diameter), the sphere edges will be 100 units closer than the formula above would indicate, so we need to subtract 100 from our formula above to get

x dist = ABS(−500 − (`mysphere.GetX`)) − 100.

This is the equation that we will use to find the distance between the static sphere and the moving sphere called `mysphere`.

Before we move on, we must note some important things about this equation:

- Every left parenthesis has a matching right parenthesis to go with it. This will be true of all equations!
- It's important to get the parentheses right so that the absolute value gets taken of precisely the part that you need.

Hierarchy of Operations and Basic Calculations

Before we continue, we need to stop for one minute and think about the order in which calculations are done in an equation. *Jamagic* will do every-

thing in parentheses first, then it will do the multiplication and division, and finally it will do the addition and subtraction.

For example, if we had written

$$\text{dist} = -100 + \text{abs}(-500 - (\texttt{mysphere.GetX})),$$

we would have achieved the same result as the previous equation since the quantities in the parentheses would have been calculated first, followed by the addition/subtraction. The order in which calculations are performed is called the *hierarchy of operations*, and it is very important to keep it in mind when you are writing equations. For example, the two equations below give different results (incidentally, the * sign indicates multiplication, while / denotes division):

$$x = (3 * 3) + 2 / 1 = 11$$
$$x = 3 * (3 + 2 / 1) = 15$$

Refer back to the hierarchy of operations just described if you don't understand the results. Which is correct? It depends on what you, the programmer, want!

Please consult the language reference in the Jamagic *electronic manual for more information on performing mathematical calculations.*

Once we calculate the distance between the spheres, we can display it by putting the following lines inside our game loop:

```
dist = abs( -500 -(mysphere.GetX) ) - 100;
mytext.SetText("Distance: " + dist);
```

The `SetText` command tells *Jamagic* to print "`Distance: `" in mytext followed by the value calculated for the distance, which we called `dist`. It's very important to realize that we could have written anything inside the quotation marks that surround "`Distance: `" (such as "`The distance is: `", "`Here's the distance, I hope you like it: `", and so on) as long as the text you made in the `New StaticText` is long enough to hold it (see the section "Displaying Messages on the Screen" earlier in this chapter).

Another thing to note is that we left a space after the colon and before the end of the quotation marks. We did this so that there would be a space between the word `Distance` and the number `dist`.

The commands above must be placed inside the game loop or else `dist` *will not be updated continuously as the sphere moves around the screen.*

We are also starting to get somewhat creative in this program. Now when a collision occurs, we want a message to appear in a second text message. Our function, `docollision`, now looks like this:

```
Function docollision
{

mysphere.Hide;
mysphere.ReplaceMaterial(mat2);
omusic.Pause();
osound.Play();
mytext2.SetText("Press right arrow key to uncollide,
then 'f4' to see ball and then 'r' to hear music");
//last two lines on one line

}
```

You can probably figure out what is happening here: when two objects collide, `mysphere` will be hidden from view and its appearance will change—that's nothing new. The music will stop, and the sound we imported will be played. In addition, instructions will be given to the user, informing him what to do next. By pressing the left arrow key, he will cause `mysphere` to move away from the static ball so that the collision is no longer occurring. Then, when he presses the F4 key, the ball will reappear, and when he presses the letter R on the keyboard, the music will come on again. The following lines of code are the ones that make this happen:

```
if(Keyboard.IsKeyDown(Keyboard.F4))
  {
  mysphere.Show;
  }
```

No problems with this one, we hope. The next one bears some explaining.

if-and Statements

The "&&" characters in the following code indicate a very powerful capability of the `if` statement:

```
if(Keyboard.IsKeyDown('R')&& omusic.IsPaused())
  {
  omusic.Resume();
  mytext2.SetText(" ");
  }
```

The first line of this code means that if the letter r is pressed down AND the music is paused, then the instructions that follow should be performed. With this explanation, you can probably figure out what is going on in the rest of this code segment now. If the letter R is pressed down and the music is NOT playing, then the music will resume and the text in `mytext2` will change to nothing.

After this explanation, you should now be ready to type in Sphere5's code and run it. You will see the distance displayed constantly on the screen, and you will see it change when you use the right or left arrow keys. Why does distance change only with the right and left keys? This is because we are displaying the distance between the two spheres in the x direction—the right and left keys are the only ones that move the sphere along the x axis.

Sphere5 Code

```
//
// Sphere5: 5th Spherelander game. Will add music as well
    // as
// collision sounds to previous program.
// Music will be added from fish game.catch sound from
// rolling ball 3D game.
// Also added are double conditional statements.
//
// Also added text message on the screen with distance to
// static ball displayed.
// Message changes upon collision.

// Create a new world with a new camera.
oworld = New World();
ocamera = New Camera(oworld);

// Music
omusic = New Music("melody");
omusic.SetLoop(ON,3);
omusic.Play();

//Text message

mytext = New StaticText(CurWindow," ",100,10,150,20);
mytext2 = New StaticText(CurWindow," ",100,40,450,20);

// Sounds
osound = New Sound("catch");
osound.SetLoop(ON,1);
```

```
// Fog commands
ocamera.EnableFog(ON);
ocamera.SetFogColor(GetRGB(30,0,0));
ocamera.SetFogMaxZPosition(5000);
ocamera.SetFogMinZPosition(3000);

// Create a sphere with Gouraud shading.
mysphere = oworld.CreateSphere(100,100,100,10,10);
mysphere.SetPosition(0,0,0);
omaterial = New Material
    (oworld,GetRGB(50,150,200),"lightblue");//one line
mysphere.SetGouraud(ON);
mysphere.ReplaceMaterial(omaterial);

//Create a 2nd sphere with flat solid color.
sphere2 = oworld.CreateSphere(100,100,100,10,10);
sphere2.SetPosition(-500,0,0);
mat2 = New Material(oworld,GetRGB(0,200,0),"green");
mat2.SetFlat(ON);
sphere2.ReplaceMaterial(mat2);
sphere2.SetStatic();

//Create a 3rd sphere with flat mesh.
ball3 = oworld.CreateSphere(100,50,50,10,5);
ball3.SetPosition(500,500,1000);
mat3 = New Material
    (oworld,GetRGB(50,150,200),"lightblue");//one line
ball3.ReplaceMaterial(mat3);
ball3.SetStatic();

// Camera
ocamera.SetPosition(0,0,-3000);
oworld.Optimize(ocamera);

//Set collision detection on.

oworld.OnCollide = docollision;
mysphere.SetCollision(TRUE,Object.COLLISION_TYPE_STOP);

//Game loop
While(1)
{
if(Keyboard.IsKeyDown(Keyboard.UP))
 {
   mysphere.Move(-100,0.5);
 }
```

```
if(Keyboard.IsKeyDown(Keyboard.DOWN))
 {
    mysphere.Move(100,0.5);
 }
if(Keyboard.IsKeyDown(Keyboard.RIGHT))
 {
    mysphere.MoveRight(-100,0.5);
 }
if(Keyboard.IsKeyDown(Keyboard.LEFT))
 {
    mysphere.MoveLeft(-100,0.5);
 }
if(Keyboard.IsKeyDown(Keyboard.SHIFT))
 {
    mysphere.MoveDown(100,0.5);
 }
if(Keyboard.IsKeyDown(Keyboard.CAPSLOCK))
 {
    mysphere.MoveUp(100,0.5);
 }

if(Keyboard.IsKeyDown(Keyboard.F4))
 {
  mysphere.Show;
 }

if(Keyboard.IsKeyDown('R')&& omusic.IsPaused())
 {
  omusic.Resume();
  mytext2.SetText(" ");
 }

dist = Abs(-500 -(mysphere.GetX)) - 100;
mytext.SetText("Distance: " + dist);

}
Function docollision
{
    mysphere.Hide;
    mysphere.ReplaceMaterial(mat2);
    omusic.Pause();
     osound.Play();
     mytext2.SetText("Press right arrow key to uncollide,
    then 'f4' to see ball and then 'r' to hear music");
    // Last  lines should fit all on one line!
}
```

Sphere6

Here are the topics we will discuss in this section:
- Pythagorean Theorem in 3D
- Embedded `if` statements
- Inertia
- The `SetGravity` command
- Flags

This will be our first real game, not just a demonstration program like the previous ones. When the game begins you will see a sphere in front of you and a flat plane surface in the distance, at an altitude that is below the sphere. The sphere is falling slowly, and you can move it forward, backward, and to the sides. The goal is to position the sphere over the plane so that it lands on the plane, before the sphere falls too far. Figure 4.8 shows this game being run.

Adjusting Text Color

One of the first things we will change in our program is the way in which the numbers are displayed. You may recall from the previous program that the x distance was displayed with black letters in a somewhat tacky-looking white background. We will now get a much more professional looking display by making a black background (which will blend perfectly with the screen color) and by adding the following lines to the New StaticText statement:

```
mytext = New StaticText(CurWindow," ",10,10,150,20);
mytext.SetBackColor(GetRGB(0,0,0));
mytext.SetColor(GetRGB(255,255,255));
```

You will recognize the first line as the command that makes the text. The second line sets the background color of the text to black (RGB(0,0,0)). The third line sets the color of the letters in the text to white.

The SetGravity Command

Here is the statement that will simulate gravity in our code:

```
mysphere.SetGravity(0.002);
```

This line makes `mysphere` fall towards the bottom of the screen at a rate determined by the number inside the parentheses. If you want to make

Figure 4.8 Screenshot of Sphere6 game. The sphere must be maneuvered onto the landing surface before the sphere falls too far.

mysphere fall more quickly, simply increase the number. By using negative numbers inside the parentheses you can make the mysphere fall up! For our game, 0.002 will be just about right.

mysphere will fall until it collides with a static object, so we must make sure we have enabled collision detection.

The Camera Follow Command

Another new feature of this program is that the camera will be made to follow behind the moving sphere at a set distance by using the following command:

```
ocamera.Follow(mysphere,-3000);
```

This line makes the camera follow 3000 units behind mysphere. If we had used 3000 without the minus sign, the camera would have followed 3000 ahead of mysphere (and then it would actually be leading, not following!).

There is quite a bit of flexibility to the Follow statement that we are not yet using. This will be covered in the Flight Simulator project.

Inertia

In this game, we will be concerned with inertia. *Inertia* is the tendency of an object to remain either at rest or in motion unless some force acts on it. For example, a baseball flies along its path until the bat exerts a force on it, and a car keeps moving until the brakes are applied. For the purpose of our game, we want our sphere to remain in motion until we tell it to stop. We also want it to change directions if we command it to do so. You may recall that in the previous programs, the sphere moved only for a few seconds when the arrow keys were pressed, and then stopped.

We will include inertia in our game by changing our `Move` statements. The first such change can be seen in the following `if` statement, which moves the sphere forward when the up arrow key is pressed:

```
if(Keyboard.IsKeyDown(Keyboard.UP))
{
   mysphere.Move(-5000,50);
}
```

In this case, `mysphere` will move a distance of 5000 units forward, and it will do so in 50 seconds. By using a "large" time (like 50), we ensure that `mysphere` continues moving for a while. The remaining arrow keys are programmed to move to the sides and back in the same way as described in earlier programs. When one of the other arrow keys are pressed, the new command is activated and the previous `Move` command is stopped.

For example, the user presses the up arrow key, which causes the sphere to move forward. A few seconds later, the user decides that the sphere needs to move to the right, so he presses the right arrow key. Forward motion then stops and the ball moves to the right.

We also need a way to stop the sphere when it is in motion, so in the following code, we tell the computer that when we press the letter S on the keyboard, it should stop the sphere. Of course, we could use any other available key for this, but "S" for "Stop" is easy to remember.

```
if(Keyboard.IsKeyDown("S"))
{
  mysphere.Stop();
 }
```

Recall that we will be following behind the sphere with our camera, so it will be easy to tell if the sphere is properly lined up with the plane in the x direction. However, it won't be so easy to tell when the sphere is over the plane since you are viewing the sphere from behind, not from above. Being able to see this would be like kicking a ball and being able to see it move

toward the goal from the same position from which you kicked it—it's easy to tell that the ball is going between the goal posts, but it is impossible to tell exactly when the ball crosses the goal-line. Someone observing from above would be able to tell, but from the kicker's vantage point, it's not possible to know immediately.

We could solve this problem by presenting two views of the sphere: one from above and one from behind. We will do this in a later section. For now, we will simply calculate the distance from the sphere to the plane in the x, y, and z directions and present these data on the screen. This way, the user of the game will know when he has positioned the sphere over the plane.

Here are the commands we will use to determine the position of the sphere:

```
distx = (mysphere.GetX) ;
mytext.SetText("X Distance: " + distx);
```

This should look familiar to you; these lines appeared in the previous program. The first line finds the x coordinate of `mysphere`, and the second line sets the text called `mytext` so it reads "X Distance: ", followed by the value of the x coordinate of `mysphere`. The x coordinate of the sphere is the same as the distance from the plane since we will be placing the plane at the origin (0,0,0).

In the next four lines, we find the y and z coordinates of the sphere and send them to the screen:

```
disty = (mysphere.GetY) ;
mytext2.SetText("Y Distance: " + disty);
distz = (mysphere.GetZ) ;
mytext3.SetText("Z Distance: " + distz);
```

The Pythagorean Theorem

To make our program work correctly, we would like to know the total distance between the sphere and the plane. Let's say we are dealing in two dimensions and we know how far apart two points are in the x and y directions. Take a look at Figure 4.9. In this figure, you can see that if X is the distance between the points in the x direction, and Y is the distance between them in the y direction, then we can find the distance C using the Pythagorean theorem, which is shown here:

$$C = \operatorname{Sqrt}(\, X * X + Y * Y)$$

Figure 4.9 The Pythagorean theorem for finding the distance C between two points.

Sqrt means the square root of whatever is inside the parentheses. So in this equation, we are squaring length X and adding it to the square of length Y, and then we are taking the square root of the whole thing.

The Pythagorean theorem can be extended to 3D by including the distance Z between the points, as is shown in Figure 4.10. The distance between two points in 3D space is represented as follows:

$$C = \text{Sqrt}(\ X*X + Y*Y + Z*Z\).$$

Figure 4.10 Distance between points in 3D space.

In other words, if we apply the 3D Pythagorean theorem to our situation, the distance between our sphere's center and the plane (at 0,0,0) can be represented as

totaldist = Sqrt(distx*distx + disty*disty + distz*distz).

Just for review, remember that the multiplication is done first and then the addition.

We will display this distance that results from this equation in a text box:

```
mytext4.SetText("Total Distance: " + totaldist);
```

You will probably recall being introduced to the docollision function. This function will come into play now because in order for the game to be won, the user will need to land his sphere on the plane—in other words, he will collide the sphere and the plane.

We want several things to happen when the collision takes place: we want the current music to stop and a sound called osound2 to play, and we want to let the user know that he has achieved his goal by displaying a message on his screen. These actions are shown here:

```
Function docollision
{
   omusic.Stop();
    osound2.Play();
   mytext5.SetText("Congratulations! You landed on
     target!");     // all on one line
}
```

This seems logical enough when you look at it. However, if you were to try it you would find that the sound osound2 never plays in its entirety, causing an unpleasant result. In fact, it keeps playing only its very beginning over and over and over. Basically, if osound2 consisted of the song "Jingle Bells" the code would play "Jingle — Jingle — Jingle — Jingle —" repeatedly.

The reason this is happening is that the collision is constantly being detected, even after it has already occurred. If statements like omusic.Stop and the SetText command are repeated in the function, there is no problem because when these statements are repeated over and over, the user doesn't notice. However, with the osound2.Play() command, it is quite a different story. We only need this command to run once, and we next explain how to do this.

Flags and Counters

Consider the following lines of code:

```
counter = 0
while(1)
//Beginning of game loop
{
 counter = counter + 1

if (counter == 1)
 {
    mytext.SetText(counter)
 }
// End of game loop
}
```

Let's figure out what is going on here. As you know, the program is constantly looping through the game loop. In the first loop, the variable counter starts out with a value of zero, but this is incremented by one when the program reaches the first line of the loop.

Then, at the `if` statement, the program decides whether to perform whatever is between the brackets. The first time the loop gets to the `if` statement, counter = 1, so the text displays 1.

The loop continues in this manner until the user exits the program, so the statement: counter = counter +1 is reached one more time. This time the counter is set to 2, and as a result, the `if` statement condition is not met. At this point, the program does not print `mytext` again, and it skips over whatever is inside the brackets contained by the `if` statement.

Now examine the code below, which contains a different version of the function `docollision`. If you understood the explanation above, you should have little trouble understanding how we now get the sound `osound2` to play only once. Please note that we chose our variable name as `flag` instead of `counter` to illustrate that almost any name could be used for the variable that counts the number of loops:

```
Function docollision
{
   flag = flag + 1;
   omusic.Stop();
   if(flag==1)
     {
        osound2.Play();
     }
```

```
    mytext5.SetText("Congratulations! You landed on
      target!");// all on one line
}
```

Recall from the last section that two equal signs (==) are used to test values.

Determining When the Game Is Lost or Won: Embedded `if` Statements

Now that we have seen what happens when the user successfully lands his sphere, we need to know when the user of the program fails to meet his objective. This happens when the sphere fails to land on and falls lower than the plane. The main way that we would know that the sphere had missed the plane would be if the y coordinate of the sphere (`disty`) fell below the level of the plane, which is at y = 0. So, if `disty` is less than or equal to 0 (<= 0), then the user has failed to land the sphere on the plane because the sphere has fallen too far.

If you are really astute, you might ask, "But what about when the sphere and plane collide? Doesn't `disty` = 0, make it seem as if the game has been lost when it hasn't?" The answer is that `disty` is the distance to the sphere's center, so when the sphere and plane collide `disty` will have a value of about 50 (the radius of the sphere), unless the sphere hits the edge of the plane.

All that being said, we can account for the sphere missing its target by the following code:

```
if(disty <= 0)
{
flag = flag+1;
mysphere.SetGravity(0);
mysphere.Stop();
omusic.Stop();
   if(flag ==1)
     {
       osound.Play();
     }
mytext5.SetText("Game Over. You failed to land on the
plane!");// all on one line
}
```

The first line expresses something new with the <= symbol; this line means "If `disty`'s value is less than or equal to zero." Other possible forms

that use variations of the greater than/less than symbols and the equal sign include the following: `if (x >= 20)`, which means "If x is greater than or equal to 20," and `if (x < 25)`, which means "If x is less than 25."

You can see that by the use of `flag` in this code that we are implementing a similar scheme as we did with the `docollision` example earlier. This is set up so that the sound plays only once. Also noteworthy is the fact that there is one `if` statement within another. This is known as an *embedded if statement*.

Running the Program

When you run the program, you will see the x , y, and z distances from the sphere to the plane displayed on your screen. You must adjust the z distance using the up and down arrow keys until you get the sphere closer than 100 units from the plane. Because the sphere is 100 units wide, there is no reason to get it any closer than that—your sphere will collide with the plane as long as its distance from the plane is less than 100. Of course, you will also need to adjust the position of the sphere in the x direction, but this is done visually very easily and as a result, you really do not need the text message giving you the x distance.

Remember from earlier discussions that pressing the S key stops the motion of the sphere (except under the influence of the `gravity` command).

Please type in the following code. Don't forget to import any sounds and music before you run it. This game uses the previous `catch` and `melody`, as well as a very nice sound called `jump` from the Rolling Ball 3D game in the Advanced Examples section.

Sphere6 Code

```
// Sphere6: 6th Spherelander game. Will try to land sphere
//at plane center under the influence of gravity. We will
// learn:
// (a) set gravity
// (b) camera follow command
// (c) partially accounting for inertia
// (d) calculating distance between objects - 3D
//     PythagoreanTheorem
// (e) embedded if statements

// Create a new world with a new camera.
oworld = New World();
ocamera = New Camera(oworld);
```

```
//Initialize variables

flag = 0;

// Music
omusic = New Music("melody");
omusic.SetLoop(ON,3);
omusic.Play();

//Text message

mytext = New StaticText(CurWindow," ",10,10,150,20);
mytext.SetBackColor(GetRGB(0,0,0));
mytext.SetColor(GetRGB(255,255,255));

mytext2 = New StaticText(CurWindow," ",10,40,150,20);
mytext2.SetBackColor(GetRGB(0,0,0));
mytext2.SetColor(GetRGB(255,255,255));

mytext3 = New StaticText(CurWindow," ",10,70,150,20);
mytext3.SetBackColor(GetRGB(0,0,0));
mytext3.SetColor(GetRGB(255,255,255));

mytext4 = New StaticText(CurWindow," ",10,100,150,20);
mytext4.SetBackColor(GetRGB(0,0,0));
mytext4.SetColor(GetRGB(255,255,255));

mytext5 = New StaticText(CurWindow," ",10,130,220,20);
mytext5.SetBackColor(GetRGB(0,0,0));
mytext5.SetColor(GetRGB(255,255,255));

// Sounds
osound = New Sound("catch");
osound.SetLoop(ON,1);

osound2 = New Sound("jump");

// Create a sphere with Gouraud shading.
mysphere = oworld.CreateSphere(100,100,100,20,20);
//mysphere.SetPosition(100,500,−1000);
mysphere.SetPosition(500,500,−1000);

omaterial = New Material
    (oworld,GetRGB(50,150,200),"lightblue");//one line
omaterial.SetFlat(ON);
```

```
mysphere.SetGouraud(ON);
mysphere.ReplaceMaterial(omaterial);

// Create a plane and rotate it so it's flat.
myplane = oworld.CreatePlane(100,100);
//myplane.SetPosition(0,-200,1000);
myplane.SetPosition(0,0,0);
matp =New Material(oworld,GetRGB(0,100,50));
matp.SetFlat(ON);
myplane.ReplaceMaterial(matp);
myplane.SetAngle(-Pi/2,0,0);
myplane.SetStatic();

// Camera
oworld.Optimize(ocamera);
ocamera.Follow(mysphere,-3000);

//Set collision detection.

oworld.OnCollide = docollision;
mysphere.SetCollision(TRUE,Object.COLLISION_TYPE_STOP);

// Set gravity on.
mysphere.SetGravity(0.002);

//Game loop
While(1)
{
if(Keyboard.IsKeyDown(Keyboard.UP))
 {
   mysphere.Move(-5000,50);
 }

if(Keyboard.IsKeyDown(Keyboard.DOWN))
 {
   mysphere.Move(5000,50);
 }

if(Keyboard.IsKeyDown(Keyboard.RIGHT))
 {
   mysphere.MoveRight(-5000,50);
 }
if(Keyboard.IsKeyDown(Keyboard.LEFT))
 {
   mysphere.MoveLeft(-5000,50);
 }
```

```
// Distance calculations

 distx = (mysphere.GetX) ;
 mytext.SetText("X Distance: " + distx);

 disty = (mysphere.GetY) ;
 mytext2.SetText("Y Distance: " + disty);

 distz = (mysphere.GetZ) ;
 mytext3.SetText("Z Distance: " + distz);

 totaldist = Sqrt(distx*distx + disty*disty +
    distz*distz);//one line
 mytext4.SetText("Total Distance: " + totaldist);

 if(Keyboard.IsKeyDown("S"))
  {
    mysphere.Stop();
  }

 if(disty <= 0)
 {
 flag = flag+1;
 mysphere.SetGravity(-0.002);
 mysphere.Stop();
 omusic.Stop();
 if(flag ==1)
 {
  osound.Play();
 }
 mytext5.SetText("Game Over. You Failed to Land on the
 Plane!");//all on one line
 }

 //End of game loop follows.

}

Function docollision
{
     flag = flag + 1;
    omusic.Stop();
    if(flag==1)
     {
        osound2.Play();
     }
```

```
    mytext5.SetText("Congratulations! You landed on
    target!");//all on one line
```

Sphere7

We will make this game more sophisticated than the last by doing the following:

- Add a second window that shows a view of our sphere from an orbiting satellite.
- Use clickable screen buttons to move our sphere.
- Keep track of remaining fuel.
- Introduce timers.
- Learn about different types of variables including integers, reals, strings, and Booleans.
- Control the rate at which the window is refreshed.

Figure 4.11 shows a screenshot of the resulting game. Notice the second window and the additions made to the instrument display.

Adding a Child Window

You'll recall that in our last game we knew our sphere was over its target by watching the Z Distance parameter on our screen. If a camera were placed

Figure 4.11 Screenshot of Sphere7 game.

over the target plane, we could visually determine when the sphere is properly located; for instance, if our sphere were a spacecraft, this view might be achieved from a satellite orbiting overhead. With the view from an orbiting satellite available to us, the distance readings on the instrument panel would not be as critical; instead, they could serve as a back-up to the orbiting satellite and as a way to get as close as possible to the target.

Getting a second or *child* window to display on the screen is a simple task. First we will take control of the main window by adding the following statement:

```
owindow = New Window("Spherelander",640,480,Window.STANDARD);
```

In our previous programs, we never bothered creating the main window because *Jamagic* does this automatically for us. However, it's possible to do this ourselves with this statement. This will allow us to exercise more control over our game. Default values are useful, but there comes a time when we must grab some more control. We will be doing more and more of this as we progress through the rest of the chapter.

Aspect Ratio

The command discussed in the previous section tells *Jamagic* to make a new window called `owindow`, and to display the name `Spherelander` in the title bar (this is the name of our game). This window is set to the standard 640 × 480 pixels. This is usually a good size to use, and it ensures that the game window fits on your user's screen (covering most of it) with some room to spare. You can use smaller or bigger sizes, but you should try to keep the same ratio of width to height (640/480 = 4/3).

The ratio of width/height is known as the *aspect ratio*. If you stray too far from an aspect ratio of 4/3, your screen objects will seem distorted. If you are looking for a new window size, pick the width and multiply it by 3/4 (in decimal that's 0.75) to find the correct height. Or you could pick the height and multiply it by 4/3 (or 1.33 in decimal). If you need to change the height or width so that you deviate a bit from the 4/3 aspect ratio, it may not matter very much—the best way to find out is to try it and see if the effect is important.

The portion of the line in the parentheses that says "`Window.STANDARD`" tells *Jamagic* to use a standard style of window. A standard window style means the window will have a border, a title bar, and a close box with an X to exit the program. You may consult the *Jamagic* Help section for more information on window commands.

This is one of the few cases where we have to destroy the default setting. Lines of code specifying the window size are automatically added to your program at runtime, so we have to comment these lines out. To do this, you must begin your new project (which we called Sphere7, but you can call it anything you want). Once the project is made, click the Project Icon on the *Jamagic* toolbar, and then on Settings. You will see a series of tabs with different names on them. Select Runtime Init., which is short for runtime initialization. You will see some code pop up in the window, as shown in Figure 4.12.

This line automatically creates the default window when your program starts up. All you have to do is comment the second line out by adding two slashes in front, like so:

```
// Default Win = New Window(640,480);
```

Click OK when you are done.

Our child window (the window we will create inside the main window), will be slightly different from our parent window. It will be a GAME style window, which means that there will be no Close box; again, please consult the Help section in *Jamagic* for a list of all the possible windows. The child window is created with the following command (please note that

Figure 4.12 Code to be commented out to prevent default window from being created.

the command is presented in two lines; when you type in the code, you should place it all on one line):

```
owindow1 = New Window(owindow,"View From Orbiting
Satellite",200,150,Window.GAME);// all on one line
```

This statement tells *Jamagic* to create a new window called oWindow1 and that its parent window is oWindow. The title bar should say View from Orbiting Satellite, and the window itself should be 200 pixels wide by 150 in height (aspect ratio = 200/150 = 4/3). In addition, this window is to be a GAME style window.

Next, we want to position the child window so it doesn't interfere with the view of the sphere in the main window; to do this, we place the camera over the plane, and turn the camera down 90 degrees so that it looks straight down, as shown here:

```
owindow1.SetPosition(390,5);
ocamera2.SetPosition(0,2000,0);
ocamera2.TurnDown(Pi/2.0);
```

Recall that the plane is centered at (0,0,0), so placing the second camera at (0,2000,0) puts it directly over the plane. However, by default, the camera points towards the positive z direction (into the screen), so you must rotate it down 90 degrees (pi/2 radians).

Controlling Window Refresh Rate

Jamagic automatically updates (autorefreshes) all windows every 0.02 seconds; in other words, the image on the screen is left untouched for this seemingly short time. However, if you were to run this particular program with two windows, the result would be a jerky, non-smooth motion of the sphere. We will turn this autorefresh mode off so that we can tell *Jamagic* when to update the screens at a rate faster than the default value of 0.02 seconds.

The following statements, placed before the game loop, turn off the autorefresh feature:

```
owindow1.SetAutoRefresh(OFF);
owindow.SetAutoRefresh(OFF);
```

However, after we turn off this feature, we must still tell *Jamagic* to update the screen; we will include the following lines of code inside the

game loop. The second line tells *Jamagic* to update or refresh the window, owindow, and the first line activates ocamera1. Whenever you have two cameras viewing the same scene, you must remember that only one camera can be on at a time. So, you must first turn one camera on, refresh the window that the camera is associated with, and then turn the other one on. The following code handles this:

```
ocamera1.ActivateRender();
owindow.Refresh();

ocamera2.ActivateRender();
owindow1.Refresh();
```

Adding Clickable Buttons

Next we want to add the ability to click a button with the mouse in order to move the sphere (thrusters on), instead of using the arrow keys. Please refer back to the Instrument Panel portion of Figure 4.11 if you do not understand this.

Adding clickable buttons is a very simple task with *Jamagic*. Consider the following commands:

```
myButton=New Button(owindow,"Ahead",220,30,65,20);
myButton.OnClick = Doahead;
```

You have enough background now to figure out the first line: a button called myButton is being made inside the window owindow. On the button, the word "Ahead" will be written, and the button will be located at (220,30). The button will measure 65 pixels wide by 20 in height. Pretty easy!

The second line says that function Doahead will be performed if myButton is clicked. You might recall that in the previous program, we did this by pressing the up arrow key, and that an if statement was used instead of a function. Here's the function that will cause the sphere to move forward:

```
Function doahead
{
  mysphere.Move(-5000,50);
}
```

That was pretty straightforward! In the code at the end of this section, you will see similar thruster buttons and functions for Back, Right, Left, and Stop commands. The Stop button stops the motion of the sphere, which was accomplished by pressing the S key in the previous program.

Timers

One of the other new features of this game is its ability to monitor the remaining fuel. In fact, careful use of fuel will be one of the key elements of this game. How do we monitor this? By simply keeping track of the amount of time that the thrusters are on. This game is set up so that once the thrusters have been on for 25 seconds all of the fuel is consumed. This was a figure arrived at by trial and error. Once you learn how to run the game, you can easily land the sphere using less than 25 seconds of thruster activation.

In our display, it makes more sense for the user to know the remaining fuel time—in other words, how many more seconds of fuel are left. This is easily obtained by subtracting the elapsed time from 25.

So we need some form of timing mechanism so that we can know how long the thrusters are on. In other words, when either the Ahead, Left, Right, or Back buttons are clicked, a timer must start, and the timer should stop when the Stop button is clicked. The elapsed time must then be subtracted from the 25 seconds just mentioned so that we can determine the remaining time.

Consider the following line of code:

```
ftime = System.GetElapsedTime;
```

In this line, `System.GetElapsedTime` will give the number of milliseconds (thousands of a second) that have elapsed since the computer was turned on. If `System.GetElapsedTime` were to have a value of 35000, then 35 seconds would have passed since the computer was turned on (just move the decimal point 3 positions to the left, starting from the far right of the number of milliseconds, to get the number of seconds).

When it is reached in the execution of the program, this code line sets `ftime` equal to the number of milliseconds elapsed since the computer was turned on.

We now have a way of knowing the time when one of the thrusters is activated. We add this line of code to our `doahead` function, which, as you may recall, moves the sphere forward. When the function is called, `ftime` will be set to the number of milliseconds since the computer was turned on. This process is shown here:

```
Function doahead
{
  ftime = System.GetElapsedTime;
  mysphere.Move(-5000,50);
  fuelflag = 1
}
```

The last line of the function is a flag activated when the timer starts. At the beginning of the program, `fuelflag` will be initialized to zero, and once the Ahead button is clicked, `fuelflag` will be set to a value of one.

If we know at what time the thruster was turned on (`ftime` seconds after the computer was turned on), and if we can find out at what time the thruster was turned off, then we just have to subtract one from the other to know how long the thruster was on.

Consider the following lines of code which will be contained in our game loop:

```
if(fuelflag == 1)
{
  time2 = System.GetElapsedTime;
  fueltime = (time2 - ftime)/1000.;
  fuelleft = fuel - fueltime;
}
```

This piece of code is performed only if the value of `fuelflag` is 1. The value of `time2` is set to the number of milliseconds since the computer was turned on, which will be just a little more than the value of `ftime` given in the earlier code. By calculating the difference between the current time and the previous time, we know how much time has elapsed. The elapsed time is `fueltime`, and it's divided by 1000 in order to convert the milliseconds to seconds. The parentheses are applied to (`time2` - `ftime`) to ensure that the subtraction is done first, followed by the division.

To calculate the remaining time (which is what we are interested in displaying on our game's instrument panel), we simply subtract the elapsed time `fueltime` from `fuel` (`fuel` will be initialized to a value of 25 at the beginning of the program).

There's still some unfinished business: the timer should stop when the thrusters are turned off. Consider the function `dostop`, which will be called when the Stop button is clicked on the user's screen:

```
Function dostop
{
  mysphere.Stop();
  fuelflag = 0;
  fuel = fuelleft;
}
```

When this function is called, two things happen: the sphere stops, and the value of `fuelflag` is set to zero. If you go back a few steps to the previ-

ous piece of code, you will see that the amount of fuel left is only changed if `fuelflag` is set to one. By setting `fuelflag` to zero we are instructing the computer to cease subtracting time from the initial 25 seconds (`fuel`).

We must now explain the mysterious-looking last line of the function. It is there to update `fuel`, which is the amount of fuel remaining. By setting `fuel` equal to the value of `fuelleft`, we are resetting `fuel` to the most current tally. Let's say that it's the first time you activate the thrusters, and that you do so for 5 seconds. The value of `fueltime` is then 5 seconds, and the value of `fuelleft` is then $25 - 5 = 20$ (`fuel–fueltime=fuelleft`). Everything seems OK so far.

The problem arises when you activate a thruster again, let's say for another 5 seconds. `fueltime` will again be 5 seconds, but fuel would still be 25 if it were not updated. `fuelleft` would then be $25 - 5 = 20$. There will then be 20 seconds of fuel left instead of the correct 15! The computer has "forgotten" to keep a running tab of the time. By telling the computer to change the value of `fuel` to the remaining fuel, `fuelleft`, we are updating the amount of fuel in the tank.

You may find it hard to follow the reasoning above. Sometimes it's easier to come up with your own algorithm (calculation scheme) than to follow what someone else has done! You are encouraged to do this, or you can just use this code for now and hope it clicks later.

Variable Initialization and Functions

Near the beginning of the Sphere7 program you will see the following lines:

```
//Initialize variables.
flag = 0;
fuel = 25.;
fuelleft = 25.;
ftime = 0.0;
fuelflag = 0;
```

We have seen this type of thing before, but there's more to it than meets the eye. First of all, recall that we are using functions, and that the functions use values from the main program. Functions are strange in that after they are performed and control of the program is returned to the game loop, any value that is calculated by a function will not make it back to the game loop unless you specifically instruct the function to make sure that it does! In the same way, the function won't know values calculated by the main program unless you specifically send those values to the function.

If you want, you can think of functions as separate computers far away from you; this may make it easier to remember that they must be passed all the information they require in order to do their job.

There are several ways to pass information to and from a function; the easiest is to "declare" or initialize any values that may be passed to or from functions at the beginning of the main program. This lets the computer know that the initialized values will be *global* to the entire program, meaning that they will be known by the entire program. Please consult the language reference section of the Help file in *Jamagic* if you would like more detail on how to make this work.

Variable Types: Integers and Floating Point Numbers

Believe it or not, there's even more to the command lines discussed in the preceding section. If you look closely at this section of code, you will notice that some of the numbers have decimal points after them and some do not. For example, the variable `flag` has none, while the `fuel` variable does.

The reason for this is that `flag` will always be an integer value (that is, it will never have a decimal point and will always be a whole number like 0, 1, or 2, and it will never be a number like 2.11 or 3.6). By leaving out the decimal point, we are telling the computer that `flag` will be an integer.

In contrast the variable `fuel` will have noninteger numbers like 19.386 associated with it, so by initializing it with a decimal point, we are telling the computer that `fuel` will be a *floating-point* number. Floating-point just means that there will be numbers after the decimal point.

Why bother distinguishing between the two? Why not just make all numbers floating point? There are two reasons for this: speed and precision.

Calculations involving integers are faster than those involving floating point numbers. Speed is something you should be very concerned about when making a game, particularly when the number of polygons gets large, so there's no need to add floating point numbers if adding integers will do. The difference in time for one calculation is extremely small by our standards, but if performed thousands or millions of times, these time differences add up and could affect your game.

Also extremely important is the concept of precision. With floating point numbers, if you say "x = 25.0," the actual number stored may be 25.0001—which means that the precision is not infinite. Later on, when you make a statement like "if x = = 25.0" and you are expecting this condition to be met, you may be in for a surprise. This is because even though you may have set x to 25, the `if` statement may not catch it because the

computer thinks x = 25.0001. By using integers, you can ensure that an `if` statement will know the exact value.

Most of the time you will need to use floating point numbers since you will need to keep track of decimal values.

So far, we've covered a lot in this chapter. Let's type in the code that we have come up with so far and run the program. But first, you must import the sound called `strong` from the Pacman game in the Advanced Examples section, as well as the `catch` sound from the Rolling Ball 3D game.

Sphere7 Code

```
//
// Sphere7: 7th Spherelander game. This program will

//(a) Insert a second window with a view from above.
//(b) Add control with buttons.
//(c) Keep track of fuel.
//(d) Introduce timers.

// New Main Window
owindow = New Window("Spherelander",
    640,480,Window.STANDARD);//one line

// New Child Window
owindow1 = New Window(owindow,"View From Orbiting
    Satellite",200,150,Window.GAME);// one line
owindow1.SetPosition(390,5);

owindow1.Show();
owindow.Show();
owindow1.SetAutoRefresh(OFF);
owindow.SetAutoRefresh(OFF);

// New World
oworld = New World();

//Initialize variables
flag = 0;
fuel = 25.;
fuelleft = 25.;
ftime = 0.0;
fuelflag = 0;
```

```
// New Cameras
ocamera1 = New Camera(oworld,owindow);
ocamera2 = New Camera(oworld,owindow1);

ocamera1.SetPosition(500,500,-5000);
ocamera2.SetPosition(0,2000,0);
ocamera2.TurnDown(Pi/2.0);

// Instruments
mytext6 = New StaticText(owindow,
    "INSTRUMENTS",130,0,170,20);//one line
mytext6.SetBackColor(GetRGB(0,0,0));
mytext6.SetColor(GetRGB(0,255,255));
fnt = New Font("ARIAL",20,Font.BOLD);
mytext6.SetFont(fnt);

mytext7 = New StaticText(owindow,"Remaining
Fuel:",0,150,170,20);//one line
mytext7.SetBackColor(GetRGB(0,0,0));
mytext7.SetColor(GetRGB(255,0,0));

mytext = New StaticText(owindow," ",0,30,110,20);
mytext.SetBackColor(GetRGB(0,0,0));
mytext.SetColor(GetRGB(255,255,255));

mytext2 = New StaticText(owindow," ",0,60,110,20);
mytext2.SetBackColor(GetRGB(0,0,0));
mytext2.SetColor(GetRGB(255,255,255));

mytext3 = New StaticText(owindow," ",0,90,110,20);
mytext3.SetBackColor(GetRGB(0,0,0));
mytext3.SetColor(GetRGB(255,255,255));

mytext4 = New StaticText(owindow," ",0,120,140,20);
mytext4.SetBackColor(GetRGB(0,0,0));
mytext4.SetColor(GetRGB(255,255,255));

mytext5 = New StaticText(owindow," ",170,130,220,20);
mytext5.SetBackColor(GetRGB(0,0,0));
mytext5.SetColor(GetRGB(255,0,0));

//Buttons
myButton=New Button(owindow,"Ahead",220,30,65,20);
myButton.OnClick = Doahead;
```

```
myButton2=New Button(owindow,"Off",220,60,65,20);
myButton2.OnClick = Dostop;

myButton3=New Button(owindow,"Back",220,90,65,20);
myButton3.OnClick = Doback;

myButton4=New Button(owindow,"Right",300,60,65,20);
myButton4.OnClick = Doright;

myButton5=New Button(owindow,"Left",135,60,65,20);
myButton5.OnClick = Doleft;

// Sounds
osound = New Sound("catch");
osound.SetLoop(ON,1);

osound2 = New Sound("strong");

// Create a sphere with Gouraud shading.
mysphere = oworld.CreateSphere(100,100,100,20,20);
mysphere.SetPosition(500,500,-1000);
omaterial = New Material
    (oworld,GetRGB(50,150,200),"lightblue");//one line

omaterial.SetFlat(ON);
mysphere.SetGouraud(ON);
mysphere.ReplaceMaterial(omaterial);

// Create a plane and rotate it so it's flat.
myplane = oworld.CreatePlane(100,100);
myplane.SetPosition(0,0,0);
matp =New Material(oworld,GetRGB(0,100,50));

matp.SetFlat(ON);
myplane.ReplaceMaterial(matp);
myplane.SetAngle(-Pi/2,0,0);
myplane.SetStatic();

// Camera
oworld.Optimize(ocamera1);
oworld.Optimize(ocamera2);
ocamera1.Follow(mysphere,-3000);
```

```
//Set collision detection.
oworld.OnCollide = docollision;
mysphere.SetCollision(TRUE,Object.COLLISION_TYPE_STOP);

// Set gravity on.
mysphere.SetGravity(0.002);

//Game loop
While(1)
{

// Distance calculations

distx = (mysphere.GetX) ;
mytext.SetText("X Distance: " + distx);

disty = (mysphere.GetY) ;
mytext2.SetText("Y Distance: " + disty);

distz = (mysphere.GetZ) ;
mytext3.SetText("Z Distance: " + distz);

totaldist = Sqrt(distx*distx + disty*disty
    + distz*distz);//one line
mytext4.SetText("Total Distance: " + totaldist);

if(disty <= 0)
{
flag = flag+1;
mysphere.SetGravity(-0.002);
mysphere.Stop();

if(flag ==1)
{
osound.Play();
}
mytext5.SetText("Game Over. You Failed to Land on the
Plane!");//one line
}

// Refresh
    ocamera1.ActivateRender();
    owindow.Refresh();
```

```
      ocamera2.ActivateRender();
      owindow1.Refresh();

//Fuel calculations
if(fuelflag == 1)
{
   time2 = System.GetElapsedTime;
   fueltime = time2 - ftime;
   fuelleft = fuel - fueltime/1000.;
}

mytext7.SetText("Remaining Fuel Time: " + fuelleft);

//End of game loop follows.

}

Function docollision
{
     flag = flag + 1;
     if(flag==1)
       {
          osound2.Play();
       }

   mytext5.SetText("Congratulations! You landed on
   target!");// on one line

}

Function doahead
{
   ftime = System.GetElapsedTime;
   mysphere.Move(-5000,50);
   fuelflag = 1;
}

Function doback
{
   mysphere.Move(5000,50);
   ftime = System.GetElapsedTime;
   fuelflag = 1;
}
```

```
Function doright
{
   mysphere.MoveRight(-5000,50);
   ftime = System.GetElapsedTime;
   fuelflag = 1;
}

Function doleft
{
   mysphere.MoveLeft(-5000,50);
   ftime = System.GetElapsedTime;
   fuelflag = 1;
}

Function dostop
{
   mysphere.Stop();
   fuelflag = 0;
   fuel = fuelleft;
}
```

When you run the program, you will notice some very nice things: the sphere eventually comes into view in the child window, the buttons now control the fall of the sphere, and the remaining fuel time is displayed along with the other information in the instrument panel.

SPHERE8

If you think about it, you've learned a tremendous amount up to now. You should now have the knowledge to program a basic 3D game with collision detection, keyboard control, music, screen messages, several camera views at one time, and game logic. However, you have probably already come to the conclusion that the graphics are still somewhat primitive. We are now going to take a giant step forward by importing images made with *MilkShape 3D*, a 3D modeling package that allows you to easily create 3D objects.

In this section, we will also improve the game logic with some new programming tools: Boolean operators and `if-else` statements.

Figure 4.13 shows a screenshot of the game. You will see some pretty big improvements, including a seascape with two rugged-looking islands.

Before we proceed, please make a new game, and call it Sphere8.

Making Graphics Objects Using 3D Modeling Packages

Yes, you could make just about any complex object in *Jamagic* by joining triangles in three dimensions, but you probably already have a feel for how difficult this could be. Imagine making a 3D spaceship by figuring out where to place and join triangles!

For this reason, the 3D graphic objects in games are usually made using some form of software that makes this task much easier. There are many of these on the market, and they can cost thousands of dollars. However, there is one excellent product that is very reasonably priced—*Milk-Shape 3D* from chUmbaLum sOft. A free, limited-use version is included with the CD-ROM that comes with this book, and it will be used to make better-looking graphics for our games.

MilkShape 3D was used to make the two islands that will be placed in our 3D world, as seen in Figure 4.13. These have been given the names `mtnlow` and `plains`. The procedures used to make these 3D images are covered in further detail later in this section. These procedures are not meant to be a complete guide to *MilkShape,* but are merely enough to get you started. If you take the time to learn *MilkShape,* you will find that you can make beautiful and complex 3D images using this software. Please consult

Figure 4.13 Screenshot of Sphere8 game.

www.swissquake.ch/chumbalum-soft/ for more complete tutorials, or Clayton Crooks' *3D Game Programming with DirectX 8.0* (© 2001. Charles River Media, Inc.).

Eventually, you should try to make your own islands using *MilkShape 3D* so that you know how it works. However, we recommend that when you run this program, you use the islands that came with the CD-ROM since the code was written with the exact size of these islands in mind.

To make these islands, we begin by clicking the *MilkShape 3D* icon that should have been created on your desktop when you loaded the software. You should now see the image shown in Figure 4.14.

> *If the* MilkShape *icon did not appear, then look for it under Programs in the Start menu. If this does not work, you may have forgotten to load* MilkShape!

Notice that there are four windows on the screen. In each window, you will see different views of the object you're drawing: the upper-left window shows a frontal view, the upper-right shows a view from the left, the lower-left shows a top view, and the lower-right shows an isometric view (you may recall from Chapter 2 that isometric views are taken at angles). Let's explore these views.

Figure 4.14 *MilkShape 3D* initial screen.

Figure 4.15 Points added to make island.

You will see a surface that looks something like a floor on the isometric view, and if you drag your mouse on the window, you can change the angle of your isometric view. This surface will not be part of the object drawn; it's just there to help orient you in the 3D world.

On the right of the screen you can see several buttons. Click the one marked Vertex. This will allow you to make points in the windows that will become triangles, which will be joined to make our 3D object.

Now move your mouse to the front view and begin clicking. Each time you click, a point will be made on the screen. Position the points so that they mark the outline of what our island is going to look like. Figure 4.15 shows what this should now look like. Notice that the points are visible from the top view as well.

The more points you make the smoother the final result will be. However, keep in mind that a large number of points will result in a large number of triangles, which could slow down your program. How many points is enough? This depends on your game and your own standards. Experience and trial and error are the best tools here.

Next we need to mark the outline of the island as seen from the top (the previous procedure gave us the outline as seen from the front). On the top view, click points marking the island's shape, as shown by Figure 4.16.

Figure 4.16 Points showing outline of island from top.

Now we need to tell the program which points are connected to make triangles. To do this, follow these steps:

1. Click the Face button from the buttons at the right.
2. Now click three points, one after the other. Pick points that are close to each other, and that you could envision forming a triangular surface on your desired object. Please select the points in a clockwise order to ensure visibility (the opposite direction from the winding order in *Jamagic*!). You will see that a red triangle has been formed once you click the 3rd point. This process is shown in Figure 4.17.
3. Pick another three points and repeat the procedure until you have your desired shape made of triangles.

We are now finished with our island! Make sure that you have left no faces blank, or you will see a hole in your figure.

Now we need to make sure that this island gets saved in a format that *Jamagic* will recognize. *Jamagic* will accept 3D files in the following formats from different software packages:

3DS—Files made with *3D Studio*
DXF—Files made with Autodesk® *AutoCAD*®

Figure 4.17 Points joined to make triangles.

OBJ—Files made with *Wavefront*
COB—Files made with *trueSpace*

MilkShape allows you to save your project in the first three formats. To do so, click File in the upper-left corner of your screen, then select Export, and pick one of the three formats. The islands drawn for our game were saved in *AutoCAD* DXF format. You will be prompted as to where you want to save your new 3D object. You can put it almost anywhere, but it probably makes the most sense to save it directly into C:\Program Files\Jamagic\Projects\Sphere8.

Importing the New 3D Graphics

Now we need to import the images we just made into our game. Get back into *Jamagic* and open our new game, Sphere8. At the left, a few lines beneath Sources, you will see 3D. Right-click 3D, select Import, and follow the prompts to bring the image in. At one point, you will be asked for the location of the directory from which you will get the textures for this image

Figure 4.18 You will be prompted for the directory where textures are located.

(see Figure 4.18). In this case, we will apply our own colors from the RGB scale (but just about anything would do), so just instruct *Jamagic* to use the Pictures category in your game.

When you double-click 3D on your *Jamagic* screen, the two images you imported should be listed (see Figure 4.19). If they are not there, you have made some form of error, and should repeat the procedure.

Improving the Previous Game

In the previous section, we saw how to make a 3D island using *MilkShape 3D*. We suggest that you use the island 3D images created by the author for this game because the game has been designed around them. As mentioned earlier, there are two 3D images of islands that we will use—`plains` and `mtnlow`—which are located on the CD-ROM which came with your book. To import them, simply do as instructed in the preceding section, but when prompted for the location of the images, simply specify your CD-ROM. When you are prompted for the texture directory, you may select anything because there will be no textures applied to the two islands; we will use the RGB color scale instead.

Figure 4.19 The imported files should be visible under the 3D category.

We have imported our object into our game, but we still need code telling *Jamagic* to bring it to the screen and where it should be placed. We will now discuss particular lines of code.

```
oworld.Load("mtnlow");
```

This is easy enough to understand; the image called mtnlow is to be loaded into our world, oworld.

```
oflatland = oworld.GetObject(oworld.GetNObjects()-1);
```

This line instructs *Jamagic* to get all of the objects that might be associated with the previous load statement: pictures, lights, and so on. The new 3D object is to be called oflatland, but you could have given it nearly any other name.

```
oflatland.Scale(10);
```

This line of code shows a very useful feature; you do not have to worry about how big to make your object at its initial construction. With this statement you are making oflatland ten times bigger than it would appear

on your screen normally. You can even change the size of 3D objects in specific directions. For example, consider this line:

```
oflatland.Scale(10,5,0.5);
```

This statement instructs *Jamagic* to make the object ten times wider in the x direction, five times higher in the y direction, and one-half the size in the z direction (these values were determined by trial and error).

The following statements associated with our first island should all be familiar to you. Basically, we are setting the position of the island and setting its color with the RGB scale (incidentally, the RGB color (100,200,0) was also arrived at by trial and error). In addition, we are assigning Gouraud shading to the island and specifying it as a static object.

```
oflatland.SetPosition(0,0,3000);
matflatland =New Material(oworld,GetRGB(100,200,0));
matflatland.SetMapped(ON);
oflatland.SetGouraud(ON);
oflatland.ReplaceMaterial(matflatland);
oflatland.SetStatic();
```

A similar set of commands is executed to load the second island. Please see the full code listed later for more details.

In the previous game, we controlled only the x, y position of the sphere as it dropped. We would now like to add the capability to move up by adding an upward thruster. You might recall that we had subjected our sphere to a downward gravitational pull with the command

```
mysphere.SetGravity(0.002);
```

We can now make the sphere move up at the same rate as it falls by adding a new button marked Thrust Up that activates this line:

```
mysphere.SetGravity(-0.002);
```

The negative sign (–) causes a movement up, and we can reset gravity to 0.002 when the Off button is clicked.

We also wish to fix some logical errors that were introduced in the previous program. For one thing, as the program is now set up, clicking any thruster directly after another thruster has been on resets the fuel remaining to the full amount, rather than producing an accurate count of fuel. In order for the fuel count to remain accurate when going from thruster to thruster, we must first click the Off button.

So, we would like to make it so that the program user has to click the Off button before using another thruster. How do we do this? By using some form of flag, we can know if a specific button has been pressed. For example, we want the thrusters to be activated *only* if the Off button has been pressed before they are activated. In the previous project, we did something exactly like this by setting a flag to zero or one, depending on whether a button had been clicked. In that situation, a value of one could mean the button had been clicked, while a value of zero could indicate the button was not clicked. We wish to do the same thing in a different way now, using Boolean variables.

Boolean Variables

Earlier, we introduced integer and floating point variables. You should remember that integers are whole numbers with no decimals, while floating point numbers have decimal points.

A *Boolean variable* is even simpler to understand, since a Boolean can only have two values—TRUE or FALSE—which makes them great for flags. You can set a variable, say, one that you called `clickcheck`, to TRUE at the beginning of your program, and then you can specify that a thruster can only be activated if `clickcheck` is TRUE. Once a thruster is activated, `clickcheck` is automatically set to FALSE. Under these conditions, it is impossible to go from one thruster command to another. The Boolean `clickcheck` is reset to TRUE only when the Off button is clicked, thus allowing the thrusters to come on.

Look at the following code, which is activated when the user clicks the Off button to stop the sphere's motion. You will see some familiar lines as well as the new line that sets `clickcheck` to TRUE:

```
Function dostop
{
 clickcheck = TRUE;
 mysphere.Stop();
 fuelflag = 0;
 fuel = fuelleft;
 mysphere.SetGravity(0.002);
 }
```

The code for the right thruster would be as follows:

```
Function doright
{
 if (block == FALSE && clickcheck == TRUE)
```

```
{
 mysphere.MoveRight(-5000,50);
 ftime = System.GetElapsedTime;
 fuelflag = 1;
 clickcheck = FALSE;
}
}
```

You may be wondering what is the purpose of `block = = FALSE` in the `if` statement. From one of the previous programs, you should already recognize that the `&&` represents an AND statement, which means that both conditions must be met in order for instructions in the `if` statement to be performed. In other words, `block` must be FALSE and `clickcheck` must be TRUE.

The `block` Boolean is there to account for the case in which the fuel is completely consumed before the sphere lands on its target. It seems reasonable not to allow any of the thrusters to operate if all of the fuel is consumed. The following lines of code handle this possibility (recall from the previous program that `fuelleft` is the quantity of fuel remaining):

```
if(fuelleft<0)
{
 mytext5.SetText("FUEL GONE!!");
 block = TRUE;
}
```

Now you can see that if fuel remains (`block = FALSE`) and the Off button has been clicked (`clickcheck = TRUE`), then the Right, Left, Ahead, Back, and Up buttons can be activated.

Discriminating Between Good and Bad Collisions

We have added another change in Sphere8. We have made a second smaller plane our target and placed it farther away on the furthest island. The collision detection in the game will now detect when we hit the target plane, but it also detects when we hit the other island or the water surface. Therefore, we now need a way to discriminate between a collision with the target plane surface (which indicates that the player has won) and a collision with any of the other objects in the game.

To do this, in the game loop, we constantly calculate the distance from the target plane to the sphere. When there is a collision between the sphere and any other object in the game, we check the distance to the target plane. If the distance is less than 50, as calculated by *Jamagic*, then we conclude

that the collision took place between the target plane and the sphere, and therefore, the game player has been successful.

Why 50? The sphere measures 50 in radius, and the plane is 50 long by 50 wide. Recall that when we calculate the distance between objects, we are calculating the distance from center to center, so for a collision to have occurred, the distance between the two objects must be less than or equal to 50.

We call this distance `totalxz`, and it represents the distance between the sphere and the target plane in the x-z plane—the distance along the x and z directions only—the height difference is not considered. We do not consider the height difference between the two because it will automatically become zero when the sphere and the plane collide.

The following code in the game loop calculates distance `totalxz` between the sphere and the target plane using the Pythagorean theorem. The target plane is placed at an x coordinate of (−150) and a z coordinate of (2974).

```
distx = (mysphere.GetX) + 150;
mytext.SetText("X Distance: " + distx);

disty = (mysphere.GetY) ;
mytext2.SetText("Height: " + disty);

distz = (mysphere.GetZ)-2974 ;
mytext3.SetText("Z Distance: " + distz);

totaldist = Sqrt(distx*distx + disty*disty +
    distz*distz);//one line
totalxz = Sqrt(distx*distx + distz*distz);
mytext4.SetText("x-z distance "+ totalxz);
```

The function `docollision` then distinguishes between a successful collision with the plane and an unsuccessful collision with any other object. It uses something that you have not seen until now: the `else` statement. See if you can figure it out. It's pretty self-explanatory.

```
Function docollision
{
if(totalxz <= 50)
  {
    mytext5.SetText("You landed on target!");
   mysphere.Stop;
  }
```

```
   Else
    {
     mytext5.SetText("Back to flight school for you!");
     mysphere.Stop;
    }
  }
```

The function `docollision` above is called when any collision occurs. If `totalxz` is less than or equal to 50, then a successful collision has occurred, and the user is given the appropriate message on the screen. If `totalxz` is greater than 50, then an unsuccessful collision has occurred. The `else` statement merely says that if the condition of the `if` statement is not met, then the computer should perform the instructions specified in the `else` statement.

Notice that you do not really need the `else` *statement in the sense that another* `if` *statement could do the same job (by saying* `if totalxz > 50`*). However, this is more work for you, and it is probably slower for the computer.*

Now you are ready to type in the code. Please note that we have moved some of the text messages around to make room for the Up button and we have eliminated all music and sounds for now.

Enjoy the game, and remember that you will have to land the sphere on the target plane on the second island, while keeping an eye on the remaining fuel.

Sphere8 Code

```
//
// Sphere8: 8th Spherelander game. This program will

//(a) Make the fuel amount critical.
//(b) Add terrain from MilkShape program.
//(c) Add upward thruster.
//(d) Removed background sounds
//(e) Change target to be small landing pad on smaller island.
//(f) Use if-else statements.
//(g) Use Boolean operators.
//(h) Make it so "Off' must be activated before
        changing thrusters
//

// New Main Window
owindow = New Window("Spherelander",640,480,Window.STANDARD);
```

```
// New Child Window
owindow1 = New Window(owindow,"View From Orbiting
    Satellite",200,150,Window.GAME);// one line
owindow1.SetPosition(390,5);

owindow1.Show();
owindow.Show();
owindow1.SetAutoRefresh(OFF);
owindow.SetAutoRefresh(OFF);

// New World
oworld = New World();

// Import and massage the 1st 3D object made with
    // MilkShape
oworld.Load("mtnlow");//one line
oflatland = oworld.GetObject(oworld.GetNObjects()-1);
oflatland.Scale(10);
oflatland.SetPosition(0,0,3000);
matflatland =New Material(oworld,GetRGB(100,200,0));
matflatland.SetMapped(ON);
oflatland.SetGouraud(ON);
oflatland.ReplaceMaterial(matflatland);
oflatland.SetStatic();

// 2nd 3D object
oworld.Load("plains");
mountain = oworld.GetObject(oworld.GetNObjects()-1);
mountain.Scale(30);
mountain.SetPosition(400,0,0);
matmount =New Material(oworld,GetRGB(100,200,0));
matmount.SetFlat(ON);
mountain.SetGouraud(ON);
mountain.ReplaceMaterial(matflatland);
mountain.SetStatic();

//Initialize variables.
fuel = 200.;
fuelleft = 200.;
ftime = 0.0;
fuelflag = 0;
block = FALSE;
clickcheck = TRUE;

// New Cameras
ocamera1 = New Camera(oworld,owindow);
ocamera2 = New Camera(oworld,owindow1);
```

```
ocamera1.SetPosition(500,500,-5000);
ocamera2.SetPosition(0,10000,1200);
ocamera2.TurnDown(Pi/2.0);

// Instruments
mytext6 = New StaticText(owindow,
    "INSTRUMENTS",130,0,170,20);//one line
mytext6.SetBackColor(GetRGB(0,0,0));
mytext6.SetColor(GetRGB(0,255,255));
fnt = New Font("ARIAL",20,Font.BOLD);
mytext6.SetFont(fnt);

mytext7 = New StaticText(owindow,"Remaining
    Fuel:",0,150,170,20);
mytext7.SetBackColor(GetRGB(0,0,0));
mytext7.SetColor(GetRGB(255,0,0));

mytext = New StaticText(owindow," ",0,30,110,20);
mytext.SetBackColor(GetRGB(0,0,0));
mytext.SetColor(GetRGB(255,255,255));

mytext2 = New StaticText(owindow," ",0,60,110,20);
mytext2.SetBackColor(GetRGB(0,0,0));
mytext2.SetColor(GetRGB(255,255,255));

mytext3 = New StaticText(owindow," ",0,90,110,20);
mytext3.SetBackColor(GetRGB(0,0,0));
mytext3.SetColor(GetRGB(255,255,255));

mytext4 = New StaticText(owindow," ",0,120,140,20);
mytext4.SetBackColor(GetRGB(0,0,0));
mytext4.SetColor(GetRGB(255,255,255));

mytext5 = New StaticText(owindow," ",0,170,220,20);
mytext5.SetBackColor(GetRGB(0,0,0));
mytext5.SetColor(GetRGB(0,0,255));

//Buttons
myButton=New Button(owindow,"Ahead",220,30,65,20);
myButton.OnClick = Doahead;

myButton2=New Button(owindow,"Off",220,60,65,20);
myButton2.OnClick = Dostop;

myButton3=New Button(owindow,"Back",220,90,65,20);
myButton3.OnClick = Doback;
```

```
myButton4=New Button(owindow,"Right",300,60,65,20);
myButton4.OnClick = Doright;

myButton5=New Button(owindow,"Left",135,60,65,20);
myButton5.OnClick = Doleft;

mybutton6 = New Button(owindow,
    "Thrust Up", 220,120,65,20);//one line
mybutton6.OnClick = doup;

// Create a sphere with Gouraud shading.
mysphere = oWorld.CreateSphere(50,50,50,20,20);
mysphere.SetPosition(500,150,-2000);
omaterial = New Material
    (oworld,GetRGB(50,150,200),"lightblue");//one line

omaterial.SetFlat(ON);
mysphere.SetGouraud(ON);
mysphere.ReplaceMaterial(omaterial);

// Create a plane and rotate it so it's flat.
myplane = oworld.CreatePlane(10000,10000);
myplane.SetPosition(0,0,0);
matp =New Material(oworld,GetRGB(0,100,255));

matp.SetFlat(ON);
//myplane.SetGouraud(ON);
myplane.ReplaceMaterial(matp);
myplane.SetAngle(-Pi/2,0,0);
myplane.SetStatic();

// Create a target plane and rotate it so it's flat.
myplane2 = oworld.CreatePlane(50,50);
myplane2.SetPosition(-150,40,2974);
matp2 =New Material(oworld,GetRGB(100,200,0));

matp2.SetFlat(ON);
myplane2.SetGouraud(ON);
myplane2.ReplaceMaterial(matp2);
myplane2.SetAngle(-Pi/2,0,0);
myplane2.SetStatic();

// Camera
ocamera1.Follow(mysphere,-2000);
oworld.Optimize(ocamera1);
oworld.Optimize(ocamera2);
```

```
//Set collision detection.
oworld.OnCollide = docollision;
mysphere.SetCollision(TRUE,Object.COLLISION_TYPE_STOP);

// Set gravity on.
mysphere.SetGravity(0.002);

//Game loop
While(1)
{

// Distance calculations
//

distx = (mysphere.GetX) + 150;
mytext.SetText("X Distance: " + distx);

disty = (mysphere.GetY) ;
mytext2.SetText("Height: " + disty);

distz = (mysphere.GetZ)-2974 ;
mytext3.SetText("Z Distance: " + distz);

totaldist = Sqrt(distx*distx + disty*disty +
    distz*distz);//one line
totalxz = Sqrt(distx*distx + distz*distz);
mytext4.SetText("x-z distance "+ totalxz);

// Refresh
    ocamera1.ActivateRender();
    owindow.Refresh();
    ocamera2.ActivateRender();
    owindow1.Refresh();

//Fuel calculations
if(fuelflag == 1)
{
  time2 = System.GetElapsedTime;
  fueltime = time2 – ftime;
  fuelleft = fuel – fueltime/1000.;
}

mytext7.SetText("Remaining Fuel Time: " + fuelleft);
if(fuelleft<0)
    {
```

```
//     myshpere.Stop();
     mytext5.SetText("FUEL GONE!!");
      block = TRUE;
   }
//End of game loop follows.
}

Function docollision
{
    if(totalxz <= 50)
     {
      mytext5.SetText("Congratulations! You landed
              on target!");// one line
      mysphere.Stop;
     }
     Else
     {
      mytext5.SetText("Back to flight school for
              you!");//one line
      mysphere.Stop;
     }
}

Function doahead
{
   if (block == FALSE && clickcheck == TRUE)
    {
     ftime = System.GetElapsedTime;
     mysphere.Move(-5000,50);
     fuelflag = 1;
     clickcheck = FALSE;
    }
}

Function doback
{
   if (block == FALSE && clickcheck == TRUE)
   {
    mysphere.Move(5000,50);
    ftime = System.GetElapsedTime;
    fuelflag = 1;
    clickcheck = FALSE;
   }
}
```

```
Function doright
{
   if (block == FALSE && clickcheck == TRUE)
   {

    mysphere.MoveRight(-5000,50);
    ftime = System.GetElapsedTime;
    fuelflag = 1;
    clickcheck = FALSE;
   }
}

Function doleft
{
   if (block == FALSE && clickcheck == TRUE)
   {
    mysphere.MoveLeft(-5000,50);
    ftime = System.GetElapsedTime;
    fuelflag = 1;
   }
}

Function dostop
{
   clickcheck = TRUE;
   mysphere.Stop();
   fuelflag = 0;
   fuel = fuelleft;
   mysphere.SetGravity(0.002);
}

Function doup
{
   if (block == FALSE && clickcheck == TRUE)
   {
    mysphere.SetGravity(-0.002);
    ftime = System.GetElapsedTime;
    fuelflag = 1;
    clickcheck = FALSE;
   }
}
```

ADDING A MENU TO OUR GAME—MENUSAMPLE PROGRAM

In this project we will cover the following topics:

- Adding a menu
- Switching case

In this program, we will add a pop-up menu to our game. This menu will allow the program user to select the level of difficulty of the game, give a brief explanation of how the game is played, give some information about the game author, and enable the user to turn the background music off. Figure 4.20 shows the end result.

Adding a Pop-Up Menu

The pop-up menu we will add will be activated when the user clicks anywhere on the screen, and we need to let the user know this. To make this happen, we will change the writing on the toolbar that creates the window as follows:

```
// New Main Window
owindow = New Window("Spherelander-Please Click on Main
Screen for Menu",640,480,Window.STANDARD);//all one line
```

Figure 4.20 A pop-up menu is added.

The menu will consist of a main pop-up menu with the following categories: Quit, Instructions, About the Author, Music Off, and Level of Difficulty. When Level of Difficulty is selected, a smaller pop-up menu will appear with two categories: Easy and Difficult.

The following lines of code create the main menu and add the menu items:

```
// This line makes a new menu which we call 'mainmenu'
mainmenu = New Menu();

//The next line creates an item called 'quitter,' which
  //will
//be inserted in our menu. The item will read 'Quit'.
quitter = mainmenu.InsertItem("Quit");

//The next line creates the second menu item, called
// 'instruct.'
//The item will read 'Instructions.'
instruct = mainmenu.InsertItem("Instructions");

//Two more similar items to be inserted into the menu
about = mainmenu.InsertItem("About the Author");
xmusic = mainmenu.InsertItem("Music Off");

//The next line will draw a line in-between the "Music Off"
// selection and the entry that will come after it.
mainmenu.InsertItemSeparator();

difmenu = New Menu();
hard = difmenu.InsertItem("Difficult");
easy = difmenu.InsertItem("Easy");
mainmenu.InsertItem(difmenu,"Select Difficulty");

// When mouse clicked, show menu.
//The command 'OnMouseUp' tells Jamagic to perform the
//function 'doshowmenu' whenever the mouse is clicked
//anywhere
// in window owindow (our window).
owindow.OnMouseUp = doshowmenu;

//When Main Menu item is selected, do Function domenu. The
//Command 'OnSelectItem' instructs the computer to perform
// 'domenu' if any menu item is clicked.
mainmenu.OnSelectItem = domenu;
```

```
// When submenu (difmenu) item is selected, do function
// seldif
difmenu.OnSelectItem = seldif;

// We need to add music to this game so that we can
// shut it off using the menu. Don't forget to import it
// into the game before running the program.
omusic = New Music("melody");
omusic.SetLoop(ON,3);
omusic.Play();
```

All we need in order to finish are the function `domenu` (which is called when an item on the main menu is clicked), the function `seldif` (which is called when an item on the submenu is clicked), and the function `doshowmenu` (which makes the menu appear when the user clicks the screen).

The `switch case` Statement

Now we will introduce the *switch case statement*, which is used in the functions mentioned above. The `switch case` statement is a tool that can, in some cases, eliminate the need for an `if` statement and save some programming time. For example, you may recall that the program user may click the Quit button (called `quitter` in the code) or on Instructions (called `instruct` in the code) on the main menu. The `switch` statement tells the program what to do if either one of these is selected.

Take a look at the function `domenu` in the following code. You will see there are four different `Cases`, each of which is one of our possible selections, inside the brackets that are encompassed by `Switch`. `Case quitter` tells *Jamagic* to end the program; `Case instruct` and `Case about` tell *Jamagic* to write a message on the screen; and `Case xmusic` tells the program to stop the music. The `Break` statement follows each case, and each has a colon (:) (rather than a semicolon (;) after it.

```
Function domenu(mainmenu,pos,id)
{
 Switch(id)
 {
 Case quitter:
   End;
   Break;
 Case instruct:
   mytext8.SetText("You must press the 'Off' button before
   changing thrusters");//one line
   Break;
```

```
    Case about:
      mytext8.SetText("This software was written by S.
      Perez.");//one line
      Break;
    Case xmusic:
      omusic.Stop;
      Break;
  }
}
```

> *You may notice that there is a set of parentheses with three items inside them in the code above. These represent information that the function needs to know. Normally, if a variable is declared (initialized) in your main program, the function will automatically know the value of the variable. However, if the variable is undeclared, then you must pass the variable to the function via the parentheses.*

The next function is `seldif`, and its job is to determine what is to be done when one of two cases (`easy` or `hard`) is selected from the submenu. This function has the same format as the preceding one:

```
Function seldif(difmenu,pos,id)
{
 Switch(id)
   {
    Case easy:
      fuel = 200.;
      fuelleft = 200.;
      Break;
    Case hard:
      fuel = 100.;
      fuelleft = 100.;
      Break;
   }
}
```

Finally, here is the function that shows the menu when the user clicks the screen:

```
Function doshowmenu
{
  mainmenu.OpenPopupMenu(300,200);
}
```

Chapter 4 Simple Games **133**

That's all the code that you need to add to your Sphere8 program in order to have a pop-up menu. Please consult the *Jamagic* documentation under Help if you wish to use a toolbar type of menu.

Here is the entire code for you to type in and run.

Menusample Code

```
//
// Menusample Game 8.5 Spherelander game. Add a menu
// to 8th game with following choices:
//(a) Select level of difficulty based on fuel amount.
//(b) Learn how to play the game.
//(c) Find out information about the game writer.
//(d) Select whether background music is on or off.

// New Main Window
owindow = New Window("Spherelander - Please Click on
   Main Screen for Menu",640,480,Window.STANDARD);//one line
owindow.Show();
owindow.SetAutoRefresh(OFF);

// New World
oworld = New World();

// Import and massage the 1st 3D object made with
//MilkShape
oworld.Load("mtnlow");
oflatland = oworld.GetObject(oworld.GetNObjects()-1);
oflatland.Scale(10);
oflatland.SetPosition(0,0,3000);
matflatland =New Material(oworld,GetRGB(100,200,0));
matflatland.SetMapped(ON);
oflatland.SetGouraud(ON);
oflatland.ReplaceMaterial(matflatland);
oflatland.SetStatic();

// 2nd 3D object
oworld.Load("plains");
mountain = oworld.GetObject(oworld.GetNObjects()-1);
mountain.Scale(30);
mountain.SetPosition(400,0,0);
matmount =New Material(oworld,GetRGB(100,200,0));
matmount.SetFlat(ON);
mountain.SetGouraud(ON);
```

```
mountain.ReplaceMaterial(matflatland);
mountain.SetStatic();

//Initialize variables
fuel = 200.;
fuelleft = 200.;
ftime = 0.0;
fuelflag = 0;
block = FALSE;
clickcheck = TRUE;

// New Cameras
ocamera1 = New Camera(oworld,owindow);
ocamera1.SetPosition(500,500,-5000);

// Instruments
mytext6 = New StaticText(owindow,"INSTRUMENTS",130,0,170,20);
mytext6.SetBackColor(GetRGB(0,0,0));
mytext6.SetColor(GetRGB(0,255,255));
fnt = New Font("ARIAL",20,Font.BOLD);
mytext6.SetFont(fnt);

mytext7 = New StaticText(owindow,"Remaining
Fuel:",0,150,170,20);//one line
mytext7.SetBackColor(GetRGB(0,0,0));
mytext7.SetColor(GetRGB(255,0,0));

mytext8 = New StaticText(owindow," ",100,350,400,100);
mytext8.SetBackColor(GetRGB(0,100,230));
mytext8.SetColor(GetRGB(255,255,255));

mytext = New StaticText(owindow," ",0,30,110,20);
mytext.SetBackColor(GetRGB(0,0,0));
mytext.SetColor(GetRGB(255,255,255));

mytext2 = New StaticText(owindow," ",0,60,110,20);
mytext2.SetBackColor(GetRGB(0,0,0));
mytext2.SetColor(GetRGB(255,255,255));

mytext3 = New StaticText(owindow," ",0,90,110,20);
mytext3.SetBackColor(GetRGB(0,0,0));
mytext3.SetColor(GetRGB(255,255,255));

mytext4 = New StaticText(owindow," ",0,120,140,20);
mytext4.SetBackColor(GetRGB(0,0,0));
mytext4.SetColor(GetRGB(255,255,255));
```

```
mytext5 = New StaticText(owindow," ",0,170,220,20);
mytext5.SetBackColor(GetRGB(0,0,0));
mytext5.SetColor(GetRGB(0,0,255));

//Buttons
myButton=New Button(owindow,"Ahead",220,30,65,20);
myButton.OnClick = Doahead;

myButton2=New Button(owindow,"Off",220,60,65,20);
myButton2.OnClick = Dostop;

myButton3=New Button(owindow,"Back",220,90,65,20);
myButton3.OnClick = Doback;

myButton4=New Button(owindow,"Right",300,60,65,20);
myButton4.OnClick = Doright;

myButton5=New Button(owindow,"Left",135,60,65,20);
myButton5.OnClick = Doleft;

mybutton6 = New Button(owindow,"Thrust Up",
   220,120,65,20);//one line
mybutton6.OnClick = doup;

// Create a sphere with Gouraud shading.
mysphere = oworld.CreateSphere(50,50,50,20,20);
mysphere.SetPosition(500,150,−2000);
omaterial = New Material(oworld,GetRGB(50,150,200),
   "lightblue");

omaterial.SetFlat(ON);
mysphere.SetGouraud(ON);
mysphere.ReplaceMaterial(omaterial);

// Create a plane and rotate it so it's flat.
myplane = oworld.CreatePlane(10000,10000);
myplane.SetPosition(0,0,0);
matp =New Material(oworld,GetRGB(0,100,255));

matp.SetFlat(ON);
//myplane.SetGouraud(ON);
myplane.ReplaceMaterial(matp);
myplane.SetAngle(-Pi/2,0,0);
myplane.SetStatic();
```

```
// Create a target plane and rotate it so it's flat.
myplane2 = oworld.CreatePlane(50,50);
myplane2.SetPosition(-150,40,2974);
matp2 =New Material(oworld,GetRGB(100,200,0));

matp2.SetFlat(ON);
myplane2.SetGouraud(ON);
myplane2.ReplaceMaterial(matp2);
myplane2.SetAngle(-Pi/2,0,0);
myplane2.SetStatic();

// Camera
ocamera1.Follow(mysphere,-2000);
oworld.Optimize(ocamera1);
//oworld.Optimize(ocamera2);

//Set collision detection.
oworld.OnCollide = docollision;
mysphere.SetCollision(TRUE,Object.COLLISION_TYPE_STOP);

// Set gravity on.
mysphere.SetGravity(0.002);

//*********   menu   *************************

mainmenu = New Menu();
quitter = mainmenu.InsertItem("Quit");
instruct = mainmenu.InsertItem("Instructions");
about = mainmenu.InsertItem("About the author");
xmusic = mainmenu.InsertItem("Music Off");
mainmenu.InsertItemSeparator();

// Add another item to the main menu, but this one
// makes a sub-menu pop-up.

difmenu = New Menu();
hard = difmenu.InsertItem("Difficult");
easy = difmenu.InsertItem("Easy");
mainmenu.InsertItem(difmenu,"Select Difficulty");

// When mouse clicked, show menu
owindow.OnMouseUp = doshowmenu;

//When Main Menu item's selected, do Function mainmenu.
mainmenu.OnSelectItem = domenu;
```

```
// When submenu item's selected, do function seldif.
difmenu.OnSelectItem = seldif;

// Music
omusic = New Music("melody");
omusic.SetLoop(ON,3);
omusic.Play();

//Game loop
While(1)
{

// Distance calculations
//

distx = (mysphere.GetX) + 150;
mytext.SetText("X Distance: " + distx);

disty = (mysphere.GetY) ;
mytext2.SetText("Height: " + disty);

distz = (mysphere.GetZ)—2974 ;
mytext3.SetText("Z Distance: " + distz);

totaldist = Sqrt(distx*distx +
disty*disty + distz*distz);//one line
totalxz = Sqrt(distx*distx + distz*distz);
mytext4.SetText("x-z distance "+ totalxz);

// Refresh
    ocamera1.ActivateRender();
    owindow.Refresh();

//Fuel calculations
if(fuelflag == 1)
{
  time2 = System.GetElapsedTime;
  fueltime = time2 - ftime;
  fuelleft = fuel - fueltime/1000.;
}

mytext7.SetText("Remaining Fuel Time: " + fuelleft);
if(fuelleft<0)
    {
//      myshpere.Stop();
    mytext5.SetText("FUEL GONE!!");
```

```
          block = TRUE;
       }
//End of game loop follows
}

Function docollision
{
    if(totalxz <= 50)
      {
       mytext5.SetText("Congratulations! You landed
           on target!");//one line
       mysphere.Stop;
      }
      Else
      {
       mytext5.SetText("Back to flight school
           for you!");//one line
       mysphere.Stop;
      }
}

Function doahead
{
   if (block == FALSE && clickcheck == TRUE)
   {
    ftime = System.GetElapsedTime;
    mysphere.Move(-5000,50);
    fuelflag = 1;
    clickcheck = FALSE;
   }
}

Function doback
{
   if (block == FALSE && clickcheck == TRUE)
   {
    mysphere.Move(5000,50);
    ftime = System.GetElapsedTime;
    fuelflag = 1;
    clickcheck = FALSE;
   }
}

Function doright
```

```
{
   if (block == FALSE && clickcheck == TRUE)
   {

    mysphere.MoveRight(-5000,50);
    ftime = System.GetElapsedTime;
    fuelflag = 1;
    clickcheck = FALSE;
   }
}

Function doleft
{
   if (block == FALSE && clickcheck == TRUE)
   {
    mysphere.MoveLeft(-5000,50);
    ftime = System.GetElapsedTime;
    fuelflag = 1;
   }
}

Function dostop
{
   clickcheck = TRUE;
   mysphere.Stop();
   fuelflag = 0;
   fuel = fuelleft;
   mysphere.SetGravity(0.002);
}

Function doup
{
   if (block == FALSE && clickcheck == TRUE)
   {
    mysphere.SetGravity(-0.002);
    ftime = System.GetElapsedTime;
    fuelflag = 1;
    clickcheck = FALSE;
   }
}

Function domenu(mainmenu,pos,id)
{
   Switch(id)
```

```
          {
        Case quitter:
          End;
          Break;
        Case instruct:
          mytext8.SetText("You must press the 'OFF' button
          before changing thrusters");//one line
          Break;
        Case about:
          mytext8.SetText("This software was written by someone
          whose wife is very upset at him at this time!");//
          Break;
        Case xmusic:
          omusic.Stop;
          Break;
          }
       }

       Function doshowmenu
       {
         mainmenu.OpenPopupMenu(300,200);
       }

       Function seldif(difmenu,pos,id)
       {
         Switch(id)
           {
            Case easy:
              fuel = 200.;
              fuelleft = 200.;
              Break;
            Case hard:
              fuel = 100.;
              fuelleft = 100.;
              Break;
           }
       }
```

SPHERE9

In this game, we will continue to increase the quality, which will prepare us for our first full-blown flight simulator in Chapter 5.

First we will explore some of the extremely nice 3D objects that come with the *Jamagic* CD-ROM. These objects include ships, planes of all types, trees, houses, spaceships, and cars, just to name a few. They are three-dimensional, and you can view them from all angles as you would any object in the real world.

We will also add some nice effects to our game: a realistic looking water surface that moves slightly, an initial sound when the game is first turned on, better music, a jet sound when the thruster is turned on, and a voice that warns the game user when he's letting the altitude get too low. The sounds will be edited using the *Jamagic* sound editor. Figure 4.21 shows a screenshot of what you should expect when we are finished.

The *Jamagic* topics you will learn in this section include the following:

- Importing 3D objects, sounds, and music from the *Jamagic* CD-ROM
- Using the `Wait` command
- Tiling
- Learning about UV Animation
- Using the *Jamagic* sound editor
- Comparing textures and materials

Figure 4.21 Screenshot from Sphere9. The sphere is replaced with a spaceship imported from the CD-ROM.

Importing a Spaceship into Our Game from the CD-ROM

The sphere has served us well, but it has to go! We need something that is visually more interesting. Sure, by now you know how to take an image and texture it onto the sphere—maybe a picture of yourself or a family member—but we want something with a more professional look.

As mentioned in the introduction to this section, the *Jamagic* CD-ROM comes with many beautiful 3D objects that have already been made for you. You could make something like them using *MilkShape 3D,* but it would take a considerable amount of work and skill. And, in addition to these objects, the *Jamagic* CD-ROM also has tons of interesting sounds (engines, people speaking, springs, horns, and so on) as well as some terrific music including classical, modern, jazz, and country. For the price, *Jamagic* is really tough to beat.

The CD-ROM that came with this book will not have all of the 3D images, sounds, and music available with the full-capability Jamagic *version.*

We will now import a 3D spaceship image (`fighter`) that comes with the book's CD-ROM and use it instead of the sphere. In the following code, you will notice that we call the new spaceship `mysphere`, the same name we gave the sphere in previous programs. We do this in order to minimize the changes to our previous code. The fighter will move under the same commands as the sphere, so it makes sense not to change the name.

```
// Import jet
oworld.Load("fighter");
mysphere= oworld.GetObject(oworld.GetNObjects()-1);
mysphere.Scale(0.01);
mysphere.SetPosition(500,150,-2000);
```

As you can see, we had to scale the fighter to a smaller size because the object was originally quite large.

We now need to bring the `fighter` image into the program. If you have the full-capability version of *Jamagic* (not the limited version that came with this book), you must import the image from the CD-ROM by doing the following:

1. From the *Jamagic* CD-ROM, select Jamagic11, and then go to Library. You will see several categories there: 3D, Animations, Musics, Objects, and Pictures.
2. Select 3D. By doing so, you will have access to the numerous 3D images that come with *Jamagic.*

3. Select the Space category, and then select our image `fighter`, followed by `fighter.3ds`.
4. You will now be prompted to choose a texture directory, and `fighter` will be automatically selected for you from the proper directory. Choose OK and you're ready to go.

ON THE CD

If you have the version of *Jamagic* that came with this book, you should do the following in order to load the `fighter` image:

1. On the *Jamagic* project screen, several lines beneath Sources on the left side of your screen, you will see 3D. Right-click 3D, and then click Import.
2. Select C:/Program Files/Jamagic/Library/3D/Space, and then select `fighter`.
3. You will be prompted to choose a texture directory, and `fighter` will be automatically selected for you from the proper directory. Choose OK and you're ready to go.

When you return to the *Jamagic* screen and click 3D, you will see `fighter` listed. In addition, if you click Pictures, you will see that some entries have been automatically added; these are the textures that are automatically placed on your new image. You can see them by double-clicking the added pictures. Please see Figure 4.22.

For this program we will also need the `mtnlow` and `plains` 3D images that we made with *MilkShape*. You can import these from the previous program.

Figure 4.22 Texture pictures loaded with `fighter`.

Adding More Sounds and Music

We would like to add three new sounds to the game: a voice that says "Watch out!" when the altitude gets too low, an introductory sound when the game first comes on, and a jet sound when the thrusters are on. In addition, we'd like to add some nice music in the background.

The voice file name is called, oddly enough, watchout, and we can import it from the CD-ROM's "Human Voices" section of the full-capability version of *Jamagic*. We have already covered how to do this in a previous section, but here are the directions again briefly: right-click Sounds and select Import, then choose the *Jamagic* CD-ROM as your source. In the CD-ROM, go to Library, then Sounds, then Human, and select watchout.

ON THE CD

If you have the *Jamagic* version that came with this book, then right-click Sounds and select Import. Select C:/Program Files/Jamagic/Library. You should then select Sounds, followed by Human, after which you will see the sound watchout.

The thruster sound is called aireng01 and can be found in the Sounds/Vehicles directory on the CD-ROM if you have the full-capability version; the introductory sound is called crevasse and it can be found in the Sounds/Music directory. The background music is called Lev1and3 and it can be found in the Library/Musics/Zeb directory. Make sure that you import the sounds into Sounds (a few lines below Sources) and the music into Musics.

ON THE CD

If you have the *Jamagic* version that came with this book, you may import the crevasse sound by clicking on Sounds, then Import, and then selecting C:/Program Files/Jamagic/Library/Sounds/Music. The music Lev1and3 can be found by clicking on Musics, followed by Import, and then by choosing Program Files/Jamagic/Library/Musics/Zeb and then selecting Zeb1and2.

Here's the code that shows the sounds and music being loaded:

```
osound = New Sound("crevasse");
osound.SetLoop(ON,1);
osound.Play();
Wait(3000);

warning = New Sound("watchout");
thruster = New Sound("aireng01");
thruster.SetLoop(ON,30);

omusic = New Music("Lev1and3");
omusic.SetLoop(ON,5);
omusic.Play();
```

The `Wait` Command

The `Wait(3000)` command in the preceding code tells the computer to pause for 3000 milliseconds (3 seconds). This allows the introductory music to play un-interrupted before the background music comes on. If this wasn't present the two would play at the same time. You can put a `Wait()` command just about anywhere in your program in order to delay the continuation of the program temporarily.

In this program, another technique is use on the thruster sound. It has to be looped 30 times to ensure that it stays on for long enough. In contrast, the warning sound is only played once.

The *Jamagic* Sound Editor

The background music `omusic` is louder than the thruster sound, so we need to raise the thruster's volume to make it audible. *Jamagic* comes with a sound editor that allows you to modify sounds (but not music). You can remove parts of a sound, amplify all or some of it, reverse it, and set echo effects.

Working with sounds is very easy. Just right-click `aireng01` while you are in the *Jamagic* main screen and select Edit. You will see a graphical representation of the sound, as shown in Figure 4.23.

Figure 4.23 *Jamagic* sound editor.

On the y axis you can see time, and the louder the sound is at a certain time, the further it is from the center line. The height of the sound above the center line is known as *amplitude*.

We will increase the amplitude (that is, raise the volume—sometimes it's hard to resist sounding technical) using the editor. To do this, simply click Sound on the upper toolbar and select Amplify. You have two choices: + 25 % or −25 %. Since we want to raise the volume, you should select + 25 %. When you do, you will see the amplitude magically increase before your eyes. The sound clip will now be louder. To listen to the change, you can play the sound using the red arrow on the toolbar.

The sound editor also allows you to select parts of the sound clip to work on, thus allowing you to change only that part of the sound. To select parts of the sound, simply click and drag your mouse over the desired portion. The selected portion will turn white. You can now amplify or set an echo effect. You can also delete the selected portion of the sound by right-clicking it and selecting Delete.

If a sound is going to be looped, it may be better to cut its length in the editor if there will be no discernible difference at runtime. This is possible with consistent sounds like the one we require for the thruster. The reason for reducing the sound length is that sound and music files take up a lot of the computer's memory, and by now, you realize that this could result in a slow-running program. For example, the `aireng01` file comes from the CD-ROM at over 700 KB and we cut it down to 200 KB in the editor with no noticeable difference when the game is run.

For fine-tuning of sounds, you can zoom-in on particular parts of the sound using the Zoom command. You will notice an icon resembling a

Figure 4.24 Zoom Feature of *Jamagic* sound editor.

magnifying glass on the left portion of the toolbar. If you click on the sound, the portion you clicked will be magnified, allowing you to work in detail on that section. Clicking again will magnify it even further, and right-clicking brings the magnification back down. Please see Figure 4.24.

To leave the magnification mode, just click the small white icon to the left of the Zoom icon. Selecting this icon puts you back in the Select mode, allowing you to select portions of the sound again. You can leave the editor by selecting any other choice on your screen, for example Sources.

Adding a Realistic Water Surface—Tiling and UV Animation

The water surface from the previous game looked completely unrealistic. In this game, we are going to import a very nice looking water surface. We could import one large image to cover the entire water surface, but this would use up lots of memory—generally the bigger the image, the greater the load on your program. Instead, we will use a small image and apply *tiling* to it.

Think of floor tiles and how the same design is repeated over and over. Tiling of images is very similar in that the same image is repeated many times on your screen. Repeating an image is much less burdensome to the computer, allowing for faster running programs. In fact, if you have an older computer with a clock speed less than about 200 MHz, you will probably begin to notice some speed problems now!

Let's begin. We first import the image called Water into our program. To do this, right-click Pictures and select Import. You will find the image in C:/ProgramFiles/Jamagic/Help/Tutorials/Simple/FinalProject/Pictures. Once in Pictures, select the image water.

To tile the image, we first make a texture from the image called otexture, and then apply it to the plane that makes up our water surface, as shown here:

```
// Add a water texture
otexture = New Texture(oworld,"water");
matplane = New Material(oworld,otexture);
matplane.SetMapped(ON);
myplane.SetGouraud(ON);
myplane.ReplaceMaterial(matplane);
otexture.SetTiling(15,15);
```

The last line of this code tells *Jamagic* to tile otexture 15 times in the x direction and 15 times in the y direction. In other words, *Jamagic* will

make sure that the image water is sized exactly right so that 15 water images fit in each direction. How did we know to tile it 15 times? This was a trial and error process. This result gave the best visual impression when the program was run. You are encouraged to experiment with this on your own!

We can add some very interesting effects to the texture by making it look like it is moving. We do this using UV Animation with the AnimUV command; this is a great effect for water surfaces or for any other illusion of motion. This command moves the entire texture at a rate that you can specify. Here is an example:

```
matplane.AnimUV(0.0001,-0.00005);
```

This line tells *Jamagic* to move the material applied to the plane 0.0001 units to the right every 0.02 seconds and towards the viewer 0.00005 units every 0.02 seconds (the 0.02 seconds is the frequency at which the motion automatically takes place). The same sign conventions are used here as are used with the remainder of the program: to the right and towards the screen are positive directions.

In this program, we have used a fairly slow speed of motion for the water surface. You notice it only when the aircraft is not moving since the water appears to move when the aircraft moves. A faster speed could be used, but a trial and error process again guided us to select the current settings. You are encouraged to experiment by increasing this speed. You will be surprised by the intensity of the feeling of motion resulting from this feature!

You may be a little confused about when to use a texture with a material. In the preceding programs, we did not use the Texture command, although we did in the very first programs. In general, textures give you much more flexibility, and allow you to use such features as tiling and UV Animation.

We are now ready to type in our code. When you run it, you will see a very nice-looking aircraft that is followed by the camera. Our object is to land the aircraft on the landing pad, as indicated by the x and z distances on your instrument panel. The trick is not to let yourself hit the water or the islands. The game is easy once you see what's going on, and it is still a bit primitive, but nevertheless fun to use (we will go for realism in the next project!). You can make it more difficult by reducing the amount of available fuel, thus making it very important to not over-use the upwards thrusters and to steer efficiently.

Chapter 4 Simple Games **149**

Sphere 9 Code

```
//
// Sphere9: 9th Spherelander game. This program will

//(a) Add new sound at the beginning from the Jamagic
     //CD-ROM.
//(b) Add voice if altitude gets too low.
//(c) Make use of the wait command.
//(d) Add a spaceship from the Jamagic CD-ROM.
//(e) Use tiling for water and islands.
//(f) Use UV Animation.
//(g) Add a thruster sound.
//(h) Use the sound editor.

// Sounds
osound = New Sound("crevasse");
osound.SetLoop(ON,1);
osound.Play();
Wait(3000);

omusic = New Music("Lev1and3");
omusic.SetLoop(ON,5);
omusic.Play();

warning = New Sound("watchout");
thruster = New Sound("aireng01");
thruster.SetLoop(ON,30);

// New Main Window
owindow = New Window
    ("Spherelander",640,480,Window.STANDARD);//one line
owindow.SetAutoRefresh(OFF);

// New World
oworld = New World(0);

// Import and massage the 1st 3D object made with
    // MilkShape.
// oworld.Load("mtnlow");

oflatland = oworld.GetObject(oworld.GetNObjects()−1);
oflatland.Scale(10);
oflatland.SetPosition(0,0,3000);
```

```
matflatland =New Material(oworld,GetRGB(100,200,0));
matflatland.SetMapped(ON);
oflatland.SetGouraud(ON);
oflatland.ReplaceMaterial(matflatland);
oflatland.SetStatic();

// 2nd 3D object
oworld.Load("plains");
mountain = oworld.GetObject(oworld.GetNObjects()-1);
//mountain = oworld.GetObject(0);
mountain.Scale(30);
mountain.SetPosition(400,0,0);
matmount =New Material(oworld,GetRGB(100,200,0));
matmount.SetFlat(ON);
mountain.SetGouraud(ON);
mountain.ReplaceMaterial(matflatland);
mountain.SetStatic();

// Import jet
oworld.Load("fighter");
mysphere= oworld.GetObject(oworld.GetNObjects()-1);
mysphere.Scale(0.01);
mysphere.SetPosition(500,150,-2000);

//Initialize variables.
fuel = 200.;
fuelleft = 200.;
ftime = 0.0;
fuelflag = 0;
block = FALSE;
upflag = FALSE;
clickcheck = TRUE;
Soundflag = FALSE;

// New Cameras
ocamera1 = New Camera(oworld,owindow);
ocamera1.SetPosition(500,500,-5000);
// Instruments
mytext6 = New StaticText
    (owindow,"INSTRUMENTS",130,0,170,20);//one line
mytext6.SetBackColor(GetRGB(0,0,0));
mytext6.SetColor(GetRGB(0,255,255));
fnt = New Font("ARIAL",20,Font.BOLD);
mytext6.SetFont(fnt);
```

```
mytext7 = New StaticText(owindow,"Remaining
Fuel:",0,150,170,20); // one line
mytext7.SetBackColor(GetRGB(0,0,0));
mytext7.SetColor(GetRGB(255,0,0));

mytext = New StaticText(owindow," ",0,30,110,20);
mytext.SetBackColor(GetRGB(0,0,0));
mytext.SetColor(GetRGB(255,255,255));

mytext2 = New StaticText(owindow," ",0,60,110,20);
mytext2.SetBackColor(GetRGB(0,0,0));
mytext2.SetColor(GetRGB(255,255,255));

mytext3 = New StaticText(owindow," ",0,90,110,20);
mytext3.SetBackColor(GetRGB(0,0,0));
mytext3.SetColor(GetRGB(255,255,255));

mytext4 = New StaticText(owindow," ",0,120,140,20);
mytext4.SetBackColor(GetRGB(0,0,0));
mytext4.SetColor(GetRGB(255,255,255));

mytext5 = New StaticText(owindow," ",0,170,220,20);
mytext5.SetBackColor(GetRGB(0,0,0));
mytext5.SetColor(GetRGB(0,0,255));

//Buttons
myButton=New Button(owindow,"Ahead",220,30,65,20);
myButton.OnClick = Doahead;

myButton2=New Button(owindow,"Off",220,60,65,20);
myButton2.OnClick = Dostop;

myButton3=New Button(owindow,"Back",220,90,65,20);
myButton3.OnClick = Doback;

myButton4=New Button(owindow,"Right",300,60,65,20);
myButton4.OnClick = Doright;

myButton5=New Button(owindow,"Left",135,60,65,20);
myButton5.OnClick = Doleft;

mybutton6 = New Button(owindow,"Thrust Up",
    220,120,65,20);//one line
mybutton6.OnClick = doup;
```

```
// Create the water surface and rotate it so it's flat.
myplane = oworld.CreatePlane(10000,10000);
myplane.SetPosition(0,0,0);

// Add a water texture.
otexture = New Texture(oworld,"water");
matplane = New Material(oworld,otexture);
matplane.SetMapped(ON);
myplane.SetGouraud(ON);
myplane.ReplaceMaterial(matplane);
otexture.SetTiling(15,15);

// Move the material automatically to give
    // effect of moving water.
// Using Anim UV
matplane.AnimUV(0.0001,-0.00005);

myplane.SetStatic();
myplane.SetAngle(-Pi/2,0,0);
myplane.SetStatic();

// Create a target plane and rotate it so it's flat.
myplane2 = oworld.CreatePlane(50,50);
myplane2.SetPosition(-150,40,2974);
matp2 =New Material(oworld,GetRGB(100,200,0));

matp2.SetFlat(ON);
myplane2.SetGouraud(ON);
myplane2.ReplaceMaterial(matp2);
myplane2.SetAngle(-Pi/2,0,0);
myplane2.SetStatic();

// Camera
ocamera1.Follow(mysphere,-100);
oworld.Optimize(ocamera1);
//oworld.Optimize(ocamera2);

//Set collision detection.
oworld.OnCollide = docollision;
mysphere.SetCollision(TRUE,Object.COLLISION_TYPE_STOP);

// Set gravity on.
mysphere.SetGravity(0.002);
```

```
//Game loop
While(1)
{

// Distance calculations
//

distx = (mysphere.GetX) + 150;
mytext.SetText("X Distance: " + distx);

disty = (mysphere.GetY) ;
mytext2.SetText("Height: " + disty);

if(disty<100 && Soundflag == FALSE)
{

// osound.SetLoop(ON,1);
 warning.Play();
 Soundflag = TRUE;
}

distz = (mysphere.GetZ)-2974 ;
mytext3.SetText("Z Distance: " + distz);

totaldist = Sqrt(distx*distx + disty*disty +
                distz*distz);//one line
totalxz = Sqrt(distx*distx + distz*distz);
mytext4.SetText("x-z distance "+ totalxz);

// Refresh
   ocamera1.ActivateRender();
   owindow.Refresh();
//fuel calculations
if(fuelflag == 1)
{
  time2 = System.GetElapsedTime;
  fueltime = time2 - ftime;
  fuelleft = fuel - fueltime/1000.;
}

mytext7.SetText("Remaining Fuel Time: " + fuelleft);
if(fuelleft<0)
   {
      mytext5.SetText("FUEL GONE!!");
```

```
        block = TRUE;
      }
//End of game loop follows.
}

Function docollision
{
  if(totalxz <= 50)
    {
     mytext5.SetText("Congratulations! You landed
         on target!");//one line
     mysphere.Stop;
    }
    Else
    {
     mytext5.SetText("Back to flight school for
         you!");//one line
     mysphere.Stop;
    }
}

Function doahead
{
   if (block == FALSE && clickcheck == TRUE)
   {
      ftime = System.GetElapsedTime;
     mysphere.Move(-5000,50);
     fuelflag = 1;
      clickcheck = FALSE;
      thruster.Play();
   }
}

Function doback
 {
   if (block == FALSE && clickcheck == TRUE)
   {
    mysphere.Move(5000,50);
    ftime = System.GetElapsedTime;
    fuelflag = 1;
    clickcheck = FALSE;
    thruster.Play();
   }
}
```

Chapter 4 Simple Games **155**

```
Function doright
{
   if (block == FALSE && clickcheck == TRUE)
   {

    mysphere.MoveRight(-5000,50);
    ftime = System.GetElapsedTime;
    fuelflag = 1;
    clickcheck = FALSE;
    thruster.Play();
   }
}

Function doleft
 {
   if (block == FALSE && clickcheck == TRUE)
   {
    mysphere.MoveLeft(-5000,50);
    ftime = System.GetElapsedTime;
    fuelflag = 1;
    thruster.Play();
   }
}

Function dostop
 {
     clickcheck = TRUE;
     mysphere.Stop();
     fuelflag = 0;
     fuel = fuelleft;
     thruster.Stop();
   if(upflag = TRUE)
    {
     mysphere.SetGravity(0.004);
     upflag = FALSE;
    }
}

Function doup
{
   if (block == FALSE && clickcheck == TRUE)
   {
    mysphere.SetGravity(-0.004);
    ftime = System.GetElapsedTime;
```

```
            fuelflag = 1;
            upflag = TRUE;
            clickcheck = FALSE;
            thruster.Play();
        }
    }
```

We are now ready to make a full-blown flight simulator!

CHAPTER 5
FLIGHT SIMULATORS

158 Elementary Game Programming and Simulators Using *Jamagic*

FLIGHT SIMULATOR BASICS

We now wish to make a realistic flight simulator. First, we should take a quick look at how an aircraft rotates about its different axes and how it is controlled. Rotation about the x-axis is called *pitch,* about the y-axis it is called *yaw,* and about the z-axis it is called *roll.* These movements are controlled with the aircraft's rudder, elevator, and ailerons. The rudder is much like a ship's rudder, and is usually mounted on an airplane's vertical stabilizer at the rear of the plane. The elevators are similar to a rudder, except that they move up and down and are mounted on the tail; they make the aircraft pitch up and down. One set of ailerons is mounted on each wing, and they move up or down in opposition to each other to make the plane roll. Please consult Figure 5.1 and make sure you understand these movements.

Yaw is controlled by moving the rudder back and forth, which is done by the pilot with right and left foot pedals. Pitch is controlled by moving the stick or control lever between the pilot's legs forward or backward. Pushing the stick forward makes the plane pitch down (dive) by making the elevators deflect down, while pulling the stick back makes the aircraft pitch up by bringing the elevators up. Roll is controlled by pushing the stick to the sides. When the stick is pushed to the left, the right aileron moves down and the left aileron moves up, causing the aircraft to roll left.

Figure 5.1 Aircraft rotation about 3 axes: pitch, yaw, and roll.

You will see that we will develop a fairly realistic simulator. Our flight simulator is to have the following characteristics:

- The aircraft should be able to land on a runway. To do so, it must be able to turn and make a controlled descent.
- An instrument panel is to be visible on the user's screen.
- A camera will follow the jet directly from behind.
- The aircraft is told to roll right and left with the right and left arrow keys.
- The aircraft pitches up and down with the down and up arrow keys.
- When the aircraft rolls to one side, it also turns towards that side. For example, when the control stick is pushed to the left (the left arrow key pressed), the aircraft rolls left and also turns to the left. This is because the lifting force from the wings is now tilted to the left as well as up, as shown in Figure 5.2. The aircraft also yaws to the left in response to an action by the rudder, which is usually activated by the pilot with his feet whenever the aircraft turns left. Applying the correct amount of rudder for a given amount of roll results in what is referred to as a *coordinated turn*. In some early aircraft (the *Ercoupe* of the 1940's is one example), the rudders were automatically activated when the aircraft rolled—there were no foot pedals for controlling the rudder. In the interest of simplicity we will not have separate rudder controls and will assume that they are automatically activated with the ailerons.
- The more the aircraft rolls to one side, the faster it will move in that direction. For example, if the aircraft is rolled slightly to the left, it will also be moving slowly to the left and yawing to the left. If the angle is increased, then the left motion and yawing is also increased.

Figure 5.2 When an aircraft rolls to one side, it also turns to one side because lift force points to the side as well as up.

- Pulling back on the stick not only causes the aircraft to pitch up, but the aircraft also begins to climb. In addition the airspeed drops. If you think about it, this makes sense: if the aircraft pitches up, the thrust of the engine points up and makes the aircraft climb, but the increased work required to make the plane go up also makes the airspeed drop. This is similar to a car not being able to move as fast when moving up a hill as it does on level ground. In real aircraft, pulling back on the stick too far will eventually cause its speed to drop excessively and its lift to drop too far, in which case the aircraft stalls, and pitches down.
- Pushing the stick forward causes the nose to pitch down and the airspeed to increase.
- Landing at too large a vertical speed will cause a crash.
- The instrument panel is to have realistic dial-type gauges for the following: compass heading, airspeed in miles per hour, rate-of-climb (up or down), and bank indicator (shows how far the aircraft is rolled to left or right).

Yes, it sounds very complicated, but we will do it in small steps. And we will have a lot of fun along the way!

FIRST FLIGHT SIMULATOR PROGRAM: `FlightSimulator`

We will begin with a simple program that imports an F16 aircraft from the *Jamagic* CD-ROM and rotates the aircraft along the x and z axes, while displaying the amount of rotation on the toolbar. We will also display the *sine* and *cosine* of the angle of roll. The sine and cosine are super-important trigonometric functions that you really should understand fully. We will use them in the next project to make the aircraft move to one side faster the more it rolls, and to calculate the vertical speed of the aircraft when it's moving pitched up or down.

If you have never had any trigonometry and are serious about learning to program games, the following explanations of sine and cosine will be worth your time.

Sine and Cosine

Let's say that we have a circle in 2D space with it's center at (0,0), as shown in Figure 5.3. So we can refer to it later, we will call this circle the *unit circle*. The radius of the circle (the distance from the center point to the edge of the circle) is 1. You can see on the figure that the circle crosses the x-axis at $x = 1$ and $x = -1$, and it crosses the y-axis at $y = 1$ and $y = -1$. Notice

Figure 5.3 The unit circle.

that the negative y-axis is up, while the positive y-axis is down! This is different from what you may be used to, and it goes along with the convention used for screen coordinates. Recall that the screen origin is at (0,0) and y values become greater as you go down the screen.

Let's draw an angle of 30 degrees on our unit circle, measured from the x-axis (see Figure 5.4). Remember that 2 pi (pi = 3.1417) radians correspond to 360 degrees, so to convert from degrees to radians multiply the degrees by 0.01745—30 degrees is then 0.524 radians.

In Figure 5.4, you will notice that we have drawn a vertical line to the x-axis and a horizontal line to the y-axis from the point where the angle meets the circle. You can see that the vertical line hits the x-axis at 0.867, and the horizontal line hits the y-axis at 0.5. The value where the vertical line hits the x-axis is called the cosine, and the value where the horizontal line hits the y-axis is called the sine. That's all there is to it.

Imagine what happens to the sine and cosine as we increase the angle to 45 degrees: the vertical line shifts to the left and the horizontal line moves down. At 45 degrees, the sine and cosine equal each other at a value of 0.707. So, as we go from 0 degrees to 90 degrees, it looks as if sine is increasing and cosine is decreasing.

Beyond 90 degrees the patterns changes and the cosine begins increasing again (although it has a negative value after 90 degrees) as the sine decreases.

Figure 5.4 0.524 radians (30 degrees) on the unit circle. Cosine is 0.867 and sine is 0.5.

Let's try to come up with some sines and cosines for some easy angles. Pleases consult the Figure 5.4 so that you can envision what is happening. At an angle of 0 degrees (0 radians) to the x-axis, the cosine is 1 and the sine is 0. At an angle of 90 degrees (pi/2 = 1.57 radians), the cosine is 0 and the sine is 1. At an angle of 180 degrees (pi = 3.14 radians) the cosine is –1 and the sine is 0. At an angle of 270 degrees (3/2 pi = 4.7 radians) the cosine is 0 and the sine is –1. At an angle of 360 degrees (2 pi radians = 6.28 radians) the cosine is again 1 and the sine is 0 (in other words, 0 and 360 are the same!). For angles greater than 6.28 radians we begin counting from zero again.

Your question right now may be, "OK, this isn't so difficult, but why bother with sine and cosine?" Remember that one of the features of our game will be to have the jet move faster to the side as the roll angle increases, which is a very realistic feature. We need some formula to calculate the sideways speed of the jet based on the angle, and the sine function will be extremely useful for this. Remember, the value of the sine is increasing from a value 0 at 0 degrees to a value of 1 at 90 degrees. If we take a number, say 100, and multiply it by the sine of the angle of roll, we get a pretty good pattern forming for sideways airspeed!

Basically, this is the way it works. At zero roll,

$$100 * \sin 0 = 0,$$

so sideways speed is 0. At a 45 degree roll,

$$100 * \sin 45 = 100 * .707 = 70.7.$$

The sideways speed is then 70.7. At a 90 degree roll,

$$100 * \sin 90 = 100,$$

so our sideways speed is at a maximum value of 100.

Pretty good, huh? We will use this in the very next program. In this program, you should study what happens on the screen to the sine and cosine as the roll angle changes.

Figures 5.5 through 5.10 show the jet through an entire 360 degree rotation (2 pi) about the z-axis, with the aircraft seen from the front. In order to understand what we mean when we say that the aircraft is rotating about the z-axis, imagine that the jet is mounted on a shaft that runs through its length. Notice what happens to the sine and cosine.

Figure 5.5 Jet seen from the front in level flight. The z-axis points into the viewer. The x-axis runs horizontally. They y-axis runs vertically. Sine is 0.

Figure 5.6 Jet is rotated 0.196 radians about the z-axis. Sine is 0.195.

Figure 5.7 Jet is rotated 0.983 radians about the z-axis. Sine is 0.83.

Figure 5.8 Jet is rotated 1.57 radians about the z-axis. Sine is 1.0.

Figure 5.9 Jet is rotated 3.148 radians about the z-axis. Sine is 0.

Figure 5.10 Jet is rotated 4.72 radians about the z-axis. Sine is −1.

We will also pitch the jet up and down, again using radians to measure the angle. The aircraft rotates about its x-axis when it is pitching; imagine that the jet is rotating about a shaft that runs parallel to its wingspan. Figures 5.11 and 5.12 show rotation about the x-axis at pi/4 and pi/2 radians (pointing straight down).

Figure 5.11 Jet rotated pi/4 radians about the x-axis.

Figure 5.12 Jet rotated pi/2 radians (straight down) about the x-axis.

You have seen us rotate the jet about the x- and z-axes. Of course, we could also have done the same with the y-axis (yaw), for a total rotation about all three axes. We can describe the total rotation of an object by specifying the rotation about all three axes. For example, an object rotated pi/4 radians about the x-axis, pi/2 radians about the y-axis, and pi radians about the z-axis could be described by the expression (.785, 1.57, 3.14).

Sine and Cosine Demonstration Program

We first want to get a feel for the sine and cosine functions, so we will make a demonstration program, `FlightSimulator`, that rotates the jet about different axes in pitch and roll while displaying the sine and cosine of the roll angle. In fact, the images you saw in the previous section were created using this demonstration program.

We will roll and pitch the aircraft using the arrow keys and the `RollLeft`, `RollRight`, `TurnDown`, and `TurnUp` commands in *Jamagic*. When the control stick is pushed forward the plane dives, and when it is pulled back the plane pitches up. For this reason, we would like the aircraft to dive when the up arrow key is pressed, and pitch up when the down arrow key is pressed, which may at first seem counter-intuitive. Even more confusing is that the `TurnUp` command makes the aircraft dive!

Please see the following code for an example of how we make the aircraft respond to the arrow keys; the amount of rotation in radians is first specified in the parentheses, followed by the number of seconds the motion is to last. In each case, the rotation is set to pi/16 radians (11.25 degrees). This will be changed in the next program.

```
If(Keyboard.IsKeyDown(Keyboard.LEFT))
 {
   myjet.RollLeft(Pi/16,1);
 }

If(Keyboard.IsKeyDown(Keyboard.RIGHT))
 {
   myjet.RollRight(Pi/16.,1);
  }

If(Keyboard.IsKeyDown(Keyboard.UP))
 {
   myjet.TurnUp(Pi/16,1);
 }
If(Keyboard.IsKeyDown(Keyboard.DOWN))
 {
   myjet.TurnDown(Pi/16.,1);
 }
```

We also wish to display the rotation about each axis, as well as the sine and cosine of the roll angle. We do so with the following command, which sends text to the window's toolbar area:

```
// next all on one line!
SetText("x,y,z angles "+ myjet.GetXAngle()+ ",
"+myjet.GetYAngle() + ", "+myjet.GetZAngle()+ "
Cosine,sine of roll angle: " + Cos(myjet.GetZAngle)
+ " "+Sin(myjet.GetZAngle));// last 4 lines on one
// line
```

There is only one other new command used in this program; it is used to set a sky-colored background on the screen:

```
ocamera1.SetBackgroundColor(GetRGB(0,150,200));
```

When the jet is loaded into your program, it will be loaded in facing you—the direction it faces when loaded depends on how it was drawn.

Since the camera always faces from the negative direction to the positive z direction, we will need to place our camera closer to the viewer to make sure the jet is visible.

You can now type in the code. You should understand the remaining portions from the previous chapters. When you run the program, please note how the x and z angles and sine and cosine change as you rotate the jet.

Sine and Cosine Demo Code: FlightSimulator

```
owindow1 = New Window("Flight
Simulator",640,480,Window.STANDARD);//one line
//Window maintenance
owindow1.SetAutoRefresh(OFF);

// New world
oworld = New World();

//Import jet.
oworld.Load("f16");
myjet= oworld.GetObject(oworld.GetNObjects()-1);
myjet.Scale(0.01);
myjet.SetPosition(0,150,0);

// Create the ground surface and rotate it so it's flat.
ground = oworld.CreatePlane(10000,10000);
ground.SetPosition(0,0,0);
ground.SetStatic();
ground.SetAngle(-Pi/2,0,0);
ground.SetStatic();
matp =New Material(oworld,GetRGB(0,100,50));
matp.SetFlat(ON);
ground.ReplaceMaterial(matp);

// New cameras
ocamera1 = New Camera(oworld,owindow1);

ocamera1.SetPosition(0,150,-75);
ocamera1.SetBackgroundColor(GetRGB(0,150,200));
oworld.Optimize(ocamera1);

//Game loop
While(1)
{
```

```
        ocamera1.ActivateRender();
        owindow1.Refresh();

    If(Keyboard.IsKeyDown(Keyboard.LEFT))
      {
        myjet.RollLeft(Pi/16,1);
      }

    If(Keyboard.IsKeyDown(Keyboard.RIGHT))
      {
        myjet.RollRight(Pi/16.,1);
       }

    If(Keyboard.IsKeyDown(Keyboard.UP))
      {
        myjet.TurnUp(Pi/16,1);
       }
    If(Keyboard.IsKeyDown(Keyboard.DOWN))
      {
        myjet.TurnDown(Pi/16.,1);
      }

     SetText("x,y,z angles "+ myjet.GetXAngle()+ ",
    "+myjet.GetYAngle() + ", "+myjet.GetZAngle()+
    "   Cosine,sine of roll angle: " +
    Cos(myjet.GetZAngle) + " "+Sin(myjet.GetZAngle));//all
          // on one line

    //End of game loop follows.
    }
```

Experiment thoroughly with the program. Observe what happens to the sine and cosine values of the roll angle until you get very comfortable with what happens as the roll angle changes. Once you are ready, you may progress to the next program, which will be a working flight simulator.

FLIGHTSIMULATOR2

In this program, we will take a gigantic step forward in the quality of our game. This game will actually be a lot of fun to play, and quite challenging. If you have a computer with a processor slower than about 600 MHz, you will probably have trouble running this game and the ones that follow.

We wish to add several features to our game:

- Displays altitude, airspeed, rate of climb, pitch, and roll on screen
- Airspeed depends on pitch
- Aircraft climbs or drops with pitch
- Aircraft moves to right and left when rolling
- Aircraft yaws to right and left when rolling
- Allows the player to calculate vertical speed
- Determines if the landing was good based on location, heading, and vertical speed

Equation for Speed as a Function of Pitch

As in real-life aircraft, the airspeed of our jet is going to depend on the pitch. Speed will be highest when the aircraft is pointed straight down, and lowest when the aircraft points straight up. Anything in-between will have some intermediate value.

We then need an equation that will express this; you may have guessed that it will involve the sine of the pitch angle. We will use `thetax` as the pitch angle. (Incidentally, theta is a Greek letter often used in mathematics to name angles; the x denotes that the measurement is about the x-axis.) We will make upward pitches positive and downward pitches negative. Level flight will have zero pitch. As pitch angle increases, the sine of the pitch angle will be increasing too, so we can say (assuming 1000 is the speed in level flight)

```
airspeed = 1000 - 1000*Sin(thetax);
```

Figure 5.13 Jet pitching up. Airspeed goes down.

Notice what will happen to `airspeed` as the plane pitches up (see Figure 5.13). The angle `thetax` becomes positive and increases. The sine of `thetax` increases also, so `airspeed` goes down. If the plane pitches down, `thetax` becomes negative, and so does the sine of `thetax`, so `airspeed` then increases. But is this totally realistic? Probably not, but it produces realistic behavior. For example, the equation we are using for airspeed requires the jet's speed to be 0 when the aircraft is pointing straight up, and 2000 when pointing straight down, which may not necessarily be the case. In fact, the F-16 aircraft can climb vertically at a considerable speed! However, as mentioned earlier the general behavior of the model is good, in that speed increases when the nose goes down, and decreases when it points up. If we really wanted, we could write equations for the exact speed of the F-16 based on pitch, but to do so is beyond the scope of this book.

Once we know the airspeed, we can move the aircraft according to that speed:

```
// Move the aircraft as per the airspeed.

speed = airspeed/100.;
myjet.Move(speed);
```

The last two lines bear some explaining. We have already seen the `Move` command: it moves the object in the direction in which it's pointing. When we do not specify the time in which the motion is to take place (as in `Move(1500,2)`, which would move the aircraft 1500 units in 2 seconds), the motion occurs immediately. In the code above, `myjet` is moved immediately a distance equal to `speed`.

Computer Speed Issues

In the preceding code, you will also notice that the value of airspeed calculated is divided by 100 to come up with the value of `speed`, which goes in the `Move` statement.

Why was the airspeed value that we went through so much trouble to calculate divided by 100? The answer is that it was done to produce a realistic feeling when the program is actually run. Just because we picked somewhat realistic sounding numbers for the airspeed does not mean that they will result in realistic motion when applied to the `Move` command. The designers of *Jamagic* did not design the `Move` command to give realistic F-16 movement, nor should they have! It's our job to make the game realistic.

Dividing the airspeed by 100 resulted in acceptable motion with the particular computer used to make this game (a 900-MHz processor), but if

you have a faster or slower computer, you will probably have to use a different number; you will have to experiment with this. It is possible to come up with algorithms to automatically adjust the value 100 to a more appropriate one based on the computer's speed. For example, at the very beginning of the game, you could have the computer move an object on the screen for a second or two, and then calculate the distance it moved. Based on this distance, you could adjust the value that is currently set to 100. For now, keep in mind that you may have to adjust this and other values to ensure proper action.

Why should the speed of the computer affect the speed of the motion? After all, it's supposed to happen immediately if the time element is left from the parentheses in the Move command. Isn't what is meant by "immediate" the same regardless of the computer's speed? The answer is that the Move command will be inside the game loop, cycling continuously. Each time the program reaches the Move command, the aircraft will move per the instructions, but because a faster computer will be looping faster, the aircraft will be moved the same distance each time, but more often. This difference can be enough to significantly affect how the game plays.

Finding the Jet's Angle

You saw that we need to know the jet's pitch angle (thetax, or angle the jet is making with its x-axis) in order to determine how fast the jet moves. We will also need to know the angle the jet is making with its y-axis (this is the yaw angle or thetay), and the angle with the z-axis (the roll angle of the jet or thetaz). We need to know the roll angle because the further the jet rolls to one side, the faster it will move toward that side as a result of the wings tilting to the side.

One of your first ideas might be to use the GetXAngle, GetYAngle, and GetZAngle functions to find these angles. However, there is a problem with this in that the values returned by these functions can become distorted when the jet rotates about all three axes—at least as far as the jet is concerned. We need to then keep track of how much rotation is happening about each axis, and we can do so very easily. For example, we can keep track of the jet's roll by the following command, which is inserted in the code that rolls the jet to the right:

```
If(Keyboard.IsKeyDown(Keyboard.RIGHT))
  {

    myjet.RollRight(Pi/500.);
    thetaz = thetaz + (Pi/500.);
```

```
    If(thetaz>(2*Pi))
      {
      thetaz = 0.0;
         }

}
```

You can figure it out easily: `thetaz` is the roll angle, and each time the code above is executed the jet is rolled pi/500 to the right. By adding pi/500 to `thetaz` we are keeping track of the angle of roll of the jet. When the jet rolls to the other side, we can subtract pi/500 from `thetaz`.

In the event that the aircraft rolls more than 360 degrees (2 pi) in one direction, we would like to reset the angle to 0 as soon as one revolution is complete. This explains the last lines of this code, which set `thetaz` to 0 as soon as one revolution was complete.

The same procedure can be followed for keeping track of the angle relative to the x-axis, as shown in the here:

```
    If(Keyboard.IsKeyDown(Keyboard.UP))
     {
       myjet.TurnUp(Pi/3000.);
       thetax = thetax - (Pi/3000.);
       If(thetax<(-2*Pi))
          {
          thetax = 0.0;
          }
      }
    If(Keyboard.IsKeyDown(Keyboard.DOWN))
     {
       myjet.TurnDown(Pi/3000.);
       thetax = thetax + (Pi/3000.);
       If(thetax>(2*Pi))
          {
          thetax = 0.0;
          }
      }
```

Vertical Speed

Next, we would like to know the jet's speed in the vertical direction. For example, let's say that you were riding your bicycle down a mountain that is 1 mile high, and you get to the bottom in 1/2 hour. Your bike speedometer was reading 20 miles per hour. What was your vertical speed?

Figure 5.14 An aircraft moves 500 miles in one hour and climbs 6 miles.

Even though you were moving on the roadway at 20 miles per hour, your vertical speed was 1 mile every 1/2 hour, or 2 miles per hour.

Another example of the vertical speed (or rate of climb, as it's know in aviation) can be seen by considering an aircraft at take-off. The jet is flying at 500 miles per hour airspeed (that is, the speed of the aircraft in the direction it's pointing, relative to the air around it) and it climbs to an altitude of 6 miles in one hour. The jet's rate of climb or vertical speed is 6 miles per hour, even though the aircraft has an airspeed of 500 miles per hour. Figure 5.14 illustrates what happens.

If we know the aircraft speed and pitch angle, we can easily find its vertical speed using the sine function. You will probably remember from the previous section that the sine of the angle is the spot where the horizontal projection of the angle hits the y-axis. But if instead of using a unit circle with a radius of one, we use a unit circle with a radius equal to the aircraft's airspeed (say 500), then the horizontal projection from the angle to the y-axis will hit the y-axis at a spot 500 times greater than before. This spot on the y-axis will give the value of the vertical speed. *Bottom line: the airspeed times the sine of the angle of pitch gives the speed in the vertical direction.* In Figure 5.15, for example, the jet moves at 500 miles per hour at an angle of 10 degrees. Its vertical speed is then

$$500 * \sin(10) = 500 * .156 = 78 \text{ miles per hour.}$$

Figure 5.15 The sine of the aircraft angle times its airspeed is the speed in the vertical direction (rate of climb).

Now that we have found the vertical speed of the aircraft using the sine function, then the value of the rate of climb vert is sent to a text box:

```
vert = airspeed * sin(thetaz);
mytext6.SetText("Vertical Speed: " + vert);
```

We note that the angle thetaz must be in radians for the sine and cosine functions to work properly. If we wish to convert it to degrees we simply say

```
degrees = thetaz * 360./(2.*Pi);
```

Yaw

You may remember that we need to make the aircraft move sideways and yaw when the aircraft rolls. We also want to make the jet move and yaw faster with increasing roll angles, which is consistent with real aircraft operation. We will use a variable called leftfactor to move the jet to the side, and a variable called addfactor to yaw it, combined with the cosine of the roll angle thetaz. The cosine of thetaz is 0 at 0 roll angle, and grows to a value of 1 when thetaz is 90 degrees:

```
//Move the jet to the side when jet rolls.
// Right roll first
If(thetaz >0.01)
    {
      leftfactor = 0.0004 * Cos(thetaz);

      myjet.MoveRight(leftfactor);
      addfactor = -Pi/1500. * Cos(thetaz);
  myjet.AddAngle(0,addfactor,0);
      thetay = thetay+addfactor;
      If(thetay>(2*Pi))
         {
          thetay = 0.0;
         }
    }
//
// Roll to left.
If(thetaz < -0.01)
      {
      leftfactor = 0.0004 * Cos(thetaz);
      myjet.MoveLeft(leftfactor);
      addfactor = Pi/1500. * Cos(thetaz);
```

```
myjet.AddAngle(0,addfactor,0);
thetay = thetay+addfactor;
If(thetay < (-2*Pi))
  {
   thetay=0.0;
  }
```

You can see that the bigger `thetaz` is from 0 to 90 degrees, the larger the value of its cosine and the faster the motion of the jet when moving to the right. The statement `myjet.AddAngle(0,addfactor,0)` immediately rotates the jet about the y-axis (yaw) `addfactor` radians. If rotation had been required about the x- and z-axes, we could have used non-zero values in the parentheses. Of course, since we are only interested in yawing the aircraft, we only need to specify rotation about the one axis.

The numbers 0.004 and pi/500 (=3.14159/500) were arrived at by trial and error. With the computer used to make this game, these numbers gave satisfactory motion of the jet, however, you may need to adjust these numbers in your game.

SetFocus Command

We want the camera to follow behind the jet instantaneously, so we use the `Follow` command. You may remember that the `Optimize` command is used in conjunction with `SetStatic` to ensure efficient use of the processor. The `SetFocus` line in the following code can be used to change how much of the screen is visible to the camera—something like looking through the naked eye versus looking through a telescope. A value of 30 is about right for us; using a larger value would tend to widen the field of view, making objects smaller, and using a smaller value would decrease the field of view, making things larger and tending to distort the objects.

```
// Camera
ocamera1 = New Camera(oworld,owindow1);
ocamera1.SetBackgroundColor(GetRGB(0,150,200));
ocamera1.Follow(myjet,100);
oworld.Optimize(ocamera1);
ocamera1.SetFocus(30);
```

Figures 5.16 and 5.17 show the differences between focus values of 10 and 50.

Figure 5.16 The jet with a focus value of 10.

Figure 5.17 The jet with a focus value of 50.

We now want to be able to switch back and forth from a camera angle directly behind the jet to one from the side and behind. The following code does this using the Shift and Caps Lock keys:

```
//Set where to follow jet from.
If(Keyboard.IsKeyDown(Keyboard.SHIFT))
  {
ocamera1.Follow(myjet,10,10,10,0);
  }

If(Keyboard.IsKeyDown(Keyboard.CAPSLOCK))
  {
    ocamera1.Follow(myjet,100);
  }
```

Airport Image—Compass Heading

The *Jamagic* CD-ROM comes with a very nice 3D image of an airport that is perfectly suited for our game. The airport can be found under Terrains in the CD-ROM of the full-capability version, and it can also be found under Terrains in the 3D menu of the book's *Jamagic* version.

The airport has a control tower, two runways, roads, fences, buildings, and a tarmac for waiting aircraft. The runways run east-west, and the jet shows up on the screen heading to the north. A proper landing can be made only from the east (aircraft heading west), a restriction that was put in to simulate real-world conditions in which aircraft must land in a direction into the wind. The pilot must then turn the aircraft around through 90 degrees to make a proper landing. Please see Figure 5.18, which shows the aircraft heading north, with the runways perpendicular.

Here is the code that loads the airport, which we have elected to call `mountain` in order to avoid changing code as much as possible. It is scaled down considerably because of its size:

```
// Airport
oworld.Load("airport");
mountain = oworld.GetObject(oworld.GetNObjects()−1);
mountain.Scale(0.05,0.05,0.05);
mountain.SetPosition(0,0,−4000);
mountain.SetStatic();
```

We want the pilot to know his heading by looking at the Heading Indicator on the screen, which is calculated fairly easily from the angle of the

Figure 5.18 The aircraft heads north. The runways run perpendicular east-west.

jet `thetay` about the y-axis. The angle `thetay` is in radians, and we convert it to degrees using the procedure of multiplying by 360 and dividing by 2 pi. In addition, we subtract the calculated value from 360 since a right turn from a 0 heading caused the heading to go to 359, where we need a right turn from zero heading to cause the degrees to increase:

```
//Calculate compass heading in degrees.
degs = 360. - thetay * 360.0/(2.*Pi) ;
If (degs>360)
 {
    degs = degs - 360;
 }
mytext2.SetText("Compass heading: " + degs);
```

In addition, we would like the heading to be displayed as a compass direction, such as north or east. Please see Figure 5.19 to see the relationship between the compass directions and degree headings.

The compass direction is determined using several `if` statements that match up a compass direction with a degree heading. In order to print the proper compass heading, we will be using a new type of variable called a *string*. You may recall that we have talked about floating point numbers, integers, and Booleans. Strings are one more type of variable, and they are used for text or letters. In this case, the variable `ch` will be a string, and it is

Figure 5.19 Compass directions and corresponding degree headings.

initialized at the beginning of the program as ch = "SOUTH". This lets *Jamagic* know that ch is a string. The code below will make this clearer:

```
If(degs > 22 && degs < 67)
  {
   ch = "NORTHEAST";
  }
If(degs > 67 && degs < 112)
  {
   ch = "EAST";
  }
If(degs > 112 && degs < 157)
  {
   ch = "SOUTHEAST";
  }
If(degs > 157 && degs < 202)
  {
   ch = "SOUTH";
  }
If(degs > 202 && degs < 247)
  {
   ch = "SOUTHWEST";
  }
If(degs > 247 && degs < 292)
  {
   ch = "WEST";
  }
```

```
If(degs > 292 && degs < 337)
  {
   ch = "NORTHWEST";
  }
If(degs > 337 && degs <= 360)
  {
   ch = "NORTH";
  }
If(degs >=0 && degs <= 22)
  {
   ch = "NORTH";
  }

// Print it to the screen.
mytext7.SetText("COMPASS: " + ch);
```

Notice that there are only eight directions. We could get a much finer resolution (NNE, SSW, and so on) using more `if` statements, but there is not much point to this since we will replace these written compass directions with a compass gauge that points in the proper direction in the next section.

Criteria for a Successful Landing

The object of this game is to land the aircraft properly, which means several things:

- The vertical speed must not be too great upon landing (we chose 30 miles per hour as the maximum allowable speed—it should probably be less than this, but the game becomes very difficult if the maximum allowable vertical speed is dropped much beyond this!)
- The airplane must have a heading between 268 degrees and 272 degrees (more or less parallel to the runways, in a westerly direction).
- The jet must land before the midpoint of the runway.

Care must be taken here in that the vertical speed when landing is negative (the plane is descending), so the criterion for allowable speed is that speed must be greater than –30.

Determining whether a proper landing happened occurs in the `docollision` function, called when there is any collision in the game. The aircraft touching down on the runway is a collision between the jet and the airport object. If the collision satisfies the above criteria, then the landing is deemed a successful one. If the above criteria are not met, a message

informs the pilot that he has failed to land properly. The variables xco and zco are the x and z coordinates of the aircraft. Here is the code:

```
Function docollision
{
// In order for landing to be successful several criteria
// must be met:
// Heading must be between 268 and 272 (must come in from the
// east).
// Vertical speed vert must be less than 30 miles per hour.
// Landing must be between x = -2310 and 1770.
// z must be between -6063 and -5241 (location of landing
// area).

   If(degs >= 268 && degs <=272)
    {
      If(vert>-30 && zco -6063&& xco <1770 &&
   xco> -2310)// one line
   {
      myjet.Stop();
      SetText("Landed correctly!");
      stopflag = TRUE;
   RETURN stopflag;
      }
     Else
       {
           stopflag = TRUE;
         myjet.Stop;
           SetText("Bad landing!");
         RETURN stopflag;
       }
   }
}
```

stopflag is used to make sure that the jet stops, and the RETURN statement ensures that the value of stopflag (TRUE or FALSE) makes it back to the main program. The jet will stop if stopflag is TRUE since the command that moves the jet forward in the game loop has an if statement that requires stopflag to be false.

```
If(stopflag == FALSE)
{
  myjet.Move(speed);
}
```

More on Execution Speed

There are a few things to remember when you run the program: you may need to adjust the factors that move the jet to compensate for your computer's speed, and you may find that your computer is too slow if the processor is below about 600 MHz. In this case, you can try making your own landing surface using the `CreatePlane` command instead of using the airport (it has lots of polygons), much like we did with Sphere9 in Chapter 4. This should allow slower computers to use this code.

Another strategy you can use to try to improve the speed of execution is to change your computer color setting to as low a value as possible. This is done by going to your Windows Control Panel, selecting Display, and then clicking Settings. You will see a small window that allows you to change the colors to higher or lower values. A laptop computer with a 1.2-GHz processor was used to develop this section, and we noticed that the game was running no faster than it was on a 600-MHz desktop computer; in fact, the 600-MHz computer seemed faster! We switched the laptop's color setting from 32-bit to 16-bit, which considerably increased its speed, with no noticeable change in color quality. The desktop computer had been set to 16-bit color from the start.

You are encouraged to experiment with this game and make improvements. You may find that the aircraft moves too rapidly to the sides for your tastes—the speed was selected partly to make the game easier to play and it is probably a little unrealistic in this sense. In addition, you can correct the bugs that occur if you bank the aircraft more than 90 degrees or climb at an angle greater than 90 degrees. Try it!

All in all, this is a very fun game to play, and it takes quite a bit of practice to land the jet properly.

FlightSimulator2 Code

```
// flightsimulator2
// Move aircraft in roll, pitch, and yaw
// Import airport and check for proper landing.
// Calculate heading, roll, pitch.
// Use cosine function to move jet as it rolls in a
// realistic fashion.
// Calculate vertical speed using sine function.
// Select between two views by clicking 'shift' or
// 'caps lock' keys.
// Use string variables for compass headings.
```

```
oWindow1 = New Window("Flight
Simulator2",640,480,Window.STANDARD);//one line

//Window maintenance
owindow1.SetAutoRefresh(OFF);

// New world
oworld = New World();

//Import jet.
oworld.Load("f16");
myjet= oworld.GetObject(oworld.GetNObjects()-1);
myjet.Scale(0.01);
myjet.SetPosition(0,150,2000);

// Airport
oworld.Load("airport");
mountain = oworld.GetObject(oworld.GetNObjects()-1);
mountain.Scale(0.05,0.05,0.05);
mountain.SetPosition(0,0,-4000);
mountain.SetStatic();

// New cameras
ocamera1 = New Camera(oworld,owindow1);
ocamera1.SetBackgroundColor(GetRGB(0,150,200));

// Camera

ocamera1.Follow(myjet,100);
oworld.Optimize(ocamera1);
ocamera1.SetFocus(30);

// Text boxes
mytext = New StaticText(owindow1," ",0,10,110,20);
mytext.SetBackColor(GetRGB(0,150,200));
mytext.SetColor(GetRGB(0,0,0));

mytext2 = New StaticText(owindow1," ",0,40,150,20);
mytext2.SetBackColor(GetRGB(0,150,200));
mytext2.SetColor(GetRGB(0,0,0));

mytext3 = New StaticText(owindow1," ",170,40,110,20);
mytext3.SetBackColor(GetRGB(0,150,200));
mytext3.SetColor(GetRGB(0,0,0));
```

```
mytext4 = New StaticText(owindow1," ",170,10,140,20);
mytext4.SetBackColor(GetRGB(0,150,200));
mytext4.SetColor(GetRGB(0,0,0));

mytext5 = New StaticText(owindow1," ",350,10,220,20);
mytext5.SetBackColor(GetRGB(0,150,200));
mytext5.SetColor(GetRGB(0,0,0));

mytext6 = New StaticText(owindow1," ",350,40,220,20);
mytext6.SetBackColor(GetRGB(0,150,200));
mytext6.SetColor(GetRGB(0,0,0));

mytext7 = New StaticText(owindow1," ",0,80,220,20);
mytext7.SetBackColor(GetRGB(0,150,200));
mytext7.SetColor(GetRGB(0,0,0));

//Set collision detection.
oworld.OnCollide = docollision;
myjet.SetCollision(TRUE,Object.COLLISION_TYPE_STOP);

// Initialize variables.
airspeed = 0.0;
alt = 0.0;
thetax = 0.0;
thetay = 0.0;
thetaz = 0.0;
degs = 0.0;
speed = 0.0;
addfactor = 0.0;
leftfactor = 0.0;
xpos = 0.;
ypos = 150.;
zpos = 0.0;
Pitch2 = 0.0;
roll2 = 0.0;
rolldegs = 0.0;
stopflag = FALSE;
vert = 0.0;
xco = 0.0;
zco = 0.0;
ch = "SOUTH";

//Game loop
While(1)
{
```

```
// Window cleaning
   ocamera1.ActivateRender();
   owindow1.Refresh();

//Set where to follow jet from.
If(Keyboard.IsKeyDown(Keyboard.SHIFT))
  {
ocamera1.Follow(myjet,10,10,10,0);
  }

// Jet controls
If(Keyboard.IsKeyDown(Keyboard.CAPSLOCK))
  {
    ocamera1.Follow(myjet,100);
  }
If(Keyboard.IsKeyDown(Keyboard.LEFT))
 {

   myjet.RollLeft(Pi/500.);
   thetaz = thetaz - (Pi/500.);
   If(thetaz< (-2*Pi))
     {
     thetaz = 0.0;
     }
 }

If(Keyboard.IsKeyDown(Keyboard.RIGHT))
 {

   myjet.RollRight(Pi/500.);
   thetaz = thetaz + (Pi/500.);
   If(thetaz>(2*Pi))
     {
     thetaz = 0.0;
 }

 }
If(Keyboard.IsKeyDown(Keyboard.UP))
 {
   myjet.TurnUp(Pi/3000.);
   thetax = thetax - (Pi/3000.);
```

```
    If(thetax<(−2*Pi))
      {
      thetax = 0.0;
      }
  }
If(Keyboard.IsKeyDown(Keyboard.DOWN))
 {
   myjet.TurnDown(Pi/3000.);
   thetax = thetax + (Pi/3000.);
   If(thetax>(2*Pi))
      {
      thetax = 0.0;
      }
   }

//Calculate airspeed based on pitch.

airspeed = 1000 − 1000*Sin(thetax);

// Move the aircraft as per the airspeed.
speed = airspeed/100.;
If(stopflag == FALSE)
{
   myjet.Move(speed);
}

//Instruments
mytext.SetText("Airspeed: "+ airspeed );
//calculate compass heading in degrees
degs = 360. − thetay * 360.0/(2.*Pi) ;
If (degs>360)
 {
    degs = degs − 360;
   }
mytext2.SetText("Compass heading: " + degs);

//Altitude
alt = myjet.GetY();
mytext3.SetText("Altitude: " + alt);

// Convert to degrees.
pitch = thetax * 360./(2.*Pi);

mytext4.SetText("Pitch: " + Pitch);
 //Calculate vertical speed.
```

```
vert = airspeed * Sin(Pitch *2*Pi/360);
mytext6.SetText("Vertical Speed: " + vert);

//Convert radians to degrees.
rolldegs = thetaz * 360./(2.*Pi);

//Send the roll angle to the screen.
mytext5.SetText("Roll: " + rolldegs);

//Move the jet to the side when jet rolls.
// Right roll first
If(thetaz >0.01)
    {
    leftfactor = 0.0004 * Cos(thetaz);

    myjet.MoveRight(leftfactor);
    addfactor = -Pi/1500. * Cos(thetaz);
    myjet.AddAngle(0,addfactor,0);
    thetay = thetay+addfactor;
    If(thetay>(2*Pi))
        {
         thetay = 0.0;
        }
    }
//
// Roll to left.
If(thetaz < -0.01)
    {
    leftfactor = 0.0004 * Cos(thetaz);
    myjet.MoveLeft(leftfactor);
    addfactor = Pi/1500. * Cos(thetaz);
    myjet.AddAngle(0,addfactor,0);
    thetay = thetay+addfactor;
    If(thetay < (-2*Pi))
      {
       thetay=0.0;
      }
    }
//

xco = myjet.GetX;
zco = myjet.GetZ;
yco = myjet.GetY;
```

```
If(degs > 22 && degs < 67)
  {
   ch = "NORTHEAST";
  }
If(degs > 67 && degs < 112)
  {
   ch = "EAST";
  }
If(degs > 112 && degs < 157)
  {
   ch = "SOUTHEAST";
  }
If(degs > 157 && degs < 202)
  {
   ch = "SOUTH";
  }
If(degs > 202 && degs < 247)
  {
   ch = "SOUTHWEST";
  }
If(degs > 247 && degs < 292)
  {
   ch = "WEST";
  }
If(degs > 292 && degs < 337)
  {
   ch = "NORTHWEST";
  }
If(degs > 337 && degs <= 360)
  {
   ch = "NORTH";
  }
If(degs >=0 && degs <= 22)
  {
   ch = "NORTH";
  }

// Compass heading in north, south, etc.
mytext7.SetText("COMPASS: " + ch);

// End of game loop
}
```

```
Function docollision
{
// In order for landing to be successful several
// criteria must be met:
// Heading must be between 268 and 272
//(must come in from the east).
// Vertical speed vert must be less than 30 miles per hour.
// Landing must be between x = -2310 and 1770.
// z must be between -6063 and -5241 (location of landing
//area).
      If(degs >= 268 && degs <=272)
        {
         If(vert>-30 && zco -6063&& xco <1770 &&
      xco> -2310)//one line
          {
          myjet.Stop();
          SetText("Landed correctly!");
          stopflag = TRUE;
          Return stopflag;
          }
         Else
         {
          stopflag = TRUE;
       myjet.Stop;
          SetText("Bad landing!");
          Return stopflag;
         }
        }
}
```

FlightSimulator3

In this section, we make the final version of the flight simulator game (see Figure 5.20), in which we add a gauge-type compass (which will replace the impractical strings that we used previously to tell us the compass heading), a rate-of-climb indicator, and a roll indicator. In addition, we will adjust the roll and yaw controls so that the motion is more realistic, and we will add a few sounds to the game.

The topics we will learn about include the following:

- Working with sprites
- Making analog instruments on the screen
- Antialiasing and transparent colors

Figure 5.20 The final flight simulator with analog type instruments. The compass heading in particular is useful in landing the jet properly.

Sprites and the Analog Instrument Panel

A *sprite* is a two-dimensional figure that you can display on your screen. You can make it move anywhere, change its angle, or just let it sit there. You've probably seen sprites on web pages; they may have taken the form of something like a cartoon that moves across the display to get your attention.

It's important to realize that a sprite is not an object in your 3D game world. Think of the sprite as living on your screen, but one that never moves into the third dimension of the screen. The location of the sprite does not change as the camera moves around and remains on your screen unless you give it a specific command to move. These characteristics explain why sprites are a great way to display instruments on the screen. If sprites were objects in the 3D world, they would need to follow the camera in order to remain visible—this is too complicated!

Each instrument is going to be made up of two separate images or sprites: a round gauge and a rod-like indicator that rotates on top of the gauge. The gauge is stationary, and the indicator rotates as speed or headings change. These items are shown in Figure 5.20; the compass gauge is in the upper left, composed of a round gauge and an indicator.

192 Elementary Game Programming and Simulators Using *Jamagic*

ON THE CD

The first thing we are going to do is make the stationary gauge used in the rate-of-climb and roll indicators using the *Jamagic* picture editor. (You do not need to make these sprites since they can be found on the CD-ROM, but it's great practice for you to try your hand at it. If you do import them from the CD-ROM, please see the following important Tip.) The gauge is a 100 x 100 image that consists of a circle filled in with a light gray color, called simply Gauge (see Figure 5.21). The entire sprite is made up of a rectangle with the filled-in circle inside the rectangle. It's important that you fill only the circle with color and not the rectangle around it; if you accidentally fill the rectangle, it will be visible on the screen. As long as the rectangle isn't mistakenly filled in, it will be invisible. This is because the white color of the rectangle is the *transparent* color for *Jamagic*—anything that particular shade of white is ignored by the program. A transparent color is necessary in order to make the drawing of figures easier.

Every picture in *Jamagic* has a hot spot. If you tell *Jamagic* to put the sprite at screen coordinates (120, 120), then the hot spot will be put at that location. Also, if you tell *Jamagic* to rotate the sprite, the sprite will rotate about the hot spot.

Figure 5.21 The gauge background sprite. Note that the rectangular area is left as the original white color, which is transparent to *Jamagic*. Also note the hot-spot location at the center of the gauge and the hot-spot icon beneath the text icon.

By default the hot spot is placed at the upper-left corner of the image. But in Figure 5.21, the hot spot has been moved to the center of the circle. You can recognize the hot spot because it appears as a small circle with an X at the center. By clicking the hot-spot icon located beneath the text icon, you can make the hot spot visible, and you can move it around with the mouse. If the hot-spot icon is not visible, you will have to drag the lower boundary of the picture editor down with your mouse, since the hot-spot icon is near the lower edge of the picture editor window.

If you import a sprite from another program or elsewhere, you have to remember that sometimes the hot spot shifts back to the upper-left corner when it finishes importing. This can cause problems if the sprite is supposed to rotate about its hot spot. If you notice some strange behavior from a sprite, particularly in rotation, check the location of its hot spot using the picture editor.

Now is probably a good time to start a new program called FlightSimulator3 and to experiment with making the sprite. Make sure that you move the hot spot to the center of the circle.

We need the indicator which rotates over the gauge, showing the speed or heading. This is done by making another picture with the *Jamagic* picture editor called `dial` (see Figure 5.22). It's important that the hot spot of

Figure 5.22 The indicator dial. Note that the hot spot is at the bottom.

the indicator is at the bottom of the dial because this is the point about which the indicator rotates.

Next we make the gauge for the compass, again putting the hot spot at the center of the gauge. We also use the text tool to write in the directions (see Figure 5.23).

Now that we have the graphics, we need the code to move the indicator over the gauge. Consider the following lines of code, which should be placed outside of the game loop and after the 3D world is created. These lines make a new sprite at location 580, 20 using the gauge picture we just made (Figure 5.23) scaled down by 0.5:

```
// Roll gauge
mygauge = New Sprite(580,20,"gauge");
mygauge.SetScale(0.5,0.5);
```

How did we know to put the gauge at (580, 20) and to scale it by one half? This was determined by a trial and error process. We took into account that the game will be using a resolution of 640 x 480 pixels in order to estimate the location of the gauge at (580, 20). This resolution gives us a rough idea of where to place the gauge, and trial and error is used for fine-tuning the location.

Figure 5.23 The compass gauge with compass directions in bold letters.

Next we put the indicator in, also at (580, 20). In the following code, the last line is unnecessary. It is there merely to illustrate that the sprite can be moved using the `Set` command:

```
//Roll pointer
mysprite = New Sprite(580,20,"dial");
mysprite.SetScale(0.25,0.25);
mysprite.Set(580,20);
```

We can rotate the gauge with the following command, which must go inside of the game loop (note that the previous statements are placed before the loop):

```
mysprite.SetAngle(roll2,FALSE);
```

This command tells *Jamagic* to rotate the sprite `roll2` degrees, which is the jet's angle of roll. It's interesting to note that this is just about the only function that takes degrees and not radians! The `FALSE` tells *Jamagic* not to use antialiasing with the sprite.

Any picture on a computer screen is made up of tiny rectangular dots called *pixels*. Unfortunately, these can sometimes look rough and jagged, something like a stairway seen from the side, so a technique known as *antialiasing* is used. Antialiasing makes the colors of the image edges blend in with the colors of the background, making the border between the two fuzzy. This makes the image look smoother because you do not see the jagged edges. If you look at most stationary larger images on your screen, you will be able to see this. Unfortunately antialiasing takes the computer more time to compute, so we disable it by putting `FALSE` in the parentheses in the code just listed. It makes little difference in this case.

We also wish to have a vertical speed (rate-of-climb) indicator. Typically, this consists of a gauge similar to the one we just made for roll, except that the indicator is horizontal. Ascents result in a counter-clockwise rotation (pitching up) of the indicator, while descents point the indicator down; this is easy for the pilot to understand with a quick glance. We can use the same gauge and indicator as before; we just need to rotate the indicator 90 degrees to make it horizontal:

```
//Vertical speed gauge
myvgauge = New Sprite(580,60,"gauge");
myvgauge.SetScale(0.5,0.5);
```

```
//Vertical speed pointer
myvsprite = New Sprite(580,60,"dial");
myvsprite.SetScale(0.25,0.25);
myvsprite.SetAngle(90,FALSE);
```

For the case of the roll angle, it was very easy to relate the roll angle to the angle on the indicator. Things are not so simple for the rate-of-climb, however. This is because we have to make the indicator turn further as the vertical speed increases. We can do this by setting a proportion. For example, we can say that one revolution of the indicator (360 degrees) will correspond to 100 miles per hour, so if the vertical speed is 50 miles per hour down, then the indicator should turn half a revolution (180 degrees) down. If the vertical speed is 25 miles per hour down, the indicator would turn one-quarter revolution down, and so forth—the greater the speed, the greater the amount of revolution of the indicator.

We can make a mathematical expression to express this proportion between rotation and vertical speed, by saying 100 miles per hour is to 360 degrees as vertical speed is to indicator angle:

(100) / (360) = (vertical speed) / (indicator degrees rotation).

Solving the above for the degrees of rotation gives us

indicator degrees of rotation = current vertical speed * 360/100.

The code for setting the angle of rotation x of the indicator is then

```
x = -1* vert*360/1000 + 90.;
myvsprite.SetAngle(x,FALSE);
```

The compass gauge uses a different sprite for the background since we are making it black, but it uses the same indicator as in the previous gauges:

```
//Compass gauge
mycgauge = New Sprite(180,60,"compass");
mycgauge.SetScale(0.5,0.5);

//Compass pointer
mycsprite = New Sprite(180,60,"dial");
mycsprite.SetScale(0.25,0.25);
mycsprite.Set(180,60);
```

We can easily set the compass sprite angle using the `degs` value calculated earlier, which is the heading of the jet in degrees:

```
mycsprite.SetAngle(degs,FALSE);
```

We could also make gauges for the airspeed and the pitch, but nothing new would be learned from the effort, and they do not make the game any easier to play. The vertical speed gauge and compass gauges, on the other hand, will be quite useful in helping you land the jet properly.

We will also add two sounds, which you must import into Sounds before you run your program. The first is a voice that will say, "I like it!" if a successful landing is made, while the other is an obnoxious laugh that will be played if an unsuccessful landing is made. These sounds can be found on the *Jamagic* full-capability CD-ROM, and on the `FlightSimulator3` simulator program.

```
victor = New Sound("Ilikeit");
loser = New Sound("Laugh08");
```

We now present the full code. Bear in mind that the digital instrument displays have been moved around, the turning rates have been changed from the previous game, and the text compass readings have been eliminated. In addition, sounds have been installed to congratulate the pilot for a proper landing, and to berate him for a poor one.

FlightSimulator3 Code

```
// Will add:
// analog instruments using sprites,
// "or" statement

owindow1 = New Window("Flight
Simulator3",640,480,Window.STANDARD);//one line

//Window maintenance
owindow1.SetAutoRefresh(OFF);

// Sounds

victor = New Sound("Ilikeit");
loser = New Sound("Laugh08");
```

```
// New world
oworld = New World();

//Import jet.
oworld.Load("f16");
myjet= oworld.GetObject(oworld.GetNObjects()-1);
myjet.Scale(0.01);
myjet.SetPosition(0,150,2000);

// Airport
oworld.Load("airport");
mountain = oworld.GetObject(oworld.GetNObjects()-1);
mountain.Scale(0.05,0.05,0.05);
mountain.SetPosition(0,0,-4000);
mountain.SetStatic();

// New cameras
ocamera1 = New Camera(oworld,owindow1);
ocamera1.SetBackgroundColor(GetRGB(0,150,200));

// Camera

ocamera1.Follow(myjet,100);
oworld.Optimize(ocamera1);
//ocamera1.SetFocus(30);

// Text boxes
mytext = New StaticText(owindow1," ",0,10,110,20);
mytext.SetBackColor(GetRGB(0,150,200));
mytext.SetColor(GetRGB(0,0,0));

mytext2 = New StaticText(owindow1," ",0,50,140,20);
mytext2.SetBackColor(GetRGB(0,150,200));
mytext2.SetColor(GetRGB(0,0,0));

mytext3 = New StaticText(owindow1," ",300,50,110,20);
mytext3.SetBackColor(GetRGB(0,150,200));
mytext3.SetColor(GetRGB(0,0,0));

mytext4 = New StaticText(owindow1," ",300,10,110,20);
mytext4.SetBackColor(GetRGB(0,150,200));
mytext4.SetColor(GetRGB(0,0,0));
```

```
mytext5 = New StaticText(owindow1," ",430,10,70,20);
mytext5.SetBackColor(GetRGB(0,150,200));
mytext5.SetColor(GetRGB(0,0,0));

mytext6 = New StaticText(owindow1," ",430,50,130,20);
mytext6.SetBackColor(GetRGB(0,150,200));
mytext6.SetColor(GetRGB(0,0,0));

//Set collision detection.
oworld.OnCollide = docollision;
myjet.SetCollision(TRUE,Object.COLLISION_TYPE_STOP);

// Initialize variables.
airspeed = 0.0;
alt = 0.0;
thetax = 0.0;
thetay = 0.0;
thetaz = 0.0;
degs = 0.0;
speed = 0.0;
addfactor = 0.0;
leftfactor = 0.0;
xpos = 0.;
ypos = 150.;
zpos = 0.0;
Pitch2 = 0.0;
roll2 = 0.0;
rolldegs = 0.0;
stopflag = FALSE;
vert = 0.0;
xco = 0.0;
zco = 0.0;
icount = 0;

//Roll gauge
mygauge = New Sprite(580,20,"gauge");
mygauge.SetScale(0.5,0.5);

//Roll pointer
mysprite = New Sprite(100,100,"dial");
mysprite.SetScale(0.25,0.25);
mysprite.Set(580,20);
```

```
//Vertical speed gauge
myvgauge = New Sprite(580,60,"gauge");
myvgauge.SetScale(0.5,0.5);

//Vertical speed pointer
myvsprite = New Sprite(100,100,"dial");
myvsprite.SetScale(0.25,0.25);
//The following one is in degrees,
//the true refers to antialiasing
myvsprite.SetAngle(90,FALSE);
myvsprite.Set(580,60);

//Compass gauge
mycgauge = New Sprite(180,60,"compass");
mycgauge.SetScale(0.5,0.5);

//Compass pointer
mycsprite = New Sprite(180,60,"dial");
mycsprite.SetScale(0.25,0.25);
//myvsprite.SetTransparent(ON);
//The following one is in degrees, the true
//refers to antialiasing
mycsprite.Set(180,60);

//Game loop
While(1)
{

// Window cleaning
    ocamera1.ActivateRender();
    owindow1.Refresh();

//Set where to follow jet from.
If(Keyboard.IsKeyDown(Keyboard.SHIFT))
  {
ocamera1.Follow(myjet,10,10,10,0);
  }

// Jet controls
If(Keyboard.IsKeyDown(Keyboard.CAPSLOCK))
  {
    ocamera1.Follow(myjet,100);
  }
```

```
If(Keyboard.IsKeyDown(Keyboard.LEFT))
 {

   myjet.RollLeft(Pi/500.);
   thetaz = thetaz - (Pi/500.);
   If(thetaz< (-2*Pi))
      {
      thetaz = 0.0;
      }
 }

If(Keyboard.IsKeyDown(Keyboard.RIGHT))
 {

   myjet.RollRight(Pi/500.);
   thetaz = thetaz + (Pi/500.);
   If(thetaz>(2*Pi))
      {
      thetaz = 0.0;
      }

 }

If(Keyboard.IsKeyDown(Keyboard.UP))
 {
   myjet.TurnUp(Pi/3000.);
   thetax = thetax - (Pi/3000.);
   If(thetax<(-2*Pi))
      {
      thetax = 0.0;
      }
   }
If(Keyboard.IsKeyDown(Keyboard.DOWN))
 {
   myjet.TurnDown(Pi/3000.);
   thetax = thetax + (Pi/3000.);
   If(thetax>(2*Pi))
      {
      thetax = 0.0;
      }
   }

//Calculate airspeed based on pitch.
airspeed = 1000 - 1000*Sin(thetax);
```

```
// Move the aircraft as per the airspeed.
speed = airspeed/100.;
If(stopflag == FALSE)
{
  myjet.Move(speed);
}

//Instruments
mytext.SetText("Airspeed: "+ airspeed );
//Calculate compass heading in degrees.
degs = 360. - thetay * 360.0/(2.*Pi) ;
If (degs>360)
 {
    degs = degs - 360;
  }
mytext2.SetText("Compass heading: " + degs);

//Altitude
alt = myjet.GetY();
mytext3.SetText("Altitude: " + alt);

// Convert to degrees.
pitch = thetax * 360./(2.*Pi);

mytext4.SetText("Pitch: " + Pitch);
 //Calculate vertical speed.

vert = airspeed * Sin(Pitch *2*Pi/360);
mytext6.SetText("Vertical Speed: " + vert);

//Convert radians to degrees.
rolldegs = thetaz * 360./(2.*Pi);

//Send the roll angle to the screen.
mytext5.SetText("Roll: " + rolldegs);

//Move the jet to the side when jet rolls.
// Right roll first
If(thetaz >0.01)
    {
    leftfactor = 0.0004 * Cos(thetaz);

    myjet.MoveRight(leftfactor);
    addfactor = -Pi/1500. * Cos(thetaz);
```

```
      myjet.AddAngle(0,addfactor,0);
        thetay = thetay+addfactor;
        If(thetay>(2*Pi))
           {
           thetay = 0.0;
           }
        }
//
// Roll to left.
If(thetaz < −0.01)
      {
      leftfactor = 0.0004 * Cos(thetaz);
      myjet.MoveLeft(leftfactor);
      addfactor = Pi/1500. * Cos(thetaz);
      myjet.AddAngle(0,addfactor,0);
      thetay = thetay+addfactor;
      If(thetay < (−2*Pi))
       {
         thetay=0.0;
       }
      }
//

xco = myjet.GetX;
zco = myjet.GetZ;
yco = myjet.GetY;

//Analog instruments
mysprite.SetAngle(roll2,FALSE);

//Vertical speed— need to relate degrees to speed
//vert/100 = x/360 (each revolution of the pointer
// will be 100 miles per hour)
x = −1* vert*360/1000 + 90.;
myvsprite.SetAngle(x,FALSE);

  //Compass
mycsprite.SetAngle(degs,FALSE);

// End of game loop
}

Function docollision
{
```

```
// In order for landing to be successful,
// several criteria must be met:
// Heading must be between 268 and 272
// (must come in from the east).
// Vertical speed vert must be less than 30 miles per
//hour.
// Landing must be between x = —2310 and 1770.
// z must be between —6063 and —5241
//(location of landing area).

      If(degs >= 268 && degs <=272)
        {
         If(vert>—30 && zco < —5241 && zco >—6063&&
                xco <1770 &&//one line
     xco> —2310)//one line
         {

         SetText("Landed correctly!");
          victor.Play();
         myjet.Stop();
         stopflag = TRUE;
         Return stopflag;
         }
        }
       Else
        {

         SetText("Bad Landing!");
         loser.Play();
         myjet.Stop;
          stopflag = TRUE;
         Return stopflag;

        }

    }
```

CHAPTER 6

SHIP SIMULATORS

ON THE CD

In this program, we will import an excellent 3D image of a destroyer from the book's CD-ROM and make it move in a realistic way through the water. In addition, we will learn how to display an instrument panel with pertinent information, as shown in Figure 6.1.

BASICS OF SHIP CONTROLS

Large ships have a host of controls that allow them to maneuver properly. One of the most important controls are the bow thrusters, which are propellers situated near the front (bow) of the ship; these are used to move the bow sideways. The bow thruster propellers are at right angles to the propellers that move the ship ahead, and they are usually electrically driven from a generator that runs off of the main engines—usually big diesel engines.

The bow thrusters maneuver the ship while it is not in motion or is moving very slowly; they are great for making docking maneuvers easier. Many larger ships also have stern thrusters (the stern is the back end of the ship) for even greater maneuverability. When used together, the bow thrusters and the stern thrusters allow the ship to move completely sideways. Our model will include only bow thrusters for the sake of simplicity.

Figure 6.1 Ship Simulator screenshot.

Thrusters are controlled from the ship's bridge (the control cabin of the ship) and are usually activated by moving a handle to the right or to the left, depending on the direction the captain wants the ship to move. We will have a similar control on our bridge console; ours will be displayed as a sprite on the screen.

Bow thrusters are not effective once the ship picks up speed because they are not very powerful. Once the ship gets moving just a few knots (one knot is one nautical mile per hour, or about 6000 feet per hour), the forces required to make the ship turn increase dramatically. Bow thrusters cannot effectively overcome this resistance.

Once the ship is in motion, its direction is controlled by moving the rudder, which is located at the stern. The rudder is relatively small compared to the size of the ship, but the force exerted by the rudder becomes greater and greater as the ship's speed increases. The rudder is usually not very effective for turning at very slow speeds because there is not enough water rushing over it to create any substantial force.

The rudder is controlled from the bridge by turning the ship's wheel (a big steering wheel). This is how our rudder control will be displayed as well. The more the wheel is turned, the greater the rate of the turn. Incidentally, the ship's captain usually does not steer the ship—this is a job reserved for the helmsman, who merely responds to what the captain says. The captain may command something like "Right 15 degrees rudder," and the helmsman is to answer back as he initiates the turn "Right 15 degrees rudder aye," which is a very salty-sounding language. The 15 degrees refer to the angle of the rudder, measured from an imaginary line running lengthwise through the center of the ship.

Applying right rudder moves the back of the rudder to the right (if seen from above, the rudder would rotate counter-clockwise), causing a force on the rudder that pushes the stern to the left, which turns the bow to the right. Think of the rudder as a wing immersed vertically in the water—when you angle it slightly to the water flow, it generates a lift force that makes the stern move. The rudder is typically not moved by cables connected to the ship's wheel; this would require the helmsman to be a world-class body-builder since huge forces are required to move the rudder once the ship gets moving. Instead, the rudder is moved by a hydraulic steering system assisted by electric motors.

If the ship is moving backward and the rudder is moved right, the opposite happens. The force on the rudder/stern is then to the right, causing the bow to turn to the left. Confusing? Believe it or not, it's similar to what happens in a car. If you are moving forward and you turn the wheel right,

the front of the car goes right. If you are moving backward and you turn the wheel to the right, the front of the car goes left!

The speed of the engine is used to control the ship's speed, much as it does in an automobile. The more the throttle handle on the bridge is pushed forward, the faster the engine turns; the more the handle is pulled back, the slower the engine turns. Pulling back on the handle beyond a certain point causes the engine to turn in reverse, which eventually causes the ship to move backward. As with the rudder, the captain usually does not control the throttle on big ships. Instead, the captain barks commands like "All ahead full" or "All ahead slow" and the action is executed for him. Captains are usually stern (and we do not mean the rear of the ship!).

The engine turns the propellers via a transmission, which can be directly connected to the engine. In some cases, the engine turns an electric generator, which then drives an electric motor, which then drives the propeller. The advantage of this system is that with it, naval architects (ship designers) have more freedom as to where they place the engines and they don't have to worry about long and complicated transmission systems.

Nothing (except collisions) happens very quickly on a ship. When the throttle is pushed forward, the ship responds slowly due to its huge mass and the resistance of the water. In the same way, if the throttle is pulled back, the ship takes a while to come to a stop. This tendency to remain at rest or in motion is called *inertia*, and we must account for it. Our ship cannot turn or change speed immediately; if we set up our simulation so that it did, it might make the ship much easier to control, but it would also make the simulation unrealistic.

Our game will meet the following requirements:

- The view of the ship will be from the outside and the entire ship will be visible. The camera will follow the ship as it moves.
- The ship's bridge console with controls and instruments will be visible in an unobtrusive location on the screen.
- Controls will include a bow thruster, a rudder, and a throttle.
- The display will show the ship's wheel turning, the bow thruster's setting, the throttle setting, the speed in knots, and the water depth (this will be inoperative for this simulation).
- The ship will respond to all controls in a realistic fashion; in other words, it will obey the laws of inertia.
- The ship will have a maximum speed of 30 knots forward, and 20 knots astern.

BASIC SHIP SIMULATOR PROGRAM: SHIP SIMULATOR

ON THE CD

To get started, we first import the ship (called `Bismark`, from the *Jamagic* full-capability CD-ROM under ships, or from under the 3D category if you are using the *Jamagic* version that came with this book) and then scale it down so that its length corresponds to about 400 units on the screen. Since ships of this type are about 400 feet long, we will then have a very convenient way to measure speed later.

```
oworld.Load("bismark");
myship= oworld.GetObject(oworld.GetNObjects()-1);
myship.Scale(0.008);
myship.SetPosition(0,0,0);
myship.TurnRight(Pi/2);
```

How did we know a scaling factor of 0.008 would result in the ship measuring 400 screen units? By trial and error, of course! To figure this out, a small program was written to move the ship 400 units, using the command `myship.move(400)`. If it looked like the ship moved more than a ship's length, the scale of the ship was increased and the experiment was repeated. The scaling factor was adjusted repeatedly until the motion with 400 units corresponded to about one ship length.

After we have the ship scaled properly, we create the sea surface. This is done by creating a large plane that measures 10000 × 10000 and texturing it using the "water" picture (Program Files/Jamagic/Help/Tutorials/Simple/Final Project/Pictures). We tile this picture 20 times in each direction on the plane, and then we set it in motion to give the illusion of moving water using the `AnimUV` command:

```
myplane = oworld.CreatePlane(10000,10000);
myplane.SetPosition(0,0,0);
otexture = New Texture(oworld,"water");
matplane = New Material(oworld,otexture);
matplane.SetMapped(ON);
myplane.SetGouraud(ON);
myplane.ReplaceMaterial(matplane);
otexture.SetTiling(20,20);
//
//Move the texture to give the illusion of moving
// water.
matplane.AnimUV(0,-0.00025);
//
```

```
//Make it static to reduce the burden on computer,
// and rotate it 90 degrees so it's down.
myplane.SetStatic();
myplane.SetAngle(-Pi/2.,0,0);
```

Next we install a camera and give the screen a light blue background to give the illusion of sky.

```
ocamera1 = New Camera(oworld,owindow1);
ocamera1.SetBackgroundColor(GetRGB(0,150,200));
oworld.Optimize(ocamera1);
```

We then set the Autorefresh mode to Off to allow for more frequent screen updates than the default setting of every 0.02 seconds if it's left On:

```
owindow1.SetAutoRefresh(OFF);
```

Next we bring the sprites in for the instrument panel. `panel` is the instrument panel with no moving components; `wheel` is the ship's steering wheel, which will rotate as the rudder buttons are clicked; `hindic` and `vindic` are the two handles that will be used for the throttle and bow thruster controls—these handles will move as the control buttons activating throttle and bow thrusters are clicked; and `thruster` is the bow thruster background, which does not move (it should have been part of `panel`, but it was added after `panel` had already been drawn). These should be in the CD-ROM accompanying this book, and they were made using the *Jamagic* picture editor. Alternately, you can find them in the `ShipSimulator` game on the book's CD-ROM. The code below shows how to import the sprites:

```
//Instruments
mypanel = New Sprite(0,350,"panel");
mypanel.SetScale(0.75,0.75);

mywheel = New Sprite(50,400,"wheel");
mywheel.SetScale(0.75,0.75);

indich = New Sprite(180,380,"hindic");
indich.SetScale(0.35,0.5);

thruster = New Sprite(155,385,"thruster");
thruster.SetScale(0.60,0.60);
thruster.SetAngle(90,FALSE);
```

```
vindic = New Sprite(108,400,"vindic");
vindic.SetScale(0.4,0.2);
```

You will find that making decent graphics is probably the most time-consuming and difficult task in making a game. A great deal of time was used making and positioning the relatively simple graphics for this ship simulator instrument panel. How did we know, for example, to put the `vindic` sprite on the screen at (108, 400)? You have probably guessed by now that it was trial and error: A bit to the right, run the program to check it, a bit more to the left, a bit up... you get the picture. After a while it can get very tedious.

All of these images were made with the hot spot at the default location (upper-left corner), but sometimes the hot spot changes when you are importing files, especially if you changed the default location. If you get very strange locations on some of the panel components, either check the hot spot using the *Jamagic* picture editor or fiddle with the location of the sprites until everything lines up properly.

The ship is moved on the screen using the `Move` command, which moves an object in the direction it's pointing. You will recall that the first parameter inside the parentheses indicates the distance to be moved, while the second parameter, if present, indicates the time in seconds over which the motion is to take place. If the time parameter is omitted, the motion is immediate.

```
myship.Move(movefac);
```

This command is inside the game loop, so it is continually being performed. You may say that `movefac` is not a number; however, it represents a number that is given a value in the function `speedup`, which is activated whenever a button labeled Forward is clicked, as shown here:

```
Function speedup
 {
  If(knots<30)
  {
   movefac = movefac + 0.01;
  }
 }
```

In other words, whenever the Forward button is clicked, the value of `movefac` is increased by 0.01, which causes the ship to speed up. The speed

is increased by 0.01 only if the speed is below 30 knots, which is the speed we are specifying as the maximum for this ship.

The speed of the ship increases slowly when the Forward button is clicked because 0.01 is a relatively small value (at least it is for the computer used to create this program, with a 1-GHz processor). Your computer may require a little tweaking of the 0.01 value to make the ship have a realistic acceleration. In this way, even clicking the Forward button as quickly as possible results in an acceleration that looks right.

To make the ship slow down and eventually move in reverse, the function `speeddown` is called whenever the Back button is clicked. In this case, 0.01 is subtracted from `movefac` with every click of the Back button. Please note that the function does not allow `movefac` to get smaller than −0.6, which corresponds to our maximum of 20 knots in reverse (that `movefac` of −0.6 corresponds to 20 knots was determined by sending the value of `movefac` to the screen while this program was being developed):

```
Function speeddown
  {
    movefac = movefac − 0.01;
    If(movefac< −0.6)
      {
   movefac = −0.6;
      }
  }
```

In order to calculate the speed of the ship, we must be first be able to find the distance between two points. We can do this by using the Pythagorean theorem covered earlier. We measure the difference between the x coordinates (`deltax`) of the two points and the difference between their z coordinates (`deltaz`). Incidentally, "delta" is another Greek letter that is used frequently in mathematics. Typically it is used to denote a change or difference—hence "deltax" is a good way to express the difference between the two x coordinates. We can then use the Pythagorean formula

distance between two points = `Sqrt(deltax* deltax + deltaz* deltaz)`,

where `Sqrt` is the square root of the quantity inside the parentheses. Note that because the ship's altitude is not changing we have no need to worry about any `deltay` changes.

The speed of the ship is calculated by measuring the distance covered by the ship in one second. The code below for finding the ship's speed is placed inside the game loop, so the speed is being calculated every second. At the beginning of the program, before the code below and the game loop are reached, an initial time `time1` is remembered by the computer using a command that says `time1 = System.GetElapsedTime`. When the code for finding the speed is reached, `time2` is found, and if more than 1000 milliseconds (one second) have elapsed since `time1` was noted, the speed is calculated. Otherwise the speed calculation loop is skipped until the elapsed time is at least 1000 milliseconds.

The distance covered by the ship is calculated by first finding the x and z coordinates of the ship at the beginning of the program and before the game loop is reached. These coordinates are called `xpos1` and `zpos1`. After one second has elapsed, the x and z coordinates are found by using the `myship.GetX` and `myship.GetX` commands. It's then possible to find the distance covered in one second using the formula given earlier for the distance between two points.

You probably remembered how carefully we scaled the ship at the beginning of the program so that one screen unit was about one foot. As a result, we also know that if the distance covered by the ship is 400 screen units in 40 seconds, the ship has moved 400 feet in 40 seconds, or 10 feet every second. We know that there are about 6000 feet per nautical mile and 3600 seconds per hour, so we can convert easily from feet per second to nautical miles per hour (knots) by multiplying the feet per second by 3600/6000, or 36/60.

The following code gives the full procedure for calculating the ship's speed. Also note that the values of `xpos1`, `time1`, and `zpos1` are recalculated at the end of the speed-determining loop.

```
time2 = System.GetElapsedTime;
dift = Abs(time2 - time1);
// Loop for finding the speed
 If (dift > 1000)
    {
      xdif = myship.GetX - xpos1;
      zdif = myship.GetZ - zpos1;
      dist = Sqrt(xdif * xdif + zdif*zdif);
        speedfps = dist;
        knots = speedfps * 36./60.;
        time1 = System.GetElapsedTime;
        mytext2.SetText("Knots: " + knots);
        xpos1 = myship.GetX;
     zpos1 = myship.GetZ;
    }
```

The ship is turned right or left by the following command inside the game loop:

```
myship.TurnRight(turnfac);
```

`turnfac` is similar to `movefac` except that it is used to turn the ship rather than move it forward or backward. Positive values turn the ship right and negative values make it turn left. `movefac` is initialized to zero at the beginning of the program, and it changes whenever the program user clicks buttons marked Left Rudder or Right Rudder. Clicking Right Rudder calls function `rightrudder` in the code below, with each mouse click increasing `turnfac` by 0.0001. Again, through trial and error, this value makes the turning rate feel satisfactory within the limits dictated by inertia.

The rudder angle cannot go beyond a certain value, or else the ship will spin about its y-axis faster than a clock's second hand. For this reason, the value of `rudderangle`, which is used to calculate `turnfac`, is limited to 0.001 (determined by trial and error as an acceptable value).

And now we must explain something that will seem a little complicated at first. Recall that if the ship is moving slowly, it should be doing very little turning (it's really the rotation of the ship about its center that we are controlling with the `TurnRight` command); indeed, there must be no rotation at all if the rudder is activated when the ship is standing still, since forward motion is required for the rudders to work. Likewise, the faster the ship is moving forward, the greater the rotation rate of the ship. In other words, the rate of rotation of the ship depends on *both* the rudder angle and the speed of the ship. In mathematics-speak, we say that the rate of rotation is a *function* of both the ship's speed and rudder angle—now that you can speak like a mathematician, go and impress your friends!

So, we need some type of equation that allows the ship to rotate more (the equation should make a bigger value of `turnfac` in the `TurnRight` command mentioned earlier) when the rudder angle is bigger *and* when the ship is moving faster. The easiest type of equation to try first is an equation with powers of one in the variables `rudderangle` and `knots`:

$$\text{turnfac} = \text{rudderangle} * \text{knots} * K,$$

where K is some number that we need to figure out by trial and error. If we experiment with this equation by trying different values of K, and we find that we get realistic-looking turns at all different rudder angles, then we have been successful. If we fail, as evidenced by unrealistic behavior of the ship, then we must look at other more complicated forms of equations (like

the type with powers greater than one, those with the form turnfac = rudderangle* rudderangle * knots * knots * K). Fortunately for us, the linear form with K = 0.1 seems to give satisfactory results. Here is the resulting equation:

$$\text{turnfac} = \text{rudderangle} * \text{knots} * 0.1$$

By simply looking at it, you can probably see that this equation has many of our requirements. For example, if the ship's speed is zero (knots = 0), then turnfac must be zero, and there will be no rotation. If the rudder angle is zero, then turnfac must again be zero, also resulting in no rotation. And finally, as rudderangel or knots increase or decrease, so must turnfac.

One of the last jobs to be performed is associated with the rudders—moving the steering wheel sprite as the rudder angle changes. By experimentation, we know that the maximum value of rudderangle had to be 0.001 radians. We want this to correspond to a "reasonable" amount of real-world rudder angle and a "reasonable" amount of turning on the ship's wheel. In other words, when rudderangle is a maximum of 0.001 radians, the ship's wheel must have turned through about 60 degrees, and the rudder must have moved through about 30 degrees.

The last nasty piece of business to take care of, in as far as rudders go, is that they must turn the ship in an opposite direction when moving backward than they do when they are going forward. This is remedied very easily by multiplying by −1, which gives the opposite sign of the original number. So if movefac is less than zero, (indicating that the ship is moving backward) then the value of turnfac is changed from a positive to negative.

Check out this code. There is a lot to think about...

```
Function rightrudder
  {
    rudderangle = rudderangle + 0.00010;
    If (rudderangle>0.001)
     {
        rudderangle = 0.001;
      }
    turnfac = rudderangle* knots/10.;
    //.001 corresponds to 30 degrees of rudder, so
    // the conversion
    // factor is 30,000
    rudderconvert = rudderangle* 30000;
```

```
    If(movefac<0)
     {
         turnfac = turnfac*-1;
       }
     // We want the wheel to move about twice
     // as much as the
     //rudder so the helmsman has
     // a good feel for the wheel
        mywheel.SetAngle(rudderconvert*2.0,FALSE);
 }
```

The code for turning left is very similar, but the signs are different:

```
 Function leftrudder
 {
   rudderangle = rudderangle - 0.00010;
   If (rudderangle<-0.001)
     {
         rudderangle = -0.001;
       }
   turnfac = rudderangle* knots/10.;
   rudderconvert = rudderangle* 30000;
   If(movefac<0)
{
         turnfac = turnfac*-1;
       }

     mywheel.SetAngle(rudderconvert*2.0,FALSE);
 }
```

Figure 6.2 The instrument panel. The throttle indicator is at the right and the bow thruster indicator is near the center.

On the instrument panel (Figure 6.2), we also wish to indicate how much throttle is being applied and how much the bow thrusters are being used. As mentioned earlier, on a real ship, the throttle is a handle that is pushed forward or back, so we will move the sprite called `hsprite` back and forth as the Forward or Back buttons are clicked. In a real ship, the bow thruster is a handle that is moved to the left or right, so we will move `vsprite` back and forth as the bow thruster L or R buttons are clicked.

The more the Forward or Back buttons are pushed, the more the indicators have to move, so we need an equation that moves the indicators accordingly. By experimenting with the command that positions the throttle indicator `indich` on the screen, we know that `indich` must be at position (180, 380) when Forward or Back have not been clicked (in other words, when the throttle is at neutral). We also know from trial and error that we want the indicator `indich` to move up a maximum of 20 screen units, corresponding to the maximum speed of the boat and `movefac` = 1.2 (recall that moving up on the screen means a decreasing y coordinate).

The following code moves `indich` up or down depending on the value of `movefac`, starting at (180,380) when `movefac` is zero, decreasing linearly to (180,360) when `movefac` is 1.2, and increasing linearly to (180,400) when `movefac` is –1.2:

```
hpos = 380 - (movefac/1.2)*20;
indich.Set(180,hpos);
```

The code for moving the bow thruster indicator is very similar, except that the indicator is moved right or left instead of up or down. The indicator `vindic` is set to (108,400) when the thrusters are not on, and it moves 20 pixels right or left at the maximum bow thruster setting. The maximum bow thruster setting is 0.0008:

```
vpos = 108 + (thrustfac/0.0008)*20;
vindic.Set(vpos,400);
```

ON THE CD

OK, you are ready to create a new program in *Jamagic*. Just type in the code on the next page. Don't forget to import the `panel`, `indich`, `vindic`, `thruster`, `wheel`, and `water` pictures from the CD-ROM. Experiment with moving the ship around the screen using the different commands, and make sure you understand the instruments—you will need these skills for the next project!

Basic Ship Simulator Code: ShipSimulator

```
//Ship simulator program.
//This will include the following:
// Sprite of ship's console
// Clickable controls on the console: click wheel to right
//and it turns, turning ship,
// click thrusters and they move, moving the ship. Click the
//throttle and it moves.
// Right and left bow thrusters
// Ship experiences inertia
// Controls show, water depth, speed,
// throttle setting, thruster
//setting
// Data for write-up. Ship is scaled so 400
// pixels = 400
//feet, ship assumed 400 feet long
// All ahead speed = 30 knots
//

owindow1 = New Window("Ship
// Simulator",640,480,Window.STANDARD);

//Window maintenance
owindow1.SetAutoRefresh(OFF);

oworld = New World();

//Import ship.
oworld.Load("bismark");
myship= oworld.GetObject(oworld.GetNObjects()-1);
myship.Scale(0.008);
myship.SetPosition(0,0,-2300);
myship.TurnRight(Pi/2);
myship.SetGouraud(ON);

//Put in sea surface.
myplane = oworld.CreatePlane(10000,10000);
myplane.SetPosition(0,0,0);
otexture = New Texture(oworld,"water");
matplane = New Material(oworld,otexture);
matplane.SetMapped(ON);
myplane.SetGouraud(ON);
myplane.ReplaceMaterial(matplane);
otexture.SetTiling(20,20);
```

```
//Move the texture for illusion of moving water.
matplane.AnimUV(0,-0.00025);

//Other plane stuff
myplane.SetStatic();
myplane.SetAngle(-Pi/2.,0,0);

//Cameras
ocamera1 = New Camera(oworld,owindow1);
ocamera1.SetBackgroundColor(GetRGB(0,150,200));
ocamera1.SetPosition(0,200,-1000);
ocamera1.TurnRight(Pi);
ocamera1.Walk();
oworld.Optimize(ocamera1);

//Initialize
tf = 0.0;
//neg = 1.0;
//time = 0.0;
speed = 0.0;
movefac = 0.;
turnfac = 0.0;
knots = 0.0;
rudderangle = 0.0;
depth = 100;
thrustfac = 0.0;

//Buttons for ship control
mybutton1 = New Button(owindow1,"Forward",160,355,55,15);
mybutton1.OnClick = speedup;

mybutton2 = New Button(owindow1,"Back",160,440,55,15);
mybutton2.OnClick = speeddown;

mybutton3 = New Button(owindow1,"Right",55,440,40,15);
mybutton3.OnClick = rightrudder;

mybutton4 = New Button(owindow1,"Left",10,440,40,15);
mybutton4.OnClick = leftrudder;

mybutton5 = New Button(owindow1,"L",100,425,15,15);
mybutton5.OnClick = leftthruster;

mybutton6 = New Button(owindow1,"R",135,425,15,15);
mybutton6.OnClick = rightthruster;
```

```
// Text boxes
mytext1 = New StaticText(owindow1,"Bow
Thruster",90,370,65,15);//one line
mytext1.SetBackColor(GetRGB(0,0,0));
mytext1.SetColor(GetRGB(255,255,255));

mytext2 = New StaticText(owindow1," ",15,350,75,15);
mytext2.SetBackColor(GetRGB(0,0,0));
mytext2.SetColor(GetRGB(255,255,255));

mytext3 = New StaticText(owindow1,"Depth: ",90,350,65,15);
mytext3.SetBackColor(GetRGB(0,105,50));
mytext3.SetColor(GetRGB(255,255,255));

ocamera1.ActivateRender();
//time1 = System.GetElapsedTime;

time1 = System.GetElapsedTime;
xpos1 = myship.GetX;
zpos1 = myship.GetZ;

//instruments
mypanel = New Sprite(0,350,"panel");
mypanel.SetScale(0.75,0.75);

//myvsprite.SetTransparent(ON);
//The following one is in degrees, the true refers to
//antialiasing.
//myvsprite.SetAngle(90,FALSE);
//myvsprite.Set(580,60);
mywheel = New Sprite(50,400,"wheel");
mywheel.SetScale(0.75,0.75);

indich = New Sprite(180,380,"hindic");
indich.SetScale(0.35,0.5);

thruster = New Sprite(155,385,"thruster");
thruster.SetScale(0.60,0.60);
thruster.SetAngle(90,FALSE);

vindic = New Sprite(108,400,"vindic");
vindic.SetScale(0.4,0.2);

//Game loop
While(1)
```

```
{
mytext3.SetText("Depth: "+ depth);
// window cleaning
owindow1.Refresh();

//Move the ship
//straight ahead
myship.Move(movefac);
//due to rudders
myship.TurnRight(turnfac);
//due to thrusters
If(knots<2)
{
myship.TurnRight(thrustfac);
}

// Calculate ship speed.

 time2 = System.GetElapsedTime;
  dift = Abs(time2 — time1);
  // Check the distance covered every second.
  If (dift > 1000)
     {
      //Calculate speed.
      xdif = myship.GetX — xpos1;
      zdif = myship.GetZ — zpos1;
      dist = Sqrt(xdif * xdif + zdif*zdif);
         speedfps = dist;
         knots = speedfps * 36./60.;
         time1 = System.GetElapsedTime;
         mytext2.SetText("Knots: " + knots);
         xpos1 = myship.GetX;
      zpos1 = myship.GetZ;
        }

}

  Function speedup
  {
   If(knots<30)
    {
    movefac = movefac + 0.01;
    turnfac = rudderangle* knots/10.;
   }
```

```
    If(movefac <0)
    {
     turnfac = turnfac* −1;
    }

    //Move the speed indicator indich. movefac = + 1.2
    //corresponds
    // to a 20 pixel change on the screen.
    //movefac = 0 corresponds to y = 380

    hpos = 380 − (movefac/1.2)*20;
    indich.Set(180,hpos);
 }

Function speeddown
 {

   movefac = movefac − 0.01;
   If(movefac< −0.6)
     {
         movefac = −0.6;
         }

   turnfac = rudderangle* knots/10.;
   If(movefac <0)
   {
    turnfac = turnfac*−1.;
   }

   hpos = 380 − (movefac/1.2)*20;
   indich.Set(180,hpos);

 }

Function rightrudder
 {
    rudderangle = rudderangle + 0.00010;
    If (rudderangle>0.001)
     {
         rudderangle = 0.001;
         }
    turnfac = rudderangle* knots/10.;
    //.001 corresponds to 30 degrees of
   //rudder, so conversion
   //factor is 30,000
```

```
    rudderconvert = rudderangle* 30000;

    If(movefac<0)
     {
        turnfac = turnfac*-1;
       }
     mywheel.SetAngle(rudderconvert*2.0,FALSE);
}

Function leftrudder
{
   rudderangle = rudderangle - 0.00010;
   If (rudderangle<-0.001)
    {
        rudderangle = -0.001;
       }
   turnfac = rudderangle* knots/10.;
   rudderconvert = rudderangle* 30000;
   If(movefac<0)
    {
        turnfac = turnfac*-1;
       }

     mywheel.SetAngle(rudderconvert*2.0,FALSE);
 }

Function rightthruster
{
thrustfac = thrustfac +  0.00008;
If(thrustfac>0.0016)
 {
  thrustfac = 0.0016;
 }
//Move the thruster indicator indich.
// thrustfac = 0.0008.
//Corresponds
// to a 20 pixel change on the
// screen to the right.
// Indicator vindic originally at 108,400

   vpos = 108 + (thrustfac/0.0016)*20;
   vindic.Set(vpos,400);

}
```

```
Function leftthruster
{
thrustfac = thrustfac -  0.00008;
 If(thrustfac<-0.0016)
 {
  thrustfac = -0.0016;
 }
 //Move the thruster indicator indich. thrustfac = 0.0008.
 //Corresponds
 // to a 20 pixel change on the screen to the left.
 // Indicator vindic originally at 108,400.

   vpos = 108 + (thrustfac/0.0016)*20;
   vindic.Set(vpos,400);

}
```

Improved Ship Simulator: ShipSim2

The previous project was good but not much fun to use. In this project, we will make the simulation much more interesting by adding two islands, a region with shallow water in which you can run aground if you are not careful, three mines which can end the game if you hit them, a dock that you must maneuver the ship into at a controlled speed, camera controls that allow you to move the camera independently of the ship, and overhead views of various portions of the game scene. Figure 6.3 shows a screenshot of a game in progress, and Figure 6.4 gives an overhead view of the entire layout.

In the previous program, we used the CameraFollow command so that the camera would always keep the ship in sight. There are two problems associated with doing this. First, we cannot look around as we might wish (say for maneuvering into the dock to get a better view angle) because the camera is locked in position—attempts to move it using one of the camera move commands are fruitless since the follow command prevents this. Second, as you may have noticed, the camera changes its orientation as the ship turns, which can give the illusion that the ship is moving in a direction that it's not. This is because we specified a distance x and z from which to follow, and when the ship turns 90 degrees (pi/2 radians!), the x and z values are interchanged with reference to the ship.

Figure 6.3 ShipSim2 screenshot. The north side of main island.

Since the ship's motion will involve a relatively large area, we need the camera to move around, so we will use the Walk command to enable us to move the camera around using the arrow keys:

```
ocamera1.Walk();
```

Figure 6.4 Overhead view of game scene. The dock is on the north side of the island.

But, even moving the camera around can be laborious, especially if your hands are full maneuvering into port, so we will also view the scene from above height. Before we came to this solution, we first tried having one camera view in a separate window, but in order to see the entire game scene, the height of the camera had to be so high that it made the ship invisible. We then decided to have four overhead views: a South view that showed the ship on the south side of the island where it first appears when the game begins, an East Channel view that shows the east end of the island where the shallow water is located, a Mid-Channel view that shows the mine locations and useful paths for heading to the dock on the north side of the island, and a Dock view to help you with close maneuvering at the dock.

Instead of having four separate windows, one child window is used for these overhead views, and the program user selects which of the four views to see. The following code shows the main window and child window being made, and Autorefresh being disabled:

```
owindow1 = New Window("Ship
Simulator2",640,480,Window.STANDARD);// one line
owindow2 = New Window(owindow1,"Overhead
View",200,150,Window.GAME);// one line
owindow2.SetPosition(390,5);

//window maintenance
owindow1.SetAutoRefresh(OFF);
owindow2.SetAutoRefresh(OFF);
owindow1.Show();
owindow2.Show();
```

We then make the four buttons that enable the specific camera views to be selected. Notice that functions dochange, dochange2, and so on are called when the buttons are clicked:

```
mybutton7 = New Button(owindow1,"Dock
Overview",5,5,120,15);//one line
mybutton7.OnClick = dochange;

mybutton8 = New Button(owindow1,"East Channel
Overview",5,25,120,15);// one line
mybutton8.OnClick = dochange2;
```

```
mybutton9 = New Button(owindow1,"Mid-Channel
Overview",5,45,120,15);// one line
mybutton9.OnClick = dochange3;

mybutton10 = New Button(owindow1,"South
Overview",5,65,120,15);// one line
mybutton10.OnClick = dochange4;
```

Function `dochange` is shown in the following code, which illustrates how the camera is positioned for each overhead view:

```
Function dochange
{
ocamera2.SetPosition(440,1000,-3400);
}
```

As mentioned earlier, this simulation also features an area near the east end of the island where the water is very shallow. If the user fails to keep his eye on the depth gauge on the instrument panel, the ship will run aground. Running the ship aground will cause a sprite (named `aground`) to appear on the screen informing the user that he has lost his command and promotion—running a ship aground is not a career-building maneuver in the naval services!

The very shallow area (depth = 10 feet) is surrounded by a moderately shallow area with a depth of 20 feet. Normally, the depth in this game is 100 feet, so if the user sees the depth reduce to 20 feet, he knows he'd better change course. We first identified the moderately shallow warning region as a rectangular area located at x (`xpos1` in the program) between −2000 and −3000, and z (`zpos1` in the program) between −2800 and −3800. The very shallow area is at x between −2000 and −2600 and z between −3000 and −3600. By checking the position of the ship using some `if` statements we can tell if the ship is in either zone. The code below tells it all:

```
// Check for depth-very shallow area first
If(xpos1<-2000 && xpos1>-2600)
  {
  If(zpos1<-3000 && zpos1>-3600)
    {
    depth = 10;
    aground.Show();
    }
  }
```

```
// Check depth-warning area

 If(xpos1<-2000 && xpos1>-3000 &&

 zpos1<-2800 && zpos1>-3800)//one line
   {
     depth = 20;
   }

  Else
   {
     depth = 100;
   }
```

You may be wondering how we knew the exact location of the shallow areas. This was a fairly laborious process: once the islands were imported into the previous game, a small sphere about ten units above sea level was created and moved around the islands with the `Walk` command, followed by the camera. At the same time, the position of the sphere (x and z coordinates) was sent to text boxes on the screen so that we could know where the sphere was at any time.

We knew we wanted the shallow area near the east end of the island (to the right side when the game first begins), so we moved the sphere around and wrote down the coordinates when it looked like a suitable location was found. This is the same procedure used to determine where to place the mines and the dock pilings on the north side of the island. It was a lot of work, but there did not seem to be any alternative since we were not sure of the size of the islands. As you might recall, they were drawn with *MilkShape 3D*, imported into our game, and scaled up.

Mines were placed between the two islands, on the north side of the main island, and pilings to dock against were placed on the southwest side. The pilings were made using the `CreateBrick` command (see the following code), which is a very useful tool for making rectangular shaped 3D objects. In the parentheses of the `CreateBrick` command go the x, y, and z dimensions of the brick.

```
mine1 = oworld.CreateSphere(10,10,10);
Mine1.SetPosition(-1220,0,-3700);

mine2 = oworld.CreateSphere(10,10,10);
Mine2.SetPosition(-975,0,-3525);

mine3 = oworld.CreateSphere(10,10,10);
Mine3.SetPosition(-400,0,-3680);
```

```
//Pilings to dock against
Pile1 = oworld.CreateBrick(5,10,5);
Pile1.SetPosition(500,0,-3300);
pilemat = New Material(oworld,GetRGB(255,100,100),"pilemat");
Pilemat.SetFlat(ON);
Pile1.SetGouraud(ON);
Pile1.ReplaceMaterial(pilemat);

Pile2 = oworld.CreateBrick(5,10,5);
Pile2.SetPosition(500,0,-3260);
Pile2.ReplaceMaterial(Pilemat);
```

We then decided that the following criteria would apply for a successful docking maneuver:

- The ship's speed must be less than two knots (this is a little fast, but we can probably still walk away without too much damage).
- We must be able to determine the location of the ship in a rectangular area near the pilings (this can be determined very laboriously by moving the ship around).
- The bow thruster setting, thrustfac, cannot be greater than 0.0008 (about mid-setting).

The code below describes how we determine if a proper docking was made:

```
xcrit = myship.GetX;
zcrit = myship.GetZ;
If(xcrit< 455 && xcrit>430 && zcrit<-3260 && zcrit > -3424)// one line
{
  If(knots<2)
   {
    SetText("NICE!");
   }
   Else
   {
   SetText("TOO FAST!");
   }
}
```

Why is the determination of the area where the ship is in reference to the dock laborious if we can get the x and z coordinates of the ship easily and we know the location of the pilings? The reason is that the x and z location of the ship is somewhere near the center of the ship—not at its

edges. We are not sure where the edges of the ship are located because the ship is irregularly shaped! As a result, we must experiment to find out exactly when a collision takes place.

This brings up a very important point: collision detection is not exact with complex objects like ships. If you try running the ship into the island, you will see that collision is not detected until the ship is about halfway into the island. In the same way, running over a mine may not be detected as a collision. For more exact collision detection, you will have to use a scheme similar to the one we just described, based on the location of the ship in relation to the mines or the island. This is not an easy task with the island because its shape is also irregular!

You should now type in the following code. You will need to import the island (the same island, shipisle1, is used twice to make two islands), the sprite aground the ship from the previous project, as well as the various sprites from the CD-ROM. The island is textured using the picture "grass," which can be found in Jamagic/Help/Tutorials/Simple/Final Project/Pictures. This is in the same location as the "water" image used to texture the water surface.

Once you have run the program, keep in mind that you can adjust several things: you can move the main camera with the arrow keys and you can change overhead views with the buttons. Also, remember that when the ship is facing east, you should watch for the shallow parts near the east end of the island!

Ship Simulator 2 Code

```
//ShipSim2 program.
// Import two islands drawn with MilkShape.

owindow1 = New Window("Ship
Simulator2",640,480,Window.STANDARD);// one line
owindow2 = New Window(owindow1,"Satellite
//View",200,150,Window.GAME);//one line
owindow2.SetPosition(390,5);

//Window maintenance
owindow1.SetAutoRefresh(OFF);
owindow2.SetAutoRefresh(OFF);
owindow1.Show();
owindow2.Show();
oworld = New World();
```

```
//Import ship.
oworld.Load("bismark");
myship= oworld.GetObject(oworld.GetNObjects()−1);
myship.Scale(0.008);
myship.SetPosition(0,0,−2300);
myship.TurnRight(Pi/2);
myship.SetGouraud(ON);

//Import island.
oworld.Load("shipisle1");
isle1= oworld.GetObject(oworld.GetNObjects()−1);
isle1.Scale(50,30,30);
isle1.SetPosition(0,0,−3000);

otexture2 = New Texture(oworld,"grass");
matisle = New Material(oworld,otexture2);
matisle.SetMapped(ON);
isle1.SetGouraud(ON);
isle1.ReplaceMaterial(matisle);
otexture2.SetTiling(20,20);
isle1.SetStatic();

//Import second island.
oworld.Load("shipisle1");
isle2= oworld.GetObject(oworld.GetNObjects()−1);
isle2.Scale(20,15,10);
isle2.SetPosition(0,0,−4500);
isle2.TurnRight(Pi/4);
isle2.SetGouraud(ON);
isle2.ReplaceMaterial(matisle);
isle2.SetStatic();

// Mines

mine1 = oworld.CreateSphere(10,10,10);
Mine1.SetPosition(−1220,0,−3700);

mine2 = oworld.CreateSphere(10,10,10);
Mine2.SetPosition(−975,0,−3525);

mine3 = oworld.CreateSphere(10,10,10);
Mine3.SetPosition(−400,0,−3680);
```

```
Mine1.SetStatic;
Mine2.SetStatic;
Mine3.SetStatic;

//Pilings to dock against
Pile1 = oworld.CreateBrick(5,10,5);
Pile1.SetPosition(500,0,-3300);
pilemat = New
Material(oworld,GetRGB(255,100,100),"pilemat");//one line
Pilemat.SetFlat(ON);
Pile1.SetGouraud(ON);
Pile1.ReplaceMaterial(pilemat);

Pile2 = oworld.CreateBrick(5,10,5);
Pile2.SetPosition(500,0,-3260);
Pile2.ReplaceMaterial(Pilemat);

Pile1.SetStatic;
Pile2.SetStatic;

//Put in sea surface.
myplane = oworld.CreatePlane(20000,20000);
myplane.SetPosition(0,0,0);
otexture = New Texture(oworld,"water");
matplane = New Material(oworld,otexture);
matplane.SetMapped(ON);
myplane.SetGouraud(ON);
myplane.ReplaceMaterial(matplane);
otexture.SetTiling(20,20);

//Move the texture for illusion of moving water.
matplane.AnimUV(0,-0.00025);
//Other plane stuff
myplane.SetStatic();
myplane.SetAngle(-Pi/2.,0,0);

//Camera
ocamera1 = New Camera(oworld,owindow1);
ocamera1.SetBackgroundColor(GetRGB(0,150,200));
ocamera1.SetPosition(0,200,-1000);
ocamera1.TurnRight(Pi);
ocamera1.Walk();
oworld.Optimize(ocamera1);
// Brighten it up.
mylight = New Light(oworld, ocamera1,
```

```
GetRGB(255,255,255), 10000,200);//one line
ocamera2 = New Camera(oworld,owindow2);
ocamera2.SetPosition(-600,2500,-2500);
ocamera2.SetBackgroundColor(GetRGB(0,150,200));
ocamera2.TurnDown(Pi/2.0);
oworld.Optimize(ocamera2);

//Initialize
tf = 0.0;
//neg = 1.0;
//time = 0.0;
speed = 0.0;
movefac = 0.;
turnfac = 0.0;
knots = 0.0;
rudderangle = 0.0;
depth = 100;
thrustfac = 0.0;

//Buttons for ship control
mybutton1 = New Button(owindow1,"Forward",160,355,55,15);
mybutton1.OnClick = speedup;

mybutton2 = New Button(owindow1,"Back",160,440,55,15);
mybutton2.OnClick = speeddown;

mybutton3 = New Button(owindow1,"Right",55,440,40,15);
mybutton3.OnClick = rightrudder;

mybutton4 = New Button(owindow1,"Left",10,440,40,15);
mybutton4.OnClick = leftrudder;

mybutton5 = New Button(owindow1,"L",100,425,15,15);
mybutton5.OnClick = leftthruster;

mybutton6 = New Button(owindow1,"R",135,425,15,15);
mybutton6.OnClick = rightthruster;

mybutton7 = New Button(owindow1,"Dock
Overview",5,5,120,15);//one line
mybutton7.OnClick = dochange;

mybutton8 = New Button(owindow1,"East Channel
Overview",5,25,120,15);// one line
mybutton8.OnClick = dochange2;
```

```
mybutton9 = New Button(owindow1,"Mid-Channel
    Overview",5,45,120,15);// one line
mybutton9.OnClick = dochange3;

mybutton10 = New Button(owindow1,"South
Overview",5,65,120,15);//one line
mybutton10.OnClick = dochange4;

// text boxes
mytext1 = New StaticText(owindow1,"Bow
Thruster",90,370,65,15);//one line
mytext1.SetBackColor(GetRGB(0,0,0));
mytext1.SetColor(GetRGB(255,255,255));

mytext2 = New StaticText(owindow1," ",15,350,75,15);
mytext2.SetBackColor(GetRGB(0,0,0));
mytext2.SetColor(GetRGB(255,255,255));

mytext3 = New StaticText(owindow1,"Depth:
",90,350,65,15);//one line
mytext3.SetBackColor(GetRGB(0,105,50));
mytext3.SetColor(GetRGB(255,255,255));

time1 = System.GetElapsedTime;
xpos1 = myship.GetX;
zpos1 = myship.GetZ;

//Instruments
mypanel = New Sprite(0,350,"panel");
mypanel.SetScale(0.75,0.75);
mywheel = New Sprite(50,400,"wheel");
mywheel.SetScale(0.75,0.75);

indich = New Sprite(180,380,"hindic");
indich.SetScale(0.35,0.5);

thruster = New Sprite(155,385,"thruster");
thruster.SetScale(0.60,0.60);
thruster.SetAngle(90,FALSE);

vindic = New Sprite(108,400,"vindic");
vindic.SetScale(0.4,0.2);

aground = New Sprite(100,200,"aground");
aground.Hide();
```

```
//Set collision detection.

myship.SetCollision(TRUE,Object.COLLISION_TYPE_STOP);
oworld.OnCollide = docollision;

//Game loop
While(1)
{

//Display depth.
mytext3.SetText("Depth: "+ depth);

// Window cleaning
ocamera1.ActivateRender();
owindow1.Refresh();
ocamera2.ActivateRender();
owindow2.Refresh();

//Move the ship
//
//straight ahead.
myship.Move(movefac);
//Due to rudders
myship.TurnRight(turnfac);
//Due to thrusters
If(knots<2)
{
myship.TurnRight(thrustfac);
}

// Calculate ship speed.

 time2 = System.GetElapsedTime;
 dift = Abs(time2 – time1);
  // Check the distance covered every second.
  If (dift > 1000)
     {
   //Calculate speed.
    xdif = myship.GetX – xpos1;
    zdif = myship.GetZ – zpos1;
    dist = Sqrt(xdif * xdif + zdif*zdif);
    speedfps = dist;
       knots = speedfps * 36./60.;
       time1 = System.GetElapsedTime;
```

```
            mytext2.SetText("Knots: " + knots);
            xpos1 = myship.GetX;
        zpos1 = myship.GetZ;
          }

// Check for depth—very shallow area first.
If(xpos1<−2000 && xpos1>−2600)
    {
    If(zpos1<−3000 && zpos1>−3600)
       {
       depth = 10;
          aground.Show();
          }
     }

// Check depth—warning area.

   If(xpos1<−2000 && xpos1>−3000 && zpos1<−2800 && zpos1>−
   3800)//one line
    {
      depth = 20;
         aground.Hide();
    }

   Else
    {
     depth = 100;
        aground.Hide();
    }

// Check for proper or improper docking.
   //are at (500,0,−3260)
// and (500,0,−3300).
// Criteria will be: speed less than 2 knots,
// turning rate (thrustfac) less than 0.0008( half of max
//thruster setting),
// within 20 pixels in x coordinate, and in between two z
//coordinates.

  xcrit = myship.GetX;
  zcrit = myship.GetZ;
  If(xcrit< 455  && xcrit>430 && zcrit<−3260 && zcrit > −
  3424)//one line
  {
```

```
    If(knots<2)
     {
      SetText("NICE!");
     }
     Else
     {
     SetText("TOO FAST!");
     }
  }

}

 Function speedup
 {
  If (knots<30)
    {
    movefac = movefac + 0.04;
    }
    turnfac = rudderangle* knots/10.;
     If(movefac <0)
    {
     turnfac = turnfac* —1;
    }

    //Move the speed indicator indich. movefac = + 1.2
    //corresponds
    // to a 10 pixel change on the screen.
    //movefac = 0 corresponds to y = 380

    hpos = 380 — (movefac/1.2)*10.;
    indich.Set(180,hpos);

 }

Function speeddown
 {

   movefac = movefac — 0.04;
   If(movefac< —0.6)
    {
     movefac = —0.6;
    }

   turnfac = rudderangle* knots/10.;
```

```
    If(movefac <0)
    {
     turnfac = turnfac*-1.;
    }

    hpos = 380 - (movefac/1.2)*10;
    indich.Set(180,hpos);

  }

Function rightrudder
 {
    rudderangle = rudderangle + 0.00010;
    If (rudderangle>0.001)
     {
        rudderangle = 0.001;
       }
    turnfac = rudderangle* knots/10.;
    //.001 corresponds to 30 degrees of rudder, so
    // conversion
    // factor is 30,000.
    rudderconvert = rudderangle* 30000;

    If(movefac<0)
     {
        turnfac = turnfac*-1;
       }
     mywheel.SetAngle(rudderconvert*2.0,FALSE);
 }

 Function leftrudder
 {
    rudderangle = rudderangle - 0.00010;
    If (rudderangle<-0.001)
     {
        rudderangle = -0.001;
       }
    turnfac = rudderangle* knots/10.;
    rudderconvert = rudderangle* 30000;
    If(movefac<0)
     {
     turnfac = turnfac*-1;
     }

      mywheel.SetAngle(rudderconvert*2.0,FALSE);
 }
```

```
Function rightthruster
{
thrustfac = thrustfac +  0.00008;
 If(thrustfac>0.0016)
  {
   thrustfac = 0.0016;
  }
 //Move the thruster indicator indich.
 //thrustfac = 0.0008
 //corresponds
 // to a 20-pixel change on the screen to the right.
 // Indicator vindic originally at 108,400.

   vpos = 108 + (thrustfac/0.0016)*20;
   vindic.Set(vpos,400);

}

Function leftthruster
{
thrustfac = thrustfac -  0.00008;
 If(thrustfac<-0.0016)
  {
   thrustfac = -0.0016;
  }
 //Move the thruster indicator indich.
 //thrustfac = 0.0008
 // corresponds
 // to a 20-pixel change on the screen to the left.
 // Indicator vindic originally at 108,400.

   vpos = 108 + (thrustfac/0.0016)*20;
   vindic.Set(vpos,400);

}

Function docollision
{
 aground.Show;
}

Function dochange
{
ocamera2.SetPosition(440,1000,-3400);
}
```

```
Function dochange2
{
ocamera2.SetPosition(-2000,6000,-3800);
}

Function dochange3
{
ocamera2.SetPosition(-500,6000,-3600);
}

Function dochange4
{
ocamera2.SetPosition(-600,2500,-2500);
}
```

That was our last program. You should experiment with it and see if you can make any improvements. Here are some suggestions: add some additional overhead views since the ship sometimes goes out of view when it is coming around the east end of the island, place additional mines to make the game more challenging or to prevent the ship from coming from the easier west end, and place a timer on the screen to make time a factor in keeping score.

CHAPTER 7

CLOSING REMARKS— DISTRIBUTING YOUR SOFTWARE

The really exciting part comes now that you have the skills to start making your own games and simulations. Being immersed in your own creativity is the greatest "high" that you will ever feel, and making your own games will give you this feeling in spades.

There is still quite a bit for you to learn about *Jamagic* since this book just focuses on the fundamentals. The Help section in *Jamagic* is very useful; take the time to go through it carefully. It consists of a reference section that explains the commands used for the programs in this book and much more. Also included are scores of sample programs of varying complexity—you can learn a tremendous amount from going through them with care.

Also take the time to look at all of the sounds, music, and great 3D objects that you will find on the CD-ROM when you purchase the full-capability *Jamagic* version. You will find that these are almost indispensable for your games and that they will spark your creativity.

If you wish to distribute games to your friends or for sale, you must purchase the *Jamagic* software from *www.clickteam.com*. You cannot make stand-alone games with the limited-capability version of *Jamagic* that comes with this book. In other words, only people with *Jamagic* loaded on their computers will be able to use the programs you make with this limited-capability version.

To make a stand-alone game once you have the full-capability *Jamagic* version, simply go to File on your *Jamagic* screen, and click Build. Your program will be stored under Debug if you have configured *Jamagic* as instructed in this book, and it will have an .exe extension.

Jamagic allows you to distribute for sale any games that you create using their full-capability software, but please read all of the provisions that you must agree to very carefully when you load the software into your computer.

The author hopes that the readers of this book experience as much pleasure making games as he has. Also, an advanced version of this book will soon follow. Please keep a lookout for it!

Please feel free to send any positive or negative comments to the author through the publisher.

APPENDIX A

ABOUT THE CD-ROM

The CD-ROM that comes with this book contains the following:

- *Jamagic* Demo Program
 Version 1.2. Has all the features of the registered version, except it won't allow you to save stand-alone games. Developed by Clickteam, *www.clickteam.com*
- *MilkShape 3D* Demo Program (milksetup file)
 Version 1.6.3. Has all the features of the registered version, except it is limited to 30 days of use. Developed by chUmbaLum soft, *www.milkshape3d.com*
- Projects:
 - Project1
 - Project1b
 - Sphere1
 - Sphere2
 - Sphere3
 - Sphere4
 - Sphere5
 - Sphere6
 - Sphere7
 - Sphere8
 - Menusample
 - Sphere9
 - FlightSimulator
 - FlightSimulator2
 - FlightSimulator3
 - ShipSimulator
 - ShipSim2
- 3D Objects (.gib files)
 - mtnlow
 - mnthigh
 - plains
 - shipisle1
- Pictures
 - wheel
 - thruster
 - panel
 - aground
 - firstpic
 - pointer

Appendix A About the CD-ROM **245**

- gauge
- compass
- hindic
- vindic
- dial
- Book figures (full-color versions)
 - Ch 1
 - Ch 2
 - Ch 3
 - Ch 4
 - Ch 5
 - Ch 6

System Requirements

To ensure proper operation of your games, the following system performance is required:

- Windows 98, Me, NT, 2000, XP
- PC: Pentium or higher; 600-MHz processor or better recommended (166 MHz for the first ten projects)
- 50 MB of free hard drive space to install *Jamagic*
- 11 MB of free hard drive space to install *Milkshape 3D*
- CD-ROM/drive

APPENDIX B

JAMAGIC LANGUAGE REFERENCE

ABS

In this appendix, we present some of the more useful commands in *Jamagic* and explain how to use them. Please see the Help section of the software for a full listing of the commands.

This command returns the absolute value of a number. Here is its syntax:

```
x = abs(y)
```

Parameters

x The absolute value of y

Notes

The absolute value of a number is a very simple concept; it is the same number with the opposite sign. For instance, the absolute value of −5 is +5.

This function can be useful when you are trying to display distances between objects. For example, if you are interested in displaying the x distance between two objects, you might subtract the x coordinate of one from the x coordinate of the other. However, at times, this might result in negative numbers, which might confuse the game user. By using the absolute value function, you can ensure that a positive value is printed to the screen.

Sample Code

The following code prints the absolute value of the distance between the camera and the sphere to the screen; it also prints the distance without the absolute value. By moving the sphere with the arrow keys, you can see the effect of the absolute value function.

```
oworld = New World();
ocamera = New Camera(oworld);
sphere = oworld.CreateSphere(50,50,50,25,25);
ocamera.MoveBack(1200);
ocamera.Walk();

//Loop
While(TRUE)
 {
```

```
        Dist = (ocamera.getx - sphere.getx)
        SetText("dist " + dist + "abs val "+ Abs(dist) );
        }
```

Acos

This command calculates the arccosine. Here is its syntax:

```
x = acos(y)
```

Parameters

 x The angle in radians that corresponds to a cosine value of y

Notes

The arccosine can be useful when you perform calculations that involve geometry. For example, the cosine of 180 degrees (pi radians) is –1. The arccosine of –1 is then pi (3.1416). In other words, arccosine gives the angle in radians that corresponds to a given value of cosine.

Sample Code

The following code sends the angle of roll about the y-axis to the screen; this amount of roll is controlled with the left and right arrow keys. First the program finds the angle, then it finds the cosine of the angle, and then it uses the acos function to find the angle again based on the cosine.

```
oworld = New World();
ocamera = New Camera(oworld);
sphere = oworld.CreateSphere(50,50,50,25,25);
ocamera.MoveBack(1200);
sphere.Walk();

//Loop
While(TRUE)
 {
  z = sphere.getyangle();
  Y = cos(z);
  X = acos(y);
  SetText("yangle " + x );
 }
```

ADDANGLE

This command increases the angle of the object relative to the `world` axis. It changes the angle immediately or at a speed that you can specify.

```
object.AddAngle(xangle, yangle, zangle, time)
```

Parameters

xangle	Number of radians to add about the x-axis
yangle:	Number of radians to add about the y-axis
zangle	Number of radians to add about the z-axis
time	Number of seconds for rotation

Notes

There is another way to express this function. You might say,

```
object.AddAngle(another3DObject, time),
```

where `another3DObject` refers to another object from which to add the angle.

It is important to know that there is a difference between the `SetRelativeAngle` command and the `AddAngle` command. The `AddAngle` command moves the object about the stationary `world` axes. The `SetRelativeAngle` command moves the object about its own x, y, and z axes. Please consult the explanation for the `SetRelativeAngle` command later in this appendix to see sample code that allows you to see the differences between the two commands. The same applies to the `SetAngle` command, which is also made in reference to the `world` axes.

You should also realize that you do not really need the `SubAngle` command, which turns the object in the opposite directions: the `AddAngle` command will do the same motion if you use negative numbers.

Sample Code

```
oworld = New World();
ocamera = New Camera(oworld);
sphere = oworld.CreateSphere(50,50,50,25,25);
ocamera.MoveBack(1200);
ocamera.Walk();
```

```
sphere.AddAngle(1,2,3,5); //rotates it in 5 seconds
//Loop
While(TRUE);
```

ADDPOSITION

This command increases the x, y, and z coordinates of a 3D object. It changes the position immediately or at a speed that you can specify.

```
object.AddPosition(x,y,z,time)
```

Parameters

x	Number of units to add to the x-axis
y	Number of units to add to the y-axis
z	Number of units to add to the z-axis
time	Number of seconds for the motion to take

Notes

If the time parameter is omitted, the movement occurs immediately. Alternately, you can say,

```
object.AddPosition(another3DObject, time),
```

where `another3DObject` refers to another object from which to add the coordinate.

The `SubPosition` command is very similar to this one, but it moves the object in the opposite direction. You do not really need it since using negative numbers in this command will result in the same motion.

Sample Code

```
oworld = New World();
ocamera = New Camera(oworld);
sphere = oworld.CreateSphere(50,50,50,25,25);
ocamera.MoveBack(1200);
ocamera.Walk();

sphere.AddPosition(100,200,30,5); //move it in 5 seconds
//Loop
While(TRUE);
```

Asin

This command calculates the arcsine. Here is its syntax:

```
x = asin(y)
```

Parameters

x The angle in radians that corresponds to a sine value of y

Notes

The arcsine can be useful when you perform calculations that involve geometry. For example, the sine of 90 degrees (pi/2 radians) is 1. The arcsine of 1 is then pi/2 (3.1416/2). The arcsine finds the angle in radians that corresponds to a given sine value.

Sample Code

The following code sends the angle of roll about the y-axis to the screen; this roll is controlled with the left and right arrow keys. The program first finds the angle, then it finds the sine of the angle, and then it uses the `asin` function to find the angle again based on the sine.

```
oworld = New World();
ocamera = New Camera(oworld);
sphere = oworld.CreateSphere(50,50,50,25,25);
ocamera.MoveBack(1200);
sphere.Walk();

//Loop
While(TRUE)
 {
  z = sphere.getyangle();
  Y = sin(z);
  X = asin(y);
  SetText("yangle " + x );
   }
```

Atan

This command calculates the arctangent. Here is its syntax:

```
x = acos(y)
```

Parameters

x The angle in radians that corresponds to a tangent value of y

Notes

The arctangent can be useful when you perform calculations that involve geometry. For example, the tangent of 45 degrees (pi/2 radians) is 1. The arctangent of 1 is then pi/2 (3.1416/2).

Sample Code

The code below sends the angle of roll about the y-axis to the screen; this is controlled with the left and right arrow keys. The program first finds the angle, then it finds the tangent of the angle, and then it uses the atan function to find the angle again based on the tangent.

```
oworld = New World();
ocamera = New Camera(oworld);
sphere = oworld.CreateSphere(50,50,50,25,25);
ocamera.MoveBack(1200);
sphere.Walk();

//Loop
While(TRUE)
 {
  z = sphere.getyangle();
  y = tan(z);
  x = atan(y);
  SetText("yangle " + x );
 }
```

Cos

This command calculates the cosine of an angle. Here is its syntax:

 x = cos(y)

Parameters

x The cosine of angle y. Angle y is measured in radians.

Notes

Please see Chapter 5 for a more detailed explanation of the cosine function. The cosine is useful when you want to find the horizontal speed of an object that is moving upward at an angle, such as an aircraft climbing.

Sample Code

The following code sends the angle of roll about the y-axis to the screen, which is controllable with the left and right arrow keys. The program prints the angle and cosine of the angle to the screen.

```
oworld = New World();
ocamera = New Camera(oworld);
sphere = oworld.CreateSphere(50,50,50,25,25);
ocamera.MoveBack(1200);
sphere.Walk();

//Loop
While(TRUE)
 {
  z = sphere.getyangle();
  Y = cos(z);
  SetText("yangle " + z + "cos " + y);
 }
```

FOLLOW

This command causes your 3D object to follow another object at a controllable distance and position.

```
object.Follow(Other3DObject, distance, inertia, x, y, z)
```

Parameters

x	Number of units to add to the x value of Other3DObject.
y	Number of units to add to the y value of Other3Dobject.
z	Number of units to add to the z value of Other3Dobject.

Appendix B *Jamagic* Language Reference **255**

inertia Refers to the lag in following the other object. The lower the number, the more quickly the object's motion will follow Other3DObject's motion. Values of about 40 are usually good.

distance Refers to the distance to the object

Sample Code

The following code illustrates the command:

```
oworld = New World();
ocamera = New Camera(oworld);
sphere = oworld.CreateSphere(50,50,50,25,25);
//Create second sphere.
Sphere2 = oworld.CreateSphere(10,10,10,10,10);
ocamera.MoveBack(1200);
ocamera.Walk();

sphere.AddPosition(100,200,30,5); //Move it in 5 seconds.
// Other sphere follows it.
Sphere2.Follow(sphere,50,60,10,10,10);
//Loop
While(TRUE);
```

GetDegree/GetRadian

This command converts radians to degrees or degrees to radians.

 x = GetDegree(y)

or

 y = GetRadians(x)

Parameters

x The angle in degrees
y The angle in radians

Notes

Use `GetDegree` if you must, but you can do the conversion yourself very easily. Just remember that 2 pi radians corresponds to 360 degrees, so:

$$\text{Radians} * 57.3 = \text{degrees}$$

$$\text{Degrees}/57.3 = \text{radians}$$

Most program users will be unfamiliar or uncomfortable with radians, so if you are printing angles to the screen, degrees are the way to go.

On the other hand, most functions (like sine, cosine and tangent) in *Jamagic* require the angle to be in radians.

Sample Code

```
oworld = New World();
ocamera = New Camera(oworld);
sphere = oworld.CreateSphere(50,50,50,25,25);
ocamera.MoveBack(1200);
sphere.Walk();

//Loop
While(TRUE)
 {
  z = sphere.getyangle();
  Y = sin(z);
  // Convert to degrees.
  X = z* 57.3
  SetText("yangle " + x + "cos " + y);
 }
```

GETDISTANCE

This command gives the distance between two objects. The syntax is

```
odist = object.GetDistance(Object2);
```

where `odist` is the distance between `object` and `object2`.

Notes

Another way to express this command would be to say,

```
odist = object.GetDistance(x, y, z);
```

where x, y, and z are points in 3D space, and `odist` is the distance from that point to `object`.

Sample Code

```
oworld = New World();
ocamera = New Camera(oworld);
sphere = oworld.CreateSphere(50,50,50,25,25);
//Create second sphere.
Sphere2 = oworld.CreateSphere(10,10,10,10,10);
ocamera.MoveBack(1200);
oCamera.Walk();

sphere.AddPosition(100,200,30,5); //Move it in 5 seconds.
// Other sphere follows it.
Sphere2.Follow(sphere,50,60,10,10,10);
//Loop

While(1)
{
 SetText(sphere2.GetDistance(sphere));
}
```

GETX (ALSO GETY, GETZ)

This command gives the x, y, or z coordinate of an object. The syntax is

```
x = object.GetX();
```

where x is the x coordinate of `object`.

Notes

If the y or z coordinates are desired, then use the `GetY` or `GetZ` commands.

Sample Code

```
oworld = New World();
ocamera = New Camera(oworld);
sphere = oworld.CreateSphere(50,50,50,25,25);
//Create second sphere.
Sphere2 = oworld.CreateSphere(10,10,10,10,10);
ocamera.MoveBack(1200);
ocamera.Walk();

sphere.AddPosition(100,200,30,5); //Move it in 5 seconds.
// Other sphere follows it.
Sphere2.Follow(sphere,50,60,10,10,10);
//Loop

While(1)
{
 SetText(sphere2.GetX());
}
```

GetXAngle (also GetYAngle, GetZAngle)

This command gives the angle the object is making with the x, y, or z axes. Its syntax is

```
xangle = object.GetXAngle();
```

where `xangle` is the angle of `object` with the x-axis. If the angle with the y or z axes are desired, then use the `GetYAngle` or `GetZAngle` commands.

Notes

You must be careful if you are rotating your 3D object about more than one axis because the `GetXAngle` command can return confusing values as a result. For example, if you are trying to keep track of an object's angle with the horizon, but you are also rotating your object about one or more of the other axes, then the angle with the horizon will be distorted. In these cases, it is best to keep track of the horizon angle using your own code in which you keep track of any radians added to your object's orientation. See the flight simulator programs in Chapter 4 for an example of this.

Sample Code

```
oworld = New World();
ocamera = New Camera(oworld);
sphere = oworld.CreateSphere(50,50,50,25,25);
ocamera.MoveBack(1200);
ocamera.Walk();

sphere.AddAngle(1,0,0,5); //Rotate it 1 radian in 5 seconds.

//Loop

While(1)
{
 SetText(sphere.GetXAngle());
}
```

HIDE/SHOW

These commands remove an object from view (it still exists, but is invisible), and then make it visible again.

```
object.Hide();
```

or

```
Object.Show();
```

Sample Code

The following code hides the sphere when the left arrow is pressed and makes it visible again when the right arrow is pressed.

```
oworld = New World();
ocamera = New Camera(oworld);
sphere = oworld.CreateSphere(50,50,50,25,25);
ocamera.MoveBack(1200);
ocamera.Walk();

sphere.AddPosition(100,200,30,5); //Move it in 5 seconds.
```

```
//Loop

While(1)
{
 If(IsKeyDown(Keyboard.LEFT)) //Hides when left arrow is
                              //pressed.
  {
  Sphere.hide();
  }
 If(IsKeyDown(Keyboard.RIGHT))// Reappears when right arrow
                              // is pressed.
  {
  Sphere.Show();
  }
}
```

LIGHT

This command creates a new light object.

```
olight= New Light(world,position,color,radius,intensity,flag)
```

Parameters

world	The world in which the light is created.
position	Not the x, y, z coordinates, but another object on which the light will be situated.
color	The color of the light using the RGB scale. The color can be controlled with the SetColor command (please see the following code for an example).
radius	The size of the light.
intensity	The intensity of the light, from 0 (darkest) to 255 (brightest). This can be controlled with the SetIntensity command (please see the following code for an example).
flag	Includes these two types:

	dynamic	A moveable light. This is the default setting.
	static	Cannot be moved. These save computation and make your program run faster.

Notes

Lights affect only objects that are rendered with Gouraud or Lambert shading. An object made up of a flat color will not be affected.

Sample Code

```
oworld = New World();
ocamera = New Camera(oworld);
sphere = oworld.CreateSphere(50,50,50,25,25);
sphere.SetPosition(0,200,0);
// Create a new light at the sphere position.
mylight = New Light(oworld,sphere,GetRGB(255,255,0),100,255);
mats = New Material(oworld,,RED,"mats");
mats.SetFlat();
sphere.ReplaceMaterial(mats);
sphere.SetGouraud;
plane = oworld.CreatePlane(600,600);
Matplane = New Material(oworld, ,GREEN, "Matplane");
matplane.SetFlat;
plane.ReplaceMaterial(matplane);
plane.SetAngle(-Pi/2,0,0);
plane.SetStatic();
oworld.Optimize(ocamera);
ocamera.MoveBack(1200);
ocamera.MoveUp(200);
sphere.Walk();

// Next line is for true shadow mode.
sphere.SetShadowMode(Object.SHADOW_MODE_TRUE);

sphere.EnableShadow();
//Loop
While(TRUE)
 {
  //Change the intensity if arrow pressed.
  If(IsKeyDown(Keyboard.RIGHT))
   {
   mylight.SetIntensity(2);
   }
  //Change the color of the light.
      If(IsKeyDown(Keyboard.LEFT))
       {
   mylight.SetColor(GetRGB(0,0,255));
   }
 }
```

LookAt

This command causes one object to always look towards another, even if one or both objects move.

```
object.LookAt(Other3DObject, x, y, z)
```

Parameters

x	The offset in the x direction that `object` is so that it can look at the other object
y	The offset in the y direction that `object` is so that it can look at the other object
z	The offset in the z direction that `object` is so that it can look at the other object
Other3DObject	the object that `object` follows

Notes

This feature can be useful when you want the camera to follow a moving object.

Sample Code

```
oworld = New World();
ocamera = New Camera(oworld);
sphere = oworld.CreateSphere(50,50,50,25,25);
//Create second sphere.
brick1 = oworld.CreateBrick(10,10,10,10,10);
ocamera.MoveBack(1200);
//Move the sphere with the arrow keys.
sphere.Walk();
// Brick looks at sphere as sphere moves.
brick1.LookAt(sphere);
//Loop
While(TRUE);
```

Move

This command moves an object in the direction that it is facing.

```
object.Move(distance, time, animation, animation speed)
```

Parameters

`distance`	The distance `object` is to move
`time`	The number of seconds that the move will take (if omitted the movement is immediate).
`animation`	The animation name to play (only for 3D objects)
`animation speed`	The speed of the animation from 0 (slowest) to 100 (fastest)

Notes

The object will move in the direction it is facing. If you rotate the object, the direction of motion from the Move command will change because the object faces a new direction.

Sample Code

```
oworld = New World();
ocamera = New Camera(oworld);
sphere = oworld.CreateSphere(50,50,50,25,25);
ocamera.MoveBack(1200);
//Move the sphere.
sphere.Move(200,5);

//Loop
While(TRUE);
```

MOVEAROUND

This command causes one object to move randomly about another object. Using this command is a very good way to make a simple game of collision avoidance.

```
object.MoveAround(Other3DObject, distance, minx, miny, minz,
                 maxx, maxy, maxz, incx, incy, incz)
```

Parameters

`distance`	The distance between the two objects as the motion occurs.

`minx, miny, and minz values`	Refer to the minimum angles about each axis that the object will move about the other object.
`maxx, maxy, and maxz parameters`	Refer to the maximum angles between the objects.
`incx, incy, and incz parameters`	Refer to the value that is to be added in every loop around the object to the x, y, or z angles.

Notes

This command provides a simple way to make a game of collision avoidance. For example, with the `MoveAround` command, you can make an object move randomly about a fortress, and you can try to get through without crashing into the object.

Sample Code

```
oworld = New World();
ocamera = New Camera(oworld);
sphere = oworld.CreateSphere(50,50,50,25,25);
//Create a brick.
brick1 = oworld.CreateBrick(10,10,10);
ocamera.MoveBack(1200);
//Move the sphere with the arrow keys.
sphere.Walk();
// Brick moves around the sphere.
brick1.MoveAround(sphere,100);
//Loop
While(TRUE);
```

MoveBack

This command moves an object away from the direction that it is facing.

```
object.MoveBack(distance, time, animation, animation speed)
```

Parameters

`distance`	The distance `object` is to move
`time`	The number of seconds that the move will take (if omitted, the movement is immediate)

animation	The animation name to play (only for 3D objects)
animation speed	The speed of the animation from 0 (slowest) to 100 (fastest)

Notes

The object will move away from the direction it is facing. If you rotate the object, the direction of motion from the `MoveBack` command will change because the object faces a new direction.

Sample Code

```
oworld = New World();
ocamera = New Camera(oworld);
sphere = oworld.CreateSphere(50,50,50,25,25);
ocamera.MoveBack(1200);
//Move the sphere.
sphere.MoveBack(200,5);

//Loop
While(TRUE);
```

MoveDown/MoveUp

This command moves an object down or up while maintaining its orientation known as *strafing*).

```
object.MoveDown(distance, time, animation, animation speed)
object.MoveUp(distance, time, animation, animation speed)
```

Parameters

distance	The distance `object` is to move
time	The number of seconds that the move will take (if omitted, the movement is immediate)
animation	The animation name to play (only for 3D objects)
animation speed	The speed of the animation from 0 (slowest) to 100 (fastest).

Sample Code

```
oworld = New World();
ocamera = New Camera(oworld);
sphere = oworld.CreateSphere(50,50,50,25,25);
ocamera.MoveBack(1200);
//Move the sphere.
sphere.MoveDown(400,5);

//Loop
While(TRUE);
```

MoveLeft/MoveRight

This command moves an object to its left or right without changing its orientation (strafing), relative to the direction that it is facing.

```
object.MoveLeft(distance, time, animation, animation speed)
```

Parameters

distance	The distance object is to move
time	The number of seconds that the move will take (if omitted, the movement is immediate)
animation	The animation name to play (only for 3D objects)
animation speed	The speed of the animation from 0 (slowest) to 100 (fastest)

Sample Code

The following code has commands commented out for moving to the right. You must use one or the other (MoveLeft or MoveRight).

```
oworld = New World();
ocamera = New Camera(oworld);
sphere = oworld.CreateSphere(50,50,50,25,25);
ocamera.MoveBack(1200);
//Move the sphere.
sphere.MoveLeft(200,5);
//sphere.MoveRight(200,5);

//Loop
While(TRUE);
```

ONSTOPMOVEMENT

This command specifies the function to be called when certain commands are finished.

```
object.OnStopMovement = function
```

Notes

The function is called when movement of an object stops. The movement must have been caused by a command with a time parameter, such as the `SetPosition`, `SetAngle`, `AddAngle`, and `Move` commands.

Sample Code

The following code hides the sphere when motion stops.

```
oworld = New World();
ocamera = New Camera(oworld);
sphere = oworld.CreateSphere(50,50,50,25,25);
ocamera.MoveBack(1200);
//Move the sphere.
sphere.MoveLeft(200,5);
Sphere.OnStopMovement = hideit;

//Loop
While(TRUE);

function hideit //Hides the sphere when motion stops.
  {
    sphere.hide();
  }
```

PAUSE

This command pauses the current movement.

```
object.Pause();
```

Notes

The object stops immediately and does not resume motion until the `resume` command is issued.

Sample Code

The following code pauses motion of the sphere when the left arrow key is pressed and resumes motion with the `resume` command when the right arrow key is pressed.

```
oworld = New World();
ocamera = New Camera(oworld);
sphere = oworld.CreateSphere(50,50,50,25,25);
ocamera.MoveBack(1200);
//Move the sphere.
sphere.MoveDown(500,30);

//Loop
While(TRUE)
 {
  //Pause the motion when the left arrow key is pressed.
  If(IsKeyDown(Keyboard.LEFT))
   {
    Sphere.Pause();
   }
  // Resume motion when the right arrow key is pressed.
  If(IsKeyDown(Keyboard.RIGHT))
   {
    Sphere.Resume();
   }
 }
```

RANDOM

This command generates a random number.

```
randomnumber = random(value)
```

Parameters

randomnumber	A random number between 0 and `value`
value	Specifies what the maximum possible value is of the random number

Notes

The `random` command is useful for making a game behave in a different way every time. For example, the position of an object at game start-up could be determined by a random number so that the location of the object will be different each time the game is played. The following code shows this happening.

The random number will generate the same random number each time unless you give it a different seed value. The `SetRandom(System.GetElapsedTime())` command gives a seed value to the random number generator that is linked to the time. In this way, you will get a different set of random numbers each time.

Sample Code

Please run the following code several times so that you can see the difference in how the sphere is placed.

```
 oworld = New World();
ocamera = New Camera(oworld);
sphere = oworld.CreateSphere(50,50,50,25,25);
ocamera.MoveBack(1200);
sphere.Walk();
SetRandom(System.GetElapsedTime());
X = random(200);
Sphere.SetPosition(x,0,0);
SetText("random no " + x);

//Loop
While(TRUE)
 {
  }
```

RESUME

This command resumes a paused movement.

```
object.Resume();
```

The object resumes moving after the `pause` command has been called.

Notes

Familiarize yourself with the Pause command, earlier in this appendix.

Sample Code

```
oworld = New World();
ocamera = New Camera(oworld);
sphere = oworld.CreateSphere(50,50,50,25,25);
ocamera.MoveBack(1200);
//Move the sphere.
sphere.MoveDown(500,30);

//Loop
While(TRUE)
 {
  //Pause the motion when the left arrow key is pressed.
  If(IsKeyDown(Keyboard.LEFT))
   {
    Sphere.Pause();
   }
 // Resume motion when the right arrow key is pressed.
  If(IsKeyDown(Keyboard.RIGHT))
   {
    Sphere.Resume();
   }
 }
```

RollLeft/RollRight

This command rolls the object about its fore/aft axis.

```
object.RollLeft(angle, time, animation, animation Speed)
object.RollRight(angle, time, animation, animation Speed)
```

Parameters

angle	The number of radians rolled
time	The number of seconds in which the rotation is to take place
animation	Applies to 3D objects only and refers to the name of the animation to play during the rotation

| animation speed | The speed of the animation to be played, from 0 to 100. |

Notes

Rotation is relative to the object.

Sample Code

```
oworld = New World();
ocamera = New Camera(oworld);
sphere = oworld.CreateSphere(50,50,50,25,25);
ocamera.MoveBack(1200);
Sphere.RollLeft(2,5);

//Loop

While(1)
{
}
```

ROUND

This command rounds off a number with a decimal point (floating point number) to the nearest integer.

```
x = Round(y)
```

Parameters

| x | The rounded number |
| y | The number to be rounded off |

Notes

This is a useful command for sending values to the screen. For example, if you want the program user to know the distance between two objects, you can make numbers like 299.327 turn into 299 using the round command—you do not need, nor necessarily want, the extra digits.

Sample Code

```
oworld = New World();
ocamera = New Camera(oworld);
sphere = oworld.CreateSphere(50,50,50,25,25);
ocamera.MoveBack(1200);
sphere.Walk();

//Loop

While(1)
{
 x = sphere.GetX();
 xround = Round(x);
 SetText("rounded " + xround + " not rounded "+ x);
}
```

SINE

This command calculates the sine of an angle.

```
x = sin(y)
```

Parameters

x The sine of angle y. Angle y is in radians.

Notes

Please see Chapter 5 for an explanation of the sine function. The sine is used to find the vertical speed of an object that is moving up at an angle, such as an aircraft climbing.

Sample Code

The following code sends the angle of roll about the y-axis to the screen; this is controlled with the left and right arrow keys. The program prints the angle and sine of the angle to the screen.

```
oworld = New World();
ocamera = New Camera(oworld);
sphere = oworld.CreateSphere(50,50,50,25,25);
```

```
ocamera.MoveBack(1200);
sphere.Walk();

//Loop
While(TRUE)
 {
  z = sphere.getyangle();
  Y = sin(z);
  SetText("yangle " + z + "sin " + y);
  }
```

SCALE

This command changes the scale of an object. The command may be used in one of two ways: the object may be uniformly scaled up or down in all directions, or the object may be scaled differently in the x, y, and z directions.

```
object.Scale(ScaleRatio)
```

or

```
object.Scale(xratio,yratio,zratio)
```

Parameters

ScaleRatio	The factor by which to scale the object. A value of 1 causes no change, 2 doubles the size of the object, 0.5 scales the object down to one half its size, and so on.
xratio, yratio, zratio	Scales the object only about that axis. For example, if xratio is 2 and the other values are 1, then the object is scaled up only in the x direction, by a factor of two.

Notes

Having different values for xratio, yratio, and zratio will distort the object.

Sample Code

```
oworld = New World();
ocamera = New Camera(oworld);
obrick = oworld.CreateBrick(50,50,50);
ocamera.MoveBack(1200);
obrick.Scale(2,1,1);

//Loop
While(TRUE)
  {
  }
```

SET

This command sets the position and angle of a 3D object.

```
object.Set(x,y,z,anglex,angley,anglez,time)
```

Parameters

x, y, and z	The object's position on the x, y, and z coordinate system
anglex, angley, and anglez	Refer to the position of the object relative to the x, y, or z axes in radians.
time	The number of seconds the command requires.

Notes

Alternately, we can make the position of the object the same as another 3D object, as shown here:

```
object.Set(other3DObject, time)
```

Sample Code

```
oworld = New World();
ocamera = New Camera(oworld);
obrick = oworld.CreateBrick(50,50,50);
ocamera.MoveBack(1200);
```

```
// Set the position of the brick. It will be moved
// and rotated about all three axes in 5 seconds.
Obrick.Set(50,50,30,1,0.5,0.25,5);

//lLop
While(TRUE)
 {
  //Roll left when the left arrow key is pressed.
  If(IsKeyDown(Keyboard.LEFT))
   {
    obrick.RollLeft(1,1);
   }
  // Roll right when the right arrow key is pressed.
   If(IsKeyDown(Keyboard.RIGHT))
   {
    Obrick.RollRight(1,1);
   }
  }
```

SetAngle

This command sets the angle of a 3D object relative to the world axes, which are the fixed x, y, z axes of your 3D world.

```
object.SetAngle(anglex, angley, anglez, time)
```

Parameters

anglex, angley, anglez	Refer to the position of the object relative to the x, y, or z axes in radians.
time	The number of seconds that the command requires.

Notes

Alternately, we can make the angle of the object the same as another 3D object as shown here:

```
object.SetAngle(other3DObject, time)
```

Sample Code

```
oworld = New World();
ocamera = New Camera(oworld);
obrick = oworld.CreateBrick(50,50,50);
ocamera.MoveBack(1200);
// Set the position of the brick. It will be
// rotated about all three axes in 5 seconds.
Obrick.SetAngle(1,0.5,0.25,5);

//Create a second brick and change its angle with a
// 3 second delay.
obrick2 = oworld.CreateBrick(150,150,50);
Obrick2.SetPosition( 150, 150, 0);
Obrick2.SetAngle(2,2,2,3);

//Loop
While(TRUE)
 {
 }
```

SETCOLLISION

Turns on or off collision detection for the object.

```
object.SetCollision(TRUE/FALSE, Collision Type)
```

Parameters

TRUE	Applies when collision detection is activated for that object.
FALSE	Used to disable collision detection for the object.
Collision Type	The various collision types are as follows:

 Object.COLLISION_TYPE_NONE
 This is used to disable collision detection for the object.

 Object.COLLISION_TYPE_SLIDE
 This causes the object to slide along the surface of the object with which it collides.

 Object.COLLISION_TYPE_STOP
 This causes the object to stop its motion when it collides with another object.

Notes

Please note that if you are checking two objects for collision and neither of the objects has been designated a static object (by the `SetStatic` command), then you must enable collision detection for both of them.

Sample Code

The following sample code enables collision detection for both objects.

```
oworld = New World();
ocamera = New Camera(oworld);
obrick = oworld.CreateSphere(100,100,100);
ocamera.MoveBack(1200);

//Second brick
obrick2 = oworld.CreateSphere(150,150,50);
obrick.SetPosition(-100,0,0);
obrick2.SetPosition( 200, 0, 0);
//Move first brick past the second in 8 seconds, but will
//collide.
obrick.SetPosition(200,0,0,8);
obrick.SetCollision(TRUE,obrick.COLLISION_TYPE_STOP);
//Must enable collision detection on second object as well.
obrick2.SetCollision(TRUE);
//Loop
While(TRUE)
 {
 }
```

SetFlat/Set Gouraud/SetLambert

`SetFlat` and `SetGouraud` enable or disable the flat or Gouraud rendering modes.

```
object.SetFlat(On/Off)
```

or

```
object.SetGouraud(On/Off)
```

Notes

Objects in *Jamagic* can have Gouraud or flat shading (a third type is Lambert shading, which is nearly identical to Gouraud).

Flat shading is not very realistic. It is uniformly bright over the entire object's surface.

Gouraud shading gives a much more realistic and interesting effect in that the brightness of the surface is not uniform.

Sample Code

```
oworld = New World();
ocamera = New Camera(oworld);
sphere = oworld.CreateSphere(50,50,50,25,25);
sphere.SetPosition(0,200,0);
mats = New Material(oworld,,RED,"mats");
sphere.SetGouraud();
sphere.ReplaceMaterial(mats);
plane = oworld.CreatePlane(600,600);
Matplane = New Material(oworld, ,GREEN, "Matplane");
matplane.SetFlat;
plane.ReplaceMaterial(matplane);
plane.SetAngle(-Pi/2,0,0);
plane.SetStatic();
oworld.Optimize(ocamera);
ocamera.MoveBack(1200);
ocamera.MoveUp(200);
sphere.Walk();

sphere.SetShadowMode(Object.SHADOW_MODE_TRUE);
sphere.EnableShadow();
//loop
While(TRUE);
```

SETGRAVITY

Sets gravity (motion down) on an object.

```
object.SetGravity(speed)
```

Parameters

speed Refers to the rate at which the object will drop.

Appendix B *Jamagic* Language Reference **279**

Notes

The larger the value, the faster the drop. Please note that using negative values will cause the object to rise instead of drop.

Sample Code

The following code will drop the sphere using the gravity command until it reaches a y value of –100, at which point it will be moved back to its starting point.

Please note as well that the `Stop` command will not stop an object under the `gravity` command. You must stop it by setting gravity to zero.

```
oworld = New World();
ocamera = New Camera(oworld);
// Create sphere 100 around, and place it at (0,300,0).
osphere = oworld.CreateSphere(100,100,100)
osphere.Set Position(0,300,0);
ocamera.MoveBack(1200);
osphere.set gravity(0.01);

//Loop
While(TRUE)
  {
   If((osphere.gety) < -100)
     {
      Osphere.SetPosition(0,300,0);
     }
  }
```

SETPOSITION

Sets the location of an object in the 3D world.

```
object.SetPosition(x, y, z, speed)
```

Parameters

speed	Refers to the rate at which the change in position will be made (in seconds)
x, y, z	The new position of the object in the 3D reference axes

Notes

Alternately, we could write the following:

```
object.SetPosition(Other3DObject, speed)
```

In this case, the position of our object becomes that of another object.

Sample Code

```
oworld = New World();
ocamera = New Camera(oworld);
// Create sphere 100 around, and place it at (0,300,0).
osphere = oworld.CreateSphere(100,100,100)
osphere.Set Position(0,300,0);
ocamera.MoveBack(1200);
osphere.set gravity(0.01);

//Loop
While(TRUE)
 {
  If((osphere.gety) < -100)
   {
    Osphere.SetPosition(0,300,0);
   }
 }
```

SetRelativeAngle

This command changes the angle of the object relative to its own position. It changes the angle immediately or at a speed that you can specify.

```
object.SetRelativeAngle(xangle, yangle, zangle, time)
```

Parameters

xangle, yangle, and zangle	Refer to the number of radians to add about each axis
time	Refers to the number of seconds for which the rotation is to take place (in seconds)

Notes

Alternately, you can say

```
object.SetRelativeAngle(another3DObject, time),
```

where `another3DObject` refers to another object from which to set the angle.

It is important to know that there is a difference between the `SetRelativeAngle` command and the `AddAngle` command. The `AddAngle` command moves the object about the stationary world axes. The `SetRelativeAngle` moves the object about its own x, y, and z axes.

Sample Code

The following code illustrates the difference between moving objects with the `AddAngle` command and moving them with the `SetRelativeAngle` command by moving two different objects using the two commands.

```
oworld = New World();
ocamera = New Camera(oworld);
sphere = oworld.CreateBrick(50,50,50);
sphere2 = oworld.CreateBrick(50,50,50);
sphere2.SetPosition(100,0,0);
ocamera.MoveBack(1200);
ocamera.Walk();

sphere.AddAngle(1,2,3,10); //Rotates it in 5 seconds.
sphere2.SetRelativeAngle(1,2,3,10); //Rotates it in 5 seconds.
//Show the axes of the two objects.
oworld.ShowObjectAxis();

//Loop
While(TRUE)
{
}
```

SetShadowMode, SetShadowTexture, SetShadowTextureSize, and Enable Shadow

`SetShadowMode` selects one of two types of shadows to be used—true or texture.

```
object.SetShadowMode(ShadowMode)
```

`SetShadowTexture` selects the picture to be used as a shadow in the texture mode (see this demonstrated in the code later in this section).

`SetShadowTextureSize` sets the size of the shadow in the texture mode (see this demonstrated in the code later in this section).

`EnableShadow` turns on the shadow mode.

Parameters

There are two types of shadow modes:

`Object.SHADOW_MODE_TEXTURE`	This type is faster than True Mode and uses a texture that you specify as the shadow.
`Object.SHADOW_MODE_TRUE`	This type makes a true shadow of the object.

Notes

Objects in *Jamagic* can have shadows that rest underneath them. Shadows are displayed on static backgrounds (backgrounds that have been declared as static objects).

True shadows are slower (this is important to know if your game is starting to run slowly). They take the form of a dark surface underneath your object and they have a shape similar to the object. Textured shadows are fake in that they are images you specify to represent the shape of the shadow rather than the shape of the object and its shadow. Textured shadows run faster.

Sample Code

The following code allows you to observe the differences between the two types of shadow by commenting out the appropriate lines. Please note that shadows must be enabled using the `EnableShadow` command.

```
oworld = New World();
ocamera = New Camera(oworld);
sphere = oworld.CreateSphere(50,50,50,25,25);
sphere.SetPosition(0,200,0);
mats = New Material(oworld,,RED,"mats");
mats.SetFlat();
sphere.ReplaceMaterial(mats);
plane = oworld.CreatePlane(600,600);
```

```
Matplane = New Material(oworld, ,GREEN, "Matplane");
matplane.SetFlat;
plane.ReplaceMaterial(matplane);
plane.SetAngle(-Pi/2,0,0);
plane.SetStatic();
oworld.Optimize(ocamera);
ocamera.MoveBack(1200);
ocamera.MoveUp(200);
sphere.Walk();

// Next line is for true shadow mode.
// sphere.SetShadowMode(Object.SHADOW_MODE_TRUE);

//Next 4 lines are for texture shadow mode. Wheel is the
//picture
//to be used as a shadow. If you run this program, you must
//have
// an image under "pictures" named "wheel," or some other name
// if you modify the code.

tex = New Texture(oworld, "wheel");
sphere.SetShadowMode(Object.SHADOW_MODE_TEXTURE);
sphere.SetShadowTexture(tex);
sphere.SetShadowTextureSize(100,100);

sphere.EnableShadow();
//Loop
While(TRUE);
```

SetStatic

This command makes an object a static object.

```
object.SetStatic()
```

Notes

This is an important command for objects that will not move (for example, background objects). By designating an object as a static object, you are saving the computer work because it automatically knows not to check for motion. In this way, you can speed up the execution of your game.

The Optimize command must be used after the SetStatic command in order to for the SetStatic command to take effect.

Sample Code

```
oworld = New World();
ocamera = New Camera(oworld);
sphere = oworld.CreateSphere(50,50,50,25,25);
sphere.SetPosition(0,200,0);
mats = New Material(oworld,,RED,"mats");
sphere.SetGouraud();
sphere.ReplaceMaterial(mats);
plane = oworld.CreatePlane(600,600);
Matplane = New Material(oworld, ,GREEN, "Matplane");
matplane.SetFlat;
plane.ReplaceMaterial(matplane);
plane.SetAngle(-Pi/2,0,0);
plane.SetStatic();
oworld.Optimize(ocamera);
ocamera.MoveBack(1200);
ocamera.MoveUp(200);
sphere.Walk();

sphere.SetShadowMode(Object.SHADOW_MODE_TRUE);
sphere.EnableShadow();
//Loop
While(TRUE);
```

ShowAxis

This command shows either the x, y, and z axes of the objects in your world, or the axes of the world itself. The axes of the world always remain the same—they do not change as objects are rotated. The object axes are relative to the object—they change as the object rotates. There are two commands:

```
myworld.ShowObjectAxis()
```

and

```
myworld.ShowAxis()
```

Notes

These commands can be used to help visualize what is happening to your object as it rotates.

Sample Code

The code below shows both of these commands being used. Only one can be used at a time, though, so the one not being used must always be commented out.

```
oworld = New World();
ocamera = New Camera(oworld);
sphere = oworld.CreateBrick(50,50,50);
sphere2 = oworld.CreateBrick(50,50,50);
sphere2.SetPosition(100,0,0);
ocamera.MoveBack(1200);
ocamera.Walk();

sphere.AddAngle(1,2,3,10); //Rotates it in 5 seconds.
sphere2.SetRelativeAngle(1,2,3,10); //Rotates it in 5 seconds.
//Show the axes of the two objects.
oworld.ShowObjectAxis();
//world.ShowAxis();

//Loop
While(TRUE)
{
}
```

STOP

Stops motion of an object.

```
object.Stop()
```

Notes

This command stops the movement of an object that was initiated by commands such as `Turn`, `Follow`, `Move`, `SetAngle`, and so on. The command does not stop the motion of an object that is being moved down using the `gravity` command.

Sample Code

The following code uses the `stop` command to stop a sphere from falling after it reaches y = −100.

```
oworld = New World();
ocamera = New Camera(oworld);
//Create sphere 100 around, and place it at (0,300,0).
osphere = oworld.CreateSphere(100,100,100)
osphere.SetPosition(0,300,0);
ocamera.MoveBack(1200);
osphere.SetPosition(0,-2000,0,5);

//Loop
While(TRUE)
 {
  If((osphere.gety) < -100)
   {
    Osphere.Stop();
   }
 }
```

SubAngle

This command decreases the angle of the object relative to the `world` axis. It changes the angle immediately or at a speed that you can specify.

```
object.SubAngle(xangle, yangle, zangle, time)
```

Parameters

xangle, yangle, zangle	Refer to the number of radians to subtract from the object's orientation about each axis.
time	Refers to the number of seconds for which the rotation is to take place.

Notes

Alternately, you can say:

```
object.SubAngle(another3DObject, time),
```

where `another3DObject` refers to another object from which to add the angle.

It is important to know that there is a difference between the `SetRelativeAngle` command and the `AddAngle` and `SubAngle` commands. The `SubAngle` command moves the object about the stationary world axes. The `SetRelativeAngle` moves the object about its own x, y, and z axes. Please consult the explanation for the `SetRelativeAngle` command to see sample code that allows you to see the differences between the `SetRelativeAngle` and the `SubAngle` commands.

You should also realize that you do not really need the `SubAngle` command—the `AddAngle` command will do the same motion if you use negative numbers.

Sample Code

```
oworld = New World();
ocamera = New Camera(oworld);
sphere = oworld.CreateSphere(50,50,50,25,25);
ocamera.MoveBack(1200);
ocamera.Walk();

sphere.SubAngle(1,2,3,5); //Rotates it in 5 seconds.

//Rotate it in the opposite direction.
//sphere.SubAngle(-1,-2,-3,5); //Rotates it in 5 seconds.

//Loop
While(TRUE);
```

SUBPOSITION

This command decreases the x, y, z coordinates of a 3D object. It changes the position immediately or at a speed that you can specify.

```
object.SubPosition(x,y,z,time)
```

Parameters

x, y, z	Refer to the number of units to add to the object's position in each axis.
time	Refers to the number of seconds for which the movement is to take place. If the time value is omitted, the movement occurs immediately.

Notes

Alternately you can say

```
object.SubPosition(another3DObject, time),
```

where `another3DObject` refers to another object from which to add the co-ordinate.

The `AddPosition` command is very similar to this one, but it moves the object in the opposite direction. You do not really need both the `SubPosition` and the `AddPosition` commands since using negative numbers in the `AddPosition` command will result in backward motion.

Sample Code

```
oworld = New World();
ocamera = New Camera(oworld);
sphere = oworld.CreateSphere(50,50,50,25,25);
ocamera.MoveBack(1200);
ocamera.Walk();

sphere.SubPosition(100,200,30,5); //Move it in 5 seconds.
//Loop
While(TRUE);
```

TURNBACK

This command turns the object around so that the back of the object faces where the front was facing.

```
object.TurnBack()
```

Sample Code

The following code illustrates this command. When the left arrow key is pressed down, the cube will reverse orientation. However, note that it will continue moving in the same direction.

```
oworld = New World();
ocamera = New Camera(oworld);
sphere = oworld.CreateBrick(50,50,50,25,25);
ocamera.MoveBack(1200);

sphere.AddPosition(300,0,0,10); //Move it in 10 seconds.
```

```
//Loop
While(TRUE)
{
  If ( Keyboard.IsKeyDown(Keyboard.LEFT))
    {
      osphere.TurnBack()
    }
}
```

TurnDown/TurnUp

This command rotates the object up or down about the x-axis.

```
object.TurnDown(angle,time,animation,animation speed)
```

or:

```
object.TurnUp(angle,time,animation,animation speed)
```

Parameters

angle	The number of radians to move down
time	The number of seconds that the move will take (if omitted, the movement is immediate)
animation	The animation name to play (only for 3D objects)
animation speed	The speed of the animation from 0 to 100

Sample Code

The following code will turn the sphere down 2 radians in 5 seconds. The sphere is facing forward, so the lines on the sphere that you can see appear to rotate up.

```
oworld = New World();
ocamera = New Camera(oworld);
sphere = oworld.CreateSphere(50,50,50,25,25);
ocamera.MoveBack(1200);
ocamera.Walk();

sphere.TurnDown(2,5); //Move it in 5 seconds.
//Loop
While(TRUE);
```

TurnLeft/TurnRight

This command rotates the object left or right about the y-axis.

```
object.TurnLeft(angle,time,animation,animation speed)
```

or:

```
object.TurnRight(angle,time,animation,animation speed)
```

Parameters

angle	The number of radians to move left or right
Time	The number of seconds that the move will take (if omitted, the movement is immediate)
Animation	The animation name to play (only for 3D objects)
Animation speed	The speed of the animation from 0 to 100

Sample Code

The following code will turn the sphere left 2 radians in 5 seconds. The sphere is facing forward, so the lines on the sphere that you can see appear to rotate right.

```
oworld = New World();
ocamera = New Camera(oworld);
sphere = oworld.CreateSphere(50,50,50,25,25);
ocamera.MoveBack(1200);
ocamera.Walk();

sphere.TurnLeft(2,5); //Move it in 5 seconds.
//Loop
While(TRUE);
```

TurnTo

This command makes a 3D object look towards another object or location.

```
object.TurnTo(x,y,z,time)
```

or

```
object.TurnTo(Other3DObject,time)
```

Parameters

x, y, z The location where you want the object to look.

time The number of seconds the move will take (if omitted, the movement is immediate)

Notes

This command is different from the `LookAt` command. The `LookAt` command makes your object constantly look at another object or location. The `TurnTo` command makes your object look toward the other object or position, but it makes no further attempts after any motion is made.

Sample Code

In the following code, you will be able to move a sphere with the arrow keys. Two other spheres will be created, one using the `LookAt` command, another using the `TurnTo` command.

```
oworld = New World();
ocamera = New Camera(oworld);
sphere = oworld.CreateSphere(50,50,50,25,25);
sphere2 = oworld.CreateSphere(50,50,50,25,25);
sphere3 = oworld.CreateSphere(50,50,50,25,25);
sphere2.SetPosition(-100,-100,0);
sphere3.SetPosition(100,-100,0);
Sphere3.LookAt(sphere);
Sphere2.TurnTo(sphere,5);
ocamera.MoveBack(1200);
sphere.Walk();
//loop
While(TRUE);
```

WALK

This command makes a 3D object move in response to the arrow keys.

```
object.Walk(Player,WalkSpeed,StrafeSpeed,RotateSpeed,
        RunFactor)
```

Parameters

Player	Player number (1,2, 3, and so on). For use with the GameInput command.
WalkSpeed	Speed at which the forward or backward motion will occur.
StrafeSpeed	Strafe speed.
RotateSpeed	Speed for rotation in radians per second.
RunFactor	Multiplier factor between walking and running.

Notes

This command uses the arrow keys to move the object. The left and right arrow keys rotate the object about its y-axis, while the up and arrow keys move it forward or back (the direction of motion depends on which way the object is pointing).

This is a very easy way to make an object move through a 3D world.

Sample Code

```
oworld = New World();
ocamera = New Camera(oworld);
sphere = oworld.CreateSphere(50,50,50,25,25);
ocamera.MoveBack(1200);

sphere.Walk();
//loop
While(TRUE);23
```

INDEX

A

Abs command, 248–49
Acos command, 249
AddAngle command, 250–51
AddPosition command, 251
airport image, 178–81
amplitude, 146
analog instrument panel, 191–97
angle
 finding jet's, 172–73
 SetAngle command, 275–76
 SetRelativeAngle command, 280–81
 SubAngle command, 286–87
animation parameter, 53
AnimUV command, 148
antialiasing, 195
arccosine, 249
arcsine, 252
arctangent, 252–53
array, 41–42
artwork, 3–4, xii
Asin command, 252
aspect ratio, 97–99
Atan command, 252–53

B

background music, 74–76, 144
Boolean variables, 119–20
bow thrusters, 206–7, 217, 229
bugs, 29–30
buttons, adding clickable, 100

C

calculations
 basic, 78–80
 speed of, 104
CameraFollow command, 85, 224
cameras
 default camera location, 26
 moving, 27
 SetFocus command, 176–78
 view of, 224–27
CD-ROM, about the, 244
child window, 96–99, 226
clickable buttons, 100
collision
 avoidance, 263–64
 detection, 62–68, 120–22, 230
 docollision function, 89, 90, 121–22, 181–82
 good and bad, 120–22
 SetCollision command, 276–77
Color Mode, 30–31
colors
 adding, 45–46
 adjusting text, 84
 flat, 45–46, 277–78
 Gouraud shading, 46, 58–61, 118, 277–78

Lambert shading, 46, 277–78
RGB scale and, 45–46
commands
 Abs, 248–49
 Acos, 249
 AddAngle, 250–51
 AddPosition, 251
 AnimUV, 148
 Asin, 252
 Atan, 252–53
 CameraFollow, 85, 224
 Cos, 253–54
 CreateBrick, 228–29
 CreatePlane, 70–71
 Enable Shadow, 281–83
 Follow, 254–55
 GetDegree/GetRadian, 255–56
 GetDistance, 256–57
 GetX, 257–58
 GetXAngle, 258–59
 Hide, 65, 259–60
 Light, 260–61
 LookAt, 262
 Move, 53–54, 211–12, 262–63
 MoveAround, 263–64
 MoveBack, 264–65
 MoveDown/MoveUp, 265–66
 MoveLeft/MoveRight, 266
 OnStopMovement, 267
 Pause, 267–68
 Random, 268–69
 recognition of, by *Jamagic*, 30
 Resume, 269–70
 RollLeft/RollRight, 270–71
 Round, 271–72
 Scale, 273–74
 Set, 274–75
 SetAngle, 275–76
 SetCollision, 276–77
 SetFlat, 277–78
 SetFocus, 176–78
 SetGouraud, 277–78
 SetGravity, 84–85, 278–79
 SetLambert, 277–78
 SetPosition, 279–80
 SetRelativeAngle, 250, 280–81
 SetShadowMode, 281–83
 SetShadowTexture, 281–83
 SetShadowTextureSize, 281–83
 SetStatic, 61–62, 283–84
 SetText, 79
 Show, 65, 259–60
 ShowAxis, 284–85
 Sine, 272–73
 Stop, 285–86
 SubAngle, 286–87
 SubPosition, 287–88
 TurnBack, 288–89
 TurnDown/TurnUp, 289
 TurnLeft/TurnRight, 290
 TurnTo, 290–91
 Wait, 145
 Walk, 27, 36–40, 225, 228, 291–92
comment lines, 21–22, 37–38
compass heading, 178–81
computer programs. *See* programs
computer speed issues, 171–72, 183
coordinate systems, 8–10
coordinated turn, 159
coordinates
 GetX command and, 257–58
 mapping, 42
 SubPosition command and, 287–88
 u, v, 13–15, 42
Cos command, 253–54
cosine, 160–69, 175–76, 253–54
counters, 90–91
CreateBrick command, 228–29
CreatePlane command, 70–71
culling, 13

D

DirectX, 2
distance, calculating between objects, 77–78, 256–57
docking maneuver, 229–30
docollision function, 89, 90, 121–22, 181–82

E

`Enable Shadow` command, 281–83
ending game, 70
engines, 208
equations
 order of operations in, 78–79
 ship rotation, 214–15
 speed as a function of pitch, 170–71
errors, 29–30
Esc key, 70
execution speed, 183

F

file formats, 114–15
flags, 90–91
flat colors, 45–46, 277–78
flat shading, 58–61
flight simulators
 basics, 158–60
 FlightSimulator program, 160–69
 FlightSimulator2 program, 169–90
 FlightSimulator3 program, 190–204
floating point numbers, 104–5, 119
fog, 68–69
`Follow` command, 254–55
fuel monitoring, 101–3
functions
 defined, 64–65
 variable initialization and, 103–4

G

game loop, 27–28, 90
games
 see also programs
 determining when won or lost, 91–92
 distributing, 242
 ending, 70
gauge, 191–97
`GetDegree/GetRadian` command, 255–56
`GetDistance` command, 256–57
`GetX` command, 257–58
`GetXAngle` command, 258–59
Gouraud shading, 46, 58–61, 118, 277–78
graphics objects
 see also objects
 importing, 115–16
 making, 110–15
 working with, 116–19
gravity, 84–85, 278–79

H

`Hide` command, 65, 259–60
hierarchy of operations, 78–80
hot spot, 192–93, 211

I

`if` statements
 about, 51–53
 -and, 80–81
 Boolean variables and, 119–20
 embedded, 91–92
images
 importing, 42–43
 tiling, 147–48
inertia, 86–87, 208
initialized values, 103–4, 132
instrument panel, 191–97, 210–11
integers, 104–5, 119

J

Jamagic
 about, 2, xi–xii

loading, 4
making new program in, 18–22
picture editor, 30–33
uses for, 3

L

Lambert shading, 46, 277–78
landing, criteria for successful, 181–82
Light command, 260–61
LookAt command, 262

M

mapping, 35–36, 42
mathematics, 2–3
memory, 31
menu
 adding to game, 129–40
 pop-up, 129–31
Menusample program, 129–40
mesh shading, 58–61
messages, displaying, 76–77
MilkShape 3D
 about, 4
 loading, 5
 making graphics objects using, 110–15
Move command, 53–54, 211–12, 262–63
MoveAround command, 263–64
MoveBack command, 264–65
MoveDown/MoveUp commands, 265–66
MoveLeft/MoveRight commands, 266
movement
 if statements, 51–53
 of objects, 36–40, 50–58, 291–92
 rotations, 56–58
 ship, 214–17
 speed of, 38–40
 stopping, 285–86
 Walk command, 27, 36–40, 225, 228, 291–92
music
 adding, 74–76, 144
 modifying, 145–47

O

objects
 axes of, 284–85
 calculating distance between, 77–78, 256–57
 determining position of, 87
 importing, 110–15, 142–43
 making graphics, using 3D modeling packages, 110–15
 moving, 36–40, 50–58, 291–92
 rotating, 56–58, 70–71, 289–90
 setting location of, 279–80
 static, 61–62, 283–84
 turning, 288–89
 working with, 116–19
one-dimensional world, 8
OnStopMovement command, 267
operations
 basic calculations, 78–80
 hierarchy of, 78–79

P

parentheses, 24
Pause command, 267–68
picture editor, 30–33
pitch, 158, 160, 165, 166, 170–71
pixels, 195
planes
 adding, 68, 70
 rotating, 70–71
pop-up menu, 129–31
precision, 104–5
programming, challenge of, 2–3
programs
 creating first, 23–30
 defined, 18
 FlightSimulator, 160–69
 FlightSimulator2, 169–90
 FlightSimulator3, 190–204
 making, in *Jamagic*, 18–22
 Menusample, 129–40

saving, 36–37
Ship Simulator, 209–24
ShipSim2, 224–40
Sphere1, 50–58
Sphere2, 58–61
Sphere3, 61–68
Sphere4, 68–73
Sphere5, 74–83
Sphere6, 84–96
Sphere7, 96–110
Sphere8, 110–28
Sphere9, 140–56
Pythagorean theorem, 87–89, 212

R

Random command, 268–69
rate of climb, 173–75
rectangles, creating, 41–44
red rectangle, 29, 30
refresh rate, 99–100
Resume command, 269–70
RGB scale, 45–46, 118
roll, 158–59, 162–63, 167, 172–73, 196
RollLeft/RollRight commands, 270–71
rotation
 of aircraft, 158–59
 GetXAngle command and, 258–59
 of objects, 56–58, 289–90
 rate, 39
 of ship, 214–17
 vertical speed and, 196
Round command, 271–72
rudder, 207–8, 214–17
run speed factor, 39

S

S key, 92
Scale command, 273–74
scaling factor, 209
semicolon, 24
Set command, 274–75
SetAngle command, 275–76
setbackfacesculling (OFF) command, 38
SetCollision command, 276–77
SetFlat command, 277–78
SetFocus command, 176–78
SetGouraud command, 277–78
SetGravity command, 84–85, 278–79
SetLambert command, 277–78
SetPosition command, 279–80
SetRelativeAngle command, 250, 280–81
SetShadowMode command, 281–83
SetShadowTexture command, 281–83
SetShadowTextureSize command, 281–83
SetStatic command, 61–62, 283–84
SetText command, 79
shading, 58–61
shapes
 3D, making, 44–47
 making complicated, 40–44
ship
 movement of, 214–17
 rotation, 214–17
 speed, 211–13
ship simulators
 ship control basics, 206–8
 Ship Simulator program, 209–24
 ShipSim2 program, 224–40
ShipSim2, 224–40
Show command, 65, 259–60
ShowAxis command, 284–85
sine, 160–69, 170–71, 174–75
Sine command, 272–73
software distribution, 242
sound editor, 145–47
sounds
 adding, 74–76, 144
 modifying, 145–47
source code, accessing, 22
spaces, 28–29
speed

of calculations, 104
of computer, 171–72, 183
execution, 183
as function of pitch, 170–71
ship, 211–13
vertical, 173–75, 181, 196
Sphere1, 50–58
Sphere2, 58–61
Sphere3, 61–68
Sphere4, 68–73
Sphere5, 74–83
Sphere6, 84–96
Sphere7, 96–110
Sphere8, 110–28
Sphere9, 140–56
sprites, 191–97, 210–11, 217, 227
static objects, 61–62, 283–84
stern thrusters, 206–7
Stop command, 285–86
strafe speed, 39
strafing, 265
SubAngle command, 286–87
SubPosition command, 287–88
switch case statement, 131–33
system requirements, 4, 245

T

text
adjusting color of, 84
displaying, on screen, 76–77
texturing
adding, 33–36
culling and, 13
defined, 10–11
process, 33–36
tiling, 147–48
u, v coordinates and, 13–15
winding order and, 11–13
3D coordinate system, 8–10
3D objects
importing, 115–16, 142–43
included with *Jamagic*, 3–4, 141–43
making, 44–47
making, using 3D modeling packages, 110–15
working with, 116–19
throttle, 208, 217
thrusters, 206–7, 217, 229
tiling, 147–48
time parameter, 53
timers, 101–3
triangles
making complicated shapes with, 40–44
program for creating, 23–30
TurnBack command, 288–89
TurnDown/TurnUp commands, 289
TurnLeft/TurnRight command, 290
TurnTo command, 290–91
two-dimensional world, 8–9

U

u, v coordinates, 13–15, 42
UV animation, 147–48

V

variable initialization, 103–4
variables
Boolean, 119–20
declared vs. undeclared, 132
floating point numbers, 104–5, 119
integers, 104–5, 119
types of, 104–5
vertical speed, 173–75, 181, 196
views
camera, 224–27
child window and, 96–99

W

Wait command, 145
Walk command, 27, 36–40, 225, 228, 291–92
walk speed, 39

water depth, 227–28
water surface, 147–48, 209–10
winding order, 11–13
windows
 child, 96–99, 226
 main, 97–98
 refresh rate of, 99–100
 standard, 97

X

x distance, 77

Y

yaw, 158–59, 175–76

Z

z-axis, 9–10